HDR Photography.
From
Snapshots to
Great Shots

Tim Cooper

Peachpit Press

HDR Photography: From Snapshots to Great Shots
Tim Cooper

Peachpit Press
www.peachpit.com

To report errors, please send a note to errata@peachpit.com

Peachpit Press is a division of Pearson Education
Copyright © 2015 by Tim Cooper

Senior Editor: Nikki McDonald
Senior Production Editor: Lisa Brazieal
Development/Copyeditor: Scout Festa
Proofreader: Patricia Pane
Composition: WolfsonDesign
Indexer: James Minkin
Cover Image: Tim Cooper
Cover Design: Aren Straiger
Interior Design: Mimi Heft

ISBN-13: 978-0-134-18028-1
ISBN-10: 0-134-18028-3

9 8 7 6 5 4 3 2 1

Printed and bound in the United States of America

Acknowledgements

Writing a book is a crazy, whirlwind experience filled with highs and lows, stress and relief, and learning and teaching. It's a team effort shared by many. As I finish the last chapter, I am taking time to reflect on how incredibly fortunate I have been. My life and photographic career have been filled with so many amazing people who have loved, helped, influenced, and guided me throughout the years. Their lessons and voices echo throughout this book.

To my parents and siblings—Charlene and Jack, Christopher, Katie, and Q—thank you. Your love and understanding have enabled my existence.

To Ava Marisa, thank you for everything. Your love, encouragement, support, determination, and tolerance are unrivaled. You are by far the strongest person I know.

My first steps in this career were guided by the wise heart and hands of my friend and first photo teacher Melissa Blunt. Further encouragement and support were supplied by Neil and Jeanne of Rocky Mountain School of Photography. It's been a long road, N&J, glad to have shared it with you.

I want to thank Bruce Barnbaum, whose photography and books have been an endless source of education and inspiration, and Galen Rowell, whose enthusiasm was infectious and whose life was an object lesson in reaching for the stars.

A special thanks to Kathy Eyster for always making me believe I was good enough and for introducing me to George DeWolfe. George, you are a true artist. I would be happy to have a thimbleful of your creativity and vision.

I would also like to thank John Paul Caponigro. You are an icon of our era. Your efforts to integrate art theory, color, modern photography, and computers are unprecedented.

Every modern photographer working on the computer owes a debt to the folks at Adobe. Thanks, Adobe! Where would we be without you? And thank you to Julieanne Kost for your imagination, energy, humor, and clear teaching.

I also want to show my appreciation for B&H Photo Video. It's not only the best camera store in the world, but it's also filled with the best people in the world! It's rare to find such a wealth of knowledge and talent and people willing to share it. Thank you to Manny for reaching out so long ago. David Brommer and Deborah Gilbert—thanks! It's always a pleasure to visit and work with you two. Kelly Mena, you are an amazing talent; I want to thank you and Matt D'Alessio for making me feel comfortable and for making me look not horrible. Thanks to Jes Bruzzi for your friendship and encouragement! To the Road Crew, who has made my winter weekends something to look forward to—Gabriel Biderman, John Faison, Jason Freebird, and Christian Domecq—your humor and extensive knowledge have been invaluable.

Nan, my sister, thanks for sharing Gabriel with me. He's taught me almost everything I know about nighttime activities.

Thank you, Peachpit. Your crew is a professional group of talented folks working behind the scenes to make the authors look good. Thanks to Susan Rimerman, Nikki McDonald, Scout Festa, Patricia Pane, and Lisa Brazieal for all you do. Your work is appreciated.

During my years as a teacher, I have learned as much from my students as I have taught them. Thank you all for allowing me the privilege of working with you. Thank you, RMSP. Thanks also to the multitude of talented people that work there: Bob McGowan, Andy Kemmis, Alyssa Johnson, Melanie Wright, Marcy James, Rochelle Benton, Joyce Fielding, and Tony Rix.

In addition to learning from my students, my friends and colleagues have been a never-ending source of education, inspiration, and support. The best parts of who I am are simply a reflection of them. David Baranowski, Randy Woolley, Scott Graber, Jeff Powers, Jeff Nelson, Mike Nordskog, Doug Johnson, Elizabeth Stone, Tony Rizzuto, Eileen Rafferty, David Marx, Brad Hinkel, and the one and only Athena.

A special thanks to Tony Rizzuto and Elizabeth Stone and Ava Marisa Zangeneh. Your patience and understanding during this project have meant the world to me. Ben Zanganeh, I could never have finished this book without the espresso machine. A thousand thanks.

Contents

CHAPTER 1: WHAT IS HDR AND WHY USE IT? **1**

The Problems That HDR Solves

Poring Over the Picture	2
Poring Over the Picture	4
A Program, an Image, or a Technique?	6
Why Use HDR	8
Camera Capabilities	10
Histograms and Pixel Information	11
When HDR Is Needed	16
Chapter 1 Assignments	25

CHAPTER 2: EQUIPMENT, SETTINGS, AND EXPOSURE **27**

Setting Your Camera for Success

Poring Over the Picture	28
Poring Over the Picture	30
Photography Equipment	32
Camera Settings	36
Metering the Scene	38
Bracketing	44
Chapter 2 Assignments	47

CHAPTER 3: VISUAL PERCEPTION **49**

Learning to See

Poring Over the Picture	50
Poring Over the Picture	52
How Our Eyes and Cameras See the World	54
Visual Distractions and Attractions	62
Chapter 3 Assignments	67

CHAPTER 4: STARTING AND ENDING IN LIGHTROOM 69
Preparing Your Images for Success

Poring Over the Picture 70

Poring Over the Picture 72

Preparing Images in Lightroom 74

Adjusting Images in Lightroom 81

Basic HDR Theory 86

Chapter 4 Assignments 89

CHAPTER 5: USING HDR SOFTWARE 91
My Favorite HDR Programs

Poring Over the Picture 92

Poring Over the Picture 94

Lightroom 96

Photomatix Pro 109

Chapter 5 Assignments 127

CHAPTER 6: LANDSCAPE PHOTOGRAPHY 129
Photographing Our Natural World

Poring Over the Picture 130

Poring Over the Picture 132

Equipment Considerations 134

Camera Settings 141

Techniques 146

Chapter 6 Assignments 163

CHAPTER 7: ARCHITECTURE AND INTERIORS **165**

Symmetry and Lines

Poring Over the Picture 166

Poring Over the Picture 168

Equipment Considerations 170

White Balance 178

Position and Focal Length 182

The Lens Corrections Panel 184

Adjustments Prior to Merging to HDR 186

Processing Architectural Images in Lightroom 187

Processing Architectural Images in Photomatix 191

Chapter 7 Assignments 195

CHAPTER 8: LOW-LIGHT AND NIGHT PHOTOGRAPHY **197**

Extending Your Photographic Day

Poring Over the Picture 198

Poring Over the Picture 200

Equipment Considerations 202

Camera Settings 205

Techniques 213

Chapter 8 Assignments 224

INDEX **225**

Introduction

Like most photographers, I began carrying a point-and-shoot camera to capture memories of friends and family at weekend events and vacations. Curiosity, though, eventually led to my exploration of the camera's "advanced" features. Slow shutter? Fill flash? Wow, that was cool. Thus began my 24-year obsession with photography.

It wasn't long after I bought my first 35mm camera that I became familiar with the work of Ansel Adams. I remember marveling at his sensitivity to subject matter and at the beauty he created with his prints. Growing up in New Jersey, I was of course drawn to the magnificent and wild views of the West, but there was something else that drew me into Ansel's work: dichotomy. He was as much an artist as he was a craftsman. It wasn't enough for him to be technically proficient with his camera and chemicals—he also needed spirit, creativity, and vision to create his masterpieces.

As I grew as a photographer, I began to achieve a deeper understanding of Ansel's work. The artist/craftsman relationship was not his only dichotomy. He also straddled the line between realism and surrealism. Creating black skies and intense contrast was not an effort to conform to reality but rather an attempt to amplify its beauty. His technique rarely overwhelmed the essence of the scene.

As computers replace darkrooms, our ability to manipulate the photographic image has become limitless. With the never-ending options available in post-processing, it's more important than ever to understand the essence of our work. It's far too easy to let the manipulations overpower the spirit of the image. My goal, then, is to show you how to straddle the line between reality and possibility. Using the latest technologies, and the wisdom of a century of photography, you'll learn how to translate those difficult-to-capture scenes into believable imagery.

Beginning with an explanation of the HDR process, you'll learn the strengths and weaknesses of the camera as well as of our vision and our perception of the world. You'll discover which meters to use and how to properly expose a scene that requires multiple exposures to blend to HDR. There's an emphasis on Adobe Photoshop Lightroom and how and why to use it to download and prepare your images. I also cover Photomatix Pro and Lightroom's new Photo Merge > HDR function. The book ends with tips and tricks for three popular forms of photography that require the use of HDR: nature and landscapes, architecture and interiors, and low-light and night photography.

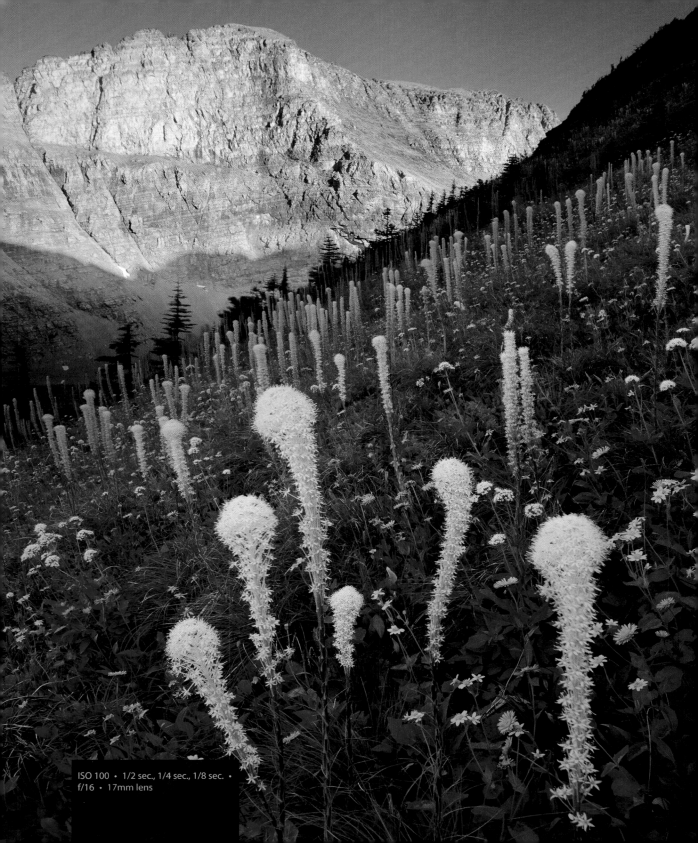

ISO 100 • 1/2 sec., 1/4 sec., 1/8 sec. •
f/16 • 17mm lens

1
What Is HDR and Why Use It?

The Problems That HDR Solves

Although HDR programs are a relatively new phenomenon, the problems they solve are as old as photography itself. Photographers have long struggled with the inability of the camera to render the scene as the eye perceives it. Our eyes are fantastic instruments that allow us to perceive detail over a very wide range of brightness. Cameras, however, have always failed to produce a photograph that matches what our eyes can see.

From the earliest days of the medium, photographers have been developing methods to remedy this disparity. Contrast-reduction methods could be as simple as waving cutout pieces of card stock over an image during printing, or as complex as calculating new developing times with altered solutions of film developer. The modern HDR programs are a cleaner, more elegant, and easier solution to the problem of high-contrast scenes.

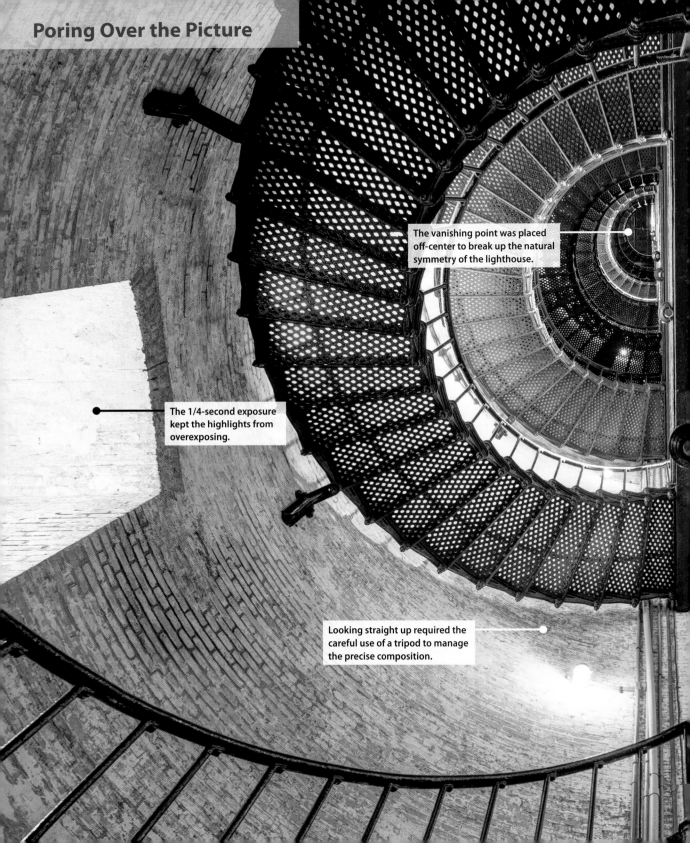

The vanishing point was placed off-center to break up the natural symmetry of the lighthouse.

The 1/4-second exposure kept the highlights from overexposing.

Looking straight up required the careful use of a tripod to manage the precise composition.

It's hard to resist the allure of a spiral staircase, with its concentric rings reaching into the sky. The trick with this staircase was to reveal detail in the dark bottom landing, straight above my head, while keeping the bright upper stairs and window wells from overexposing. The next challenge was to compose the scene in a way that kept the vanishing point out of the center of the frame while retaining a balance between the dark and light areas of the frame. I shot three separate exposures—at 1/4 of a second, 1/2 of a second, and 1 second—and blended the images together in Photomatix Pro.

The 1-second exposure provided detail in the dark landing above my head.

ISO 400 · 1/4 sec., 1/2 sec., 1 sec. · f/8 · 24mm lens

Poring Over the Picture

The exposure of 1/8 of a second kept the bright, sunlit clouds from overexposing.

A waterfall downstream created a cloud of mist that blended with the distant clouds.

This image was created at a favorite photography workshop location overlooking the Swiftcurrent River in Glacier National Park. Sunrise at this location is simply magical. As the sun began its ascent into the morning sky, it illuminated the mist created by the waterfalls downstream. Distant fog and low clouds softened the harsh sunrise and made the powerful scene somewhat more ethereal.

Composing the water as a diagonal on the right side of the frame mimics the diagonal clouds in the upper part of the image.

Slow shutter speeds of 1 second and 1/2 second gave a cotton candy feel to the water while allowing the dark areas to be rendered brighter.

ISO 100 • 1 sec., 1/2 sec., 1/4 sec., 1/8 sec. • f/16 • 16mm lens

A Program, an Image, or a Technique?

The initialism HDR stands for high dynamic range. It can refer to a computer program, a photograph that has been processed by an HDR program, or the technique of taking multiple photographs with the intention of blending them in an HDR program.

Let's begin with the phrase "dynamic range." Dynamic range refers to the brightness difference between the darkest and brightest parts of a scene. A scene low in dynamic range would have a limited range of brightness tones, as seen in **Figure 1.1**. Here you see tones that are almost all the same brightness; the entire scene is made up of midtones. A scene high in dynamic range would have a large range of brightness values, as seen in **Figure 1.2**. Here the image consists of midtones, shadows, and highlights. By including the sky and background, the difference between the highlight values and the shadow values greatly increases. This huge difference between values is what makes this scene high in dynamic range. "High-contrast" is commonly used to describe scenes with high dynamic range.

Figure 1.1
A scene with low dynamic range.

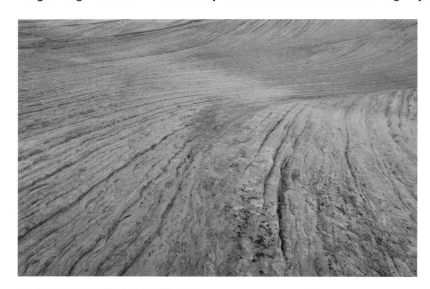

Figure 1.2
A scene with high dynamic range.

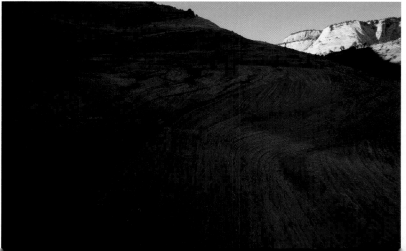

The problem with film and digital sensors is that neither is capable of providing a realistic image in these high-contrast situations. If you expose correctly for the shadow area of the scene, the bright highlight areas become overexposed (featureless white), as seen in **Figure 1.3**.

If you expose properly for the highlight area, the shadows become underexposed (featureless black), as seen in **Figure 1.4**. In cases where the contrast is really extreme, it is possible to lose detail in both the shadow areas and the highlight areas.

Both photos appear unrealistic because as we encounter these situations in real life, we see detail in the very dark and very bright parts of high-contrast scenes. We see something more like the image in **Figure 1.5**.

Figure 1.3 **A good exposure for the shadows results in overexposed highlights.**

Figure 1.4 **A good exposure for the highlights results in underexposed shadows.**

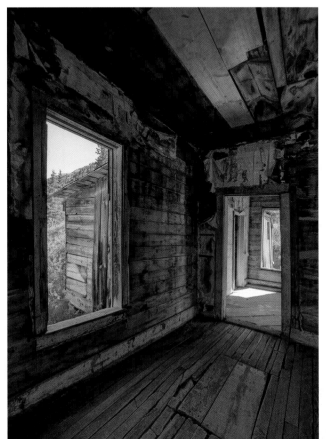

Figure 1.5
An image created by blending the two previous photos in the HDR program Photomatix.

The HDR *technique,* then, is to take multiple photographs at different exposures. Each of these photos will capture a different range of detail. Once the photos are captured, you can then import them into an HDR program. HDR programs blend all the exposures into one photograph that contains full shadow, midtone, and highlight detail. The resulting image is often referred to as an HDR image or HDR photograph.

Purchasing HDR Programs

Adobe Photoshop and Adobe Lightroom have the ability to blend images together using HDR algorithms. The industry standard HDR program is called Photomatix, which can be purchased at hdrsoft.com. I recommend purchasing the Photomatix Pro version. You can receive a 15% discount on Photomatix by typing my name, TimCooper (capital T, capital C, all one word), into the coupon code upon checkout.

Why Use HDR

The primary reason for wanting to shoot multiple exposures and blend them in an HDR program is to capture full detail in a scene that contains very bright areas and very dark areas. These high-contrast scenes can be found everywhere, from landscape and nature scenes to interior architecture and real estate situations. A classic example would be a landscape photograph taken just before sunrise: the sky is being illuminated by the sun, which is not yet high enough to illuminate the land. The result is a very high-contrast scene. If you make a good exposure for the sky, the foreground becomes black. Make a good exposure for the foreground, and the sky turns white. Neither of these situations is how we perceive the scene as we are standing there.

Controlling high contrast

In addition to their ability to provide detail in the shadows and highlights of high-contrast scenes, HDR programs come with the capability to control contrast throughout the entire image. This ability has led to the use of these programs for generating a unique, somewhat grungy look (**Figure 1.6**).

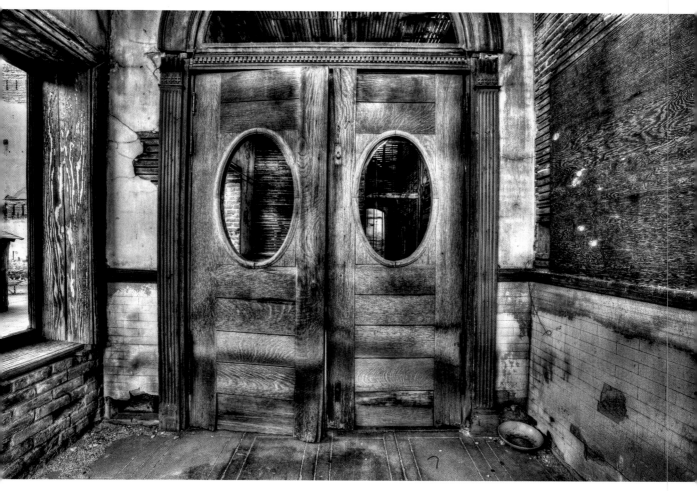

Figure 1.6 **A contemporary use of HDR programs is to create a grungy look.**

This type of imagery is relatively easy to create and will not be the focus of this book. In the upcoming chapters, I show you how to create photographs that better represent reality and that have subtlety, depth, and staying power.

Camera Capabilities

As we have seen, there is a great disparity between what our eyes perceive and what the camera's sensor captures. This difference can be measured in *stops*, which are units used by photographers to quantify light. Simply put, moving your aperture from f/8 to f/11 decreases the amount of light hitting the sensor by one stop.

Sensor capabilities

Moving your aperture from f/8 to f/5.6 increases the light by one stop. The term *stop* also applies to shutter speeds. Opening up your shutter from 1/250 to 1/125 increases the light by one stop, whereas closing it down from 1/250 to 1/500 decreases the light by one stop.

Our eyes perceive detail in scenes that contain up to 11 stops of difference in light, whereas the camera can capture only five to seven stops of light. At first this may not seem like a huge difference, but when you realize that each stop lets in twice as much light as the previous stop, you can understand that the difference is significant.

It is important for photographers to recognize when parts of their scene will be rendered as featureless black areas or as blown-out, featureless white areas. This information can lead us to use different exposures, change compositions, or even return under different lighting conditions. Your camera can display a tool called a histogram, which provides this information. Most cameras can display the histogram after each shot, but typically this is not the default behavior. Check your camera manual for directions on how to display this essential tool. Many cameras will also allow you to choose between two types of histograms: the luminosity histogram, shown in **Figure 1.7**, and the RGB histogram, shown in **Figure 1.8**. The RGB histogram shows the red, green, and blue channels of the image.

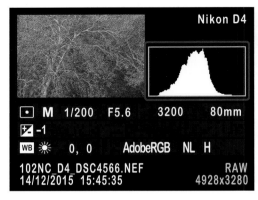

Figure 1.7 **A luminosity histogram as it appears on the back of a Nikon camera.**

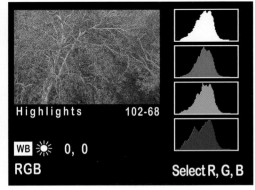

Figure 1.8 **An RGB histogram.**

The luminosity histogram is sometimes called a composite histogram because it is made up of a combination of the red, green, and blue channels. Both histograms perform the same function, and either can be used. Most image-editing programs, such as Adobe Lightroom, also provide a histogram (**Figure 1.9**).

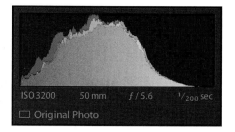

ISO 3200 50 mm f / 5.6 ¹/₂₀₀ sec

☐ Original Photo

Figure 1.9 **The same histogram as it appears in Adobe Lightroom.**

Histograms and Pixel Information

The histogram is a graphic representation of the tonal values in the scene. It tells you how much of the scene is composed of darks, lights, and midtone values. It also tells you when you are losing detail in the shadows and highlights.

In **Figure 1.10**, you see an image that contains a full range of tonal value and detail; **Figure 1.11** shows the histogram that represents it. In this photo you can see detail in both the shadows and the highlights.

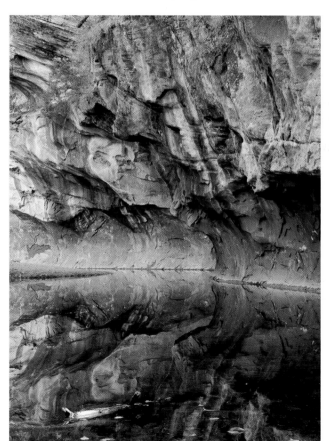

Figure 1.10
An image that contains full tonal detail.

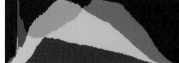

Figure 1.11 **The histogram representing that image.**

Figure 1.12 shows the areas represented by the histogram. If the spike of the graph is high in a region, it means there is a lot of that value in the scene. It's not a problem if the spikes reach or touch the top of the box (as the red and green channels do in Figure 1.12). This just tells you that there's an abundance of that value (brightness) in the scene. This histogram tells us there are plenty of midtone values in the scene. It contains fewer darks and lights and very few blacks and whites. Take a couple of minutes and examine the photo in Figure 1.10 and its histogram together. Note the small amounts of blacks and whites in the image and how that corresponds with the histogram.

When the graph comes down into the corners, as seen in **Figure 1.13**, it means you will see full detail in your blacks and whites. Examine Figure 1.10 again and you will notice that you can readily see detail in the brightest area of the photo as well as in the darkest areas.

Figure 1.12 **A histogram represents different tonal values of a photograph.**

Figure 1.13 **Histogram showing good highlight and shadow detail.**

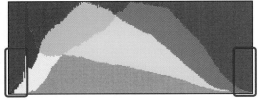

If the graph touches the left or right sides of the box, it means you will see some under- or overexposure in your final photograph. **Figure 1.14** shows a dark photo of a stairwell and its histogram. You can see how the graph is pushed up against the left wall of the histogram box. In this image there is plenty of highlight detail, demonstrated by the graph on the right side coming down into the corner. **Figure 1.15** shows a lighter photo of the same stairwell, and its histogram. Here you can see plenty of detail in the shadows but not in the highlights, which are overexposed.

> Tip [NEED SIDEBAR HEAD OTHER THAN "TIP"]
>
> Many terms in photography are left over from film days and don't always match with current circumstances or technology. For example, we would say our highlights were "blown out" when they were overexposed; overexposed highlights are pure white with no visible detail. We would also say our shadows were "blocked up" when they were underexposed; underexposed shadows are pure black with no visible detail.

Figure 1.14 On the left side of the histogram, you can see the graph touching the edge of the box; this shows you that the shadows are blocked up, resulting in a loss of detail in the black areas. The information on the right side doesn't touch the edge, meaning the highlights have good detail.

Figure 1.15 On the right side of the histogram, you can see the graph touching the edge of the box; this shows you that the highlights are blown out, resulting in a loss of detail in the white areas. The information on the left side of the histogram comes right down into the corner, indicating that the shadows have good detail.

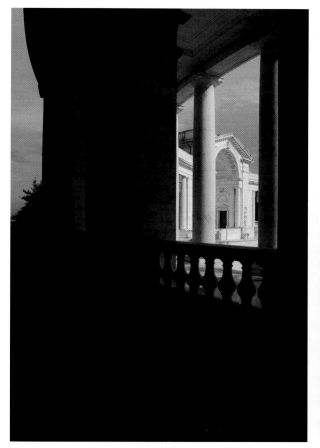

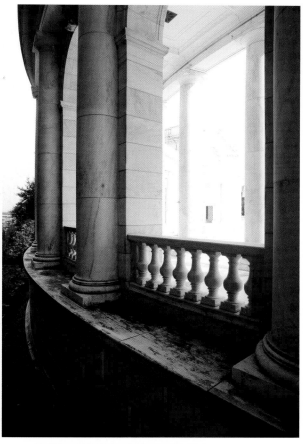

When the graph touches the edge of the box, it is really finishing outside the box, which is out of our view. **Figure 1.16** is a histogram showing good detail in both the blacks and whites. The graph is contained inside the box. **Figure 1.17** is an example of the same scene but with overexposed highlights. You can see the graph actually finishing outside the box. This is sometimes referred to as "clipping the highlights." **Figure 1.18** is an example of the same scene except with underexposed blacks. Again, the graph finishes outside the box. Another term for this is "clipping the shadows."

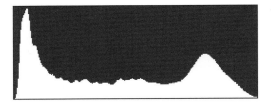

Figure 1.16 **Histogram representing an image with good highlight and shadow detail.**

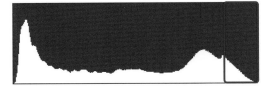

Figure 1.17 **Histogram showing overexposed highlights.**

As you can see, the histogram is an invaluable tool for judging exposure. It should be referenced after every shot to ensure that you are capturing detail when necessary. Remember that there is no perfect shape for a histogram. The shape of the graph is simply determined by the scene it represents. The histogram in **Figure 1.19**, representing the photo

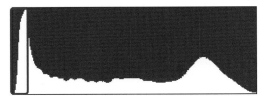

Figure 1.18 **Histogram showing underexposed shadows.**

of the snow-covered tree, is clearly unorthodox, but the scene it represents is properly exposed. Because most of the scene is highlights and whites, the graph should be over to the right. There are no real shadows in the scene, and the histogram represents that. The same could be said for **Figure 1.20**. Here, the graph is stacked to the left, as is proper for a scene with an abundance of blacks.

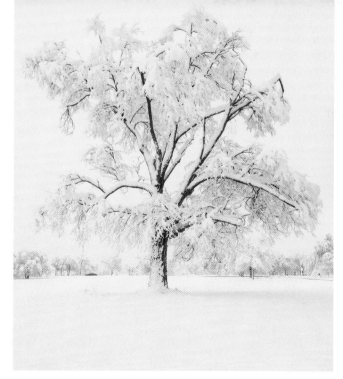

Figure 1.19 The histogram stacked to the right indicates a good exposure of this snow-covered tree.

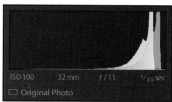

Figure 1.20 The histogram stacked to the left indicates a good exposure of this black train.

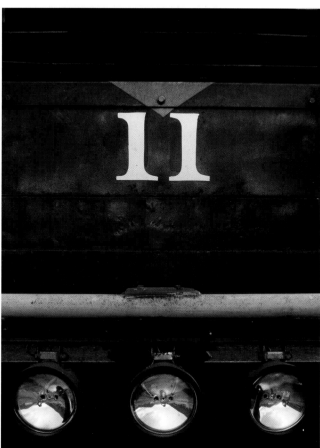

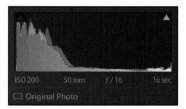

When HDR Is Needed

Although HDR is the topic of this book, it's not necessary with every photograph. Our cameras are capable of capturing the full brightness range of plenty of scenes. So when do you need HDR? The simple answer would be whenever the scene's brightness range exceeds the camera's capability to capture it.

By this measure, however, we would never have any photographs with pure blacks or whites, which are necessary to provide a photograph with a full range of brightness levels (tonal value). Some pure black or pure white without detail is fine in almost any photograph. **Figure 1.21** shows a slight clipping in the shadows. This is noticeable in the manmade structure and in some areas of the sand. As you can see, this small amount of pure black is perfectly acceptable. In fact, without it the image might feel somewhat flat (low in contrast).

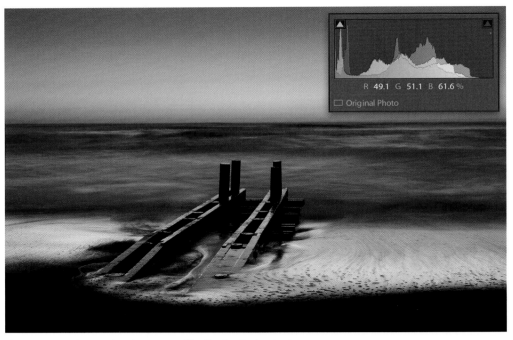

Figure 1.21 **An image showing acceptable clipping in the shadows.**

Silhouettes are another instance where you'll want some pure black in your images. **Figure 1.22** shows what we would normally consider severe clipping. Because there is no need to see any detail in silhouettes, however, the clipped shadows are just fine.

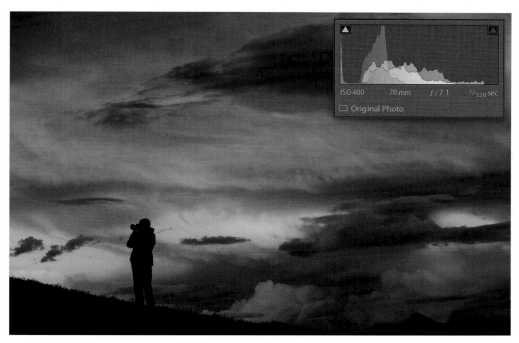

Figure 1.22 **This silhouette's histogram shows the amount of clipped shadows.**

Mood

The mood of the photograph is something else you need to take into account. Not all images need to be presented as bright and full of midtones. A *low-key* image is one that is dominated by darker tones. Not necessarily pure black, but just dark tones. **Figures 1.23** and **1.24** are examples of this type of imagery. On close examination of these shots, you can see that there are areas of pure black, but they don't fill the frame; they are interspersed with areas that are dark but contain detail.

Figure 1.23
This low-key image shows acceptable amounts of pure black.

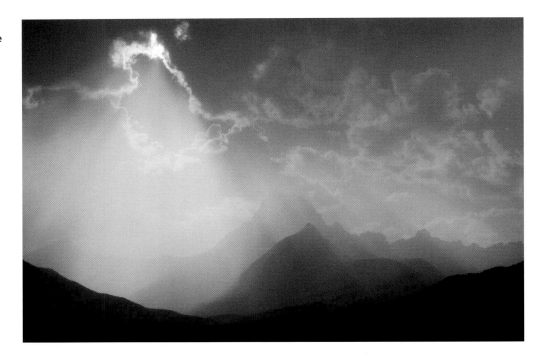

Figure 1.24
Another low-key image showing acceptable amounts of pure black.

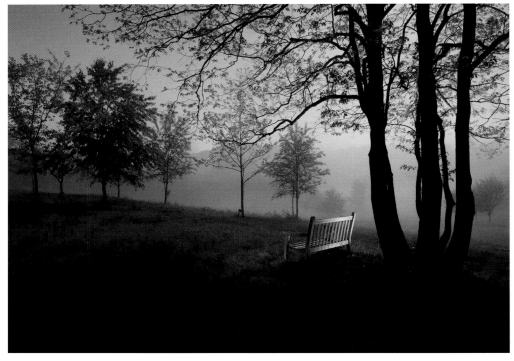

Compare Figures 1.24 and 1.24 with **Figure 1.25**. Notice that in the photo on the left, the large area of dark dominates the frame; the photo on the right is a much better composition that minimizes the amount of pure black in the frame.

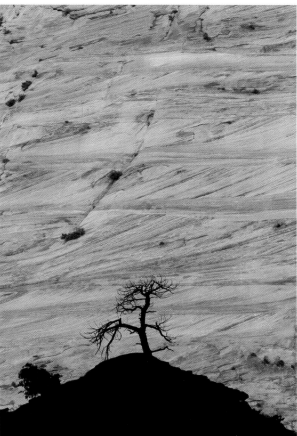

Figure 1.25 On the left, the pure black dominates the frame. On the right, a better composition, with less black filling the frame.

While some areas of pure black complement an image by giving it a full range of values, large areas of pure black or white can overwhelm an image. This is the time for HDR. When you have large areas of pure black, as seen in **Figure 1.26**, shooting multiple exposures and blending them in HDR is required to reveal detail in the shadows.

Figure 1.26 **Scene showing good highlight detail but no shadow detail.**

R 61.4 G 61.5 B 53.9 %
☐ Original Photo

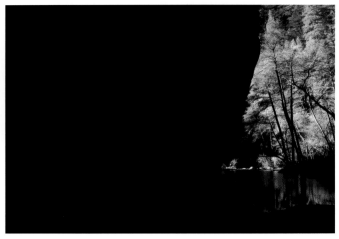

Highlight details

In the days of slide film, photographers would always make sure their highlights were exposed correctly. This was because once the highlight detail was lost to overexposure, it couldn't be brought back during the printing process. We could, however, mask the slide under the enlarger to reveal a little extra detail in the shadows.

The same is true with modern digital files. Once the highlight detail is lost, it's either difficult or impossible to bring it back. Lost detail in the shadows, however, can be retrieved with most image-editing programs. For this reason, when exposing digital images, your first step should be to ensure that you are getting good highlight detail. Figure 1.26 is a perfect example of this. You can see the graph coming right down to the right edge of the histogram box. The illuminated trees in the distance reveal plenty of detail. If you could take only one exposure, this would be the correct one.

Figure 1.27 shows the same image after I brightened up the shadows in Adobe Lightroom. You are now able to see an acceptable amount of detail in the darker areas of the photograph. This software trick cannot be done in reverse, however.

Figure 1.28 shows the same image but with two more stops of exposure given in-camera. Here the shadow detail is good, but the highlights are blown out. In **Figure 1.29**, an attempt to darken down the highlights was unsuccessful. Although the histogram has been brought back, good detail in the highlights has not been restored.

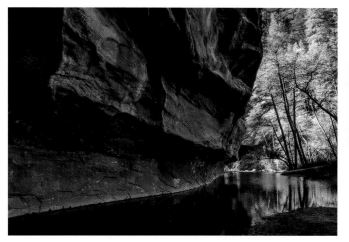

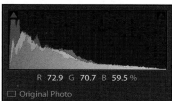

Figure 1.27 The image after the shadows have been lightened in Adobe Lightroom.

R 72.9 G 70.7 B 59.5 %

☐ Original Photo

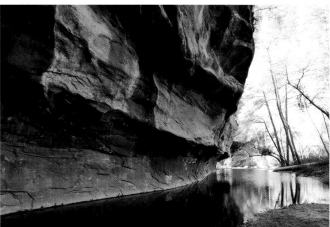

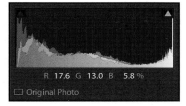

Figure 1.28 The image with two more stops of exposure given in-camera.

R 17.6 G 13.0 B 5.8 %

☐ Original Photo

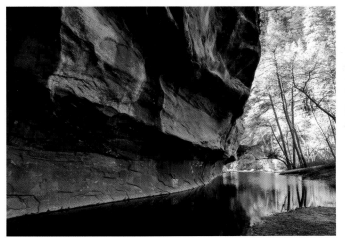

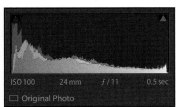

Figure 1.29 The failed attempt to bring back highlight detail.

ISO 100 24 mm f / 11 0.5 sec

☐ Original Photo

This series of images demonstrates that, even though the histogram shows some clipping in the shadows and highlights, some detail can be brought back. Once again, you'll have more luck retrieving texture from the shadows than you will the highlights. At this point you may be asking yourself why you would need to shoot multiple images for HDR if you can simply lighten the shadows in post-processing.

The simple answer is image quality. Digital files can take a fair bit of post-processing before they begin to fall apart, but severe edits will usually cause a visible degradation of the image. **Figure 1.30** shows a series of images that I captured to blend together using an HDR program. The image in the upper left is good for the shadows, while the image in the lower right is good for the highlights.

Figure 1.30
A series of images captured to blend together using an HDR program.

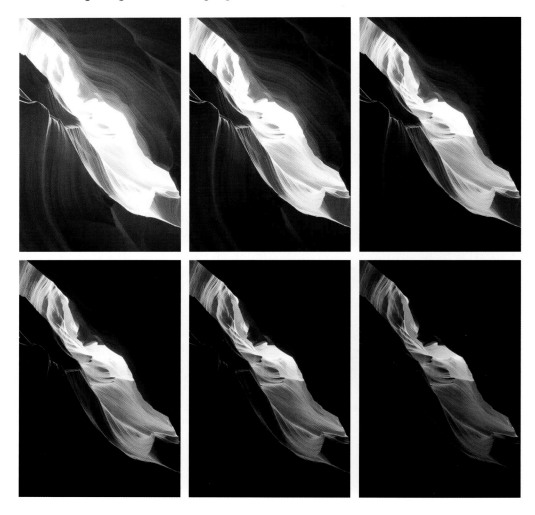

Figure 1.31 shows the resulting photograph after blending the six images together. It has a good range of tones, realistic colors, and visible detail throughout. **Figure 1.32** shows the single exposure made for the highlights (the lower-right image in Figure 1.31) with the shadows brightened in Lightroom. Notice the severe degradation to the shadow areas. This excess of noise (the grainy look) appears when you excessively brighten under-exposed shadows.

The reason for this shadow noise lies in the way a digital sensor captures information. The more light the pixels receive, the more levels of tonality they can contain. This means the midtones and highlights contain lots of valuable tonalities, while the shadows contain far less. The more tonalities a pixel contains, the better it can withstand post-processing edits such as contrast and brightness adjustments.

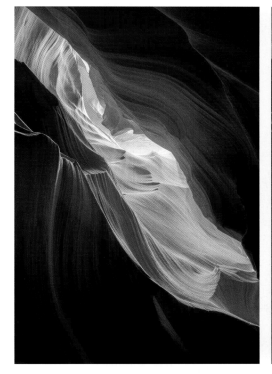

Figure 1.31 **The resulting HDR image.**

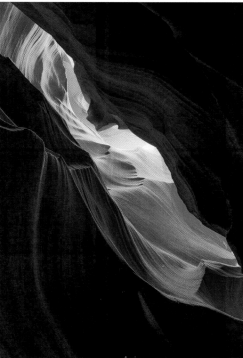

Figure 1.32 **The darkest image of the series, with the shadows brightened in Lightroom.**

Figure 1.33 demonstrates this idea. Each pixel in the right half of the histogram can contain up to 2048 levels of tone, and the midtones can contain up to 1024 levels of tone.

These pixels are very rich in information, enabling them to withstand a considerable amount of post-processing manipulation. The pixels in the shadow region of the histogram receive far less light, which means there is less information per pixel. Aggressively adjusting pixels with such little image information usually results in visible image degradation of the kind seen in Figure 1.32.

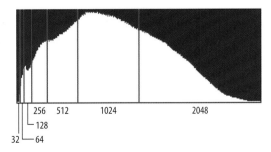

Figure 1.33 **The levels of tonality contained per pixel in a digital file.**

Shadows

The amount of noticeable image degradation varies from camera to camera and from scene to scene. Thanks to their higher bit depth, more expensive cameras produce files that suffer less from shadow manipulation. Any image, however, will suffer some degradation when you are aggressively adjusting deep shadows that fall off the left side of the histogram (**Figure 1.34**).

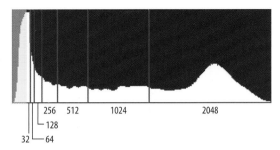

Figure 1.34 **Deep shadows, highlighted here in yellow, are captured by the camera but not displayed by the histogram. These tones will produce image degradation when manipulated.**

The bottom line is that when the histogram contains all of the image information, most post-processing edits will not damage the look of the image. If, however, you begin adjusting the tones that are buried deep in the shadows, you'll likely be disappointed in the results. So begin by making a correct exposure for your highlights. Now look at your shadows. Do they occupy too much space in the scene? If so, it's time to start thinking about taking multiple exposures.

Chapter 1 Assignments

Locate the histogram

The histogram is invaluable in determining tonal values, so your first assignment is to locate it. Check your camera manual for instructions on how to display the histogram, and practice doing so.

Experiment!

In time you'll immediately recognize scenes that require HDR. Getting there takes practice, though. Begin by simply taking pictures of many different types of scenes. Examine the resulting histograms. Are your shadows blocked up? Highlights overexposed? Does all the information fit within the histogram box? Note which types of scenes regularly surpass the camera's ability to record detail.

Underexposed shadows

Find a scene with dynamic range that surpasses the camera's ability to hold detail in both the highlights and the shadows. Make an exposure that is good for the highlights. This will underexpose your shadows. Set your camera's exposure compensation to +1 and shoot another exposure of the same scene. Set the exposure compensation to +2 and shoot again. Load the three images into Lightroom, Photoshop, or another image-editing program. Note the difficulty of trying to bring back the highlight detail on the brightest image using the Highlights and Whites sliders. Next, try to bring back shadow detail on the darkest image using the Shadows and Blacks sliders. How do they look? Compare them with the properly exposed shadows on the brighter image. Look for an excess of grain in the dark areas after completing this task.

Share your results with the book's Flickr group!
Join the group here: www.flickr.com/groups/hdr_fromsnapshotstogreatshots/

ISO 100 • 1/200 sec.,
1/400 sec., 1/800 sec.,
1/1600 sec., 1/3200 sec. •
f/22 • 24mm lens

2

Equipment, Settings, and Exposure

Setting Your Camera for Success

Once you've determined that a scene needs HDR to bring out detail in the shadows, the highlights, or both, it's time to make the exposures that can be blended together. Shooting for HDR is more than just setting your camera on Aperture Priority, Evaluative metering, and Auto-Bracketing and firing off a few shots. Care should be taken in analyzing the scene and setting your camera accordingly. Getting the right exposures depends on both dependable equipment and proper technique. This chapter covers the photography equipment necessary for capturing sharp and well-registered images, as well as methods of exposure and important camera settings to be considered before shooting.

It's not necessary to avoid clipping the highlights that are caused by point sources of light.

The 1/4-second exposure kept the highlights from overexposing.

I came across this great tunnel shortly after moving to Alexandria, Virginia. I immediately knew I wanted to photograph it at night. Over a year later, I finally made the time to return and make some images. Using a wide-angle lens at a setting of f/8 created the star pattern in the streetlights. A smaller aperture would have created a more refined star pattern, but also would've required a 15-minute exposure.

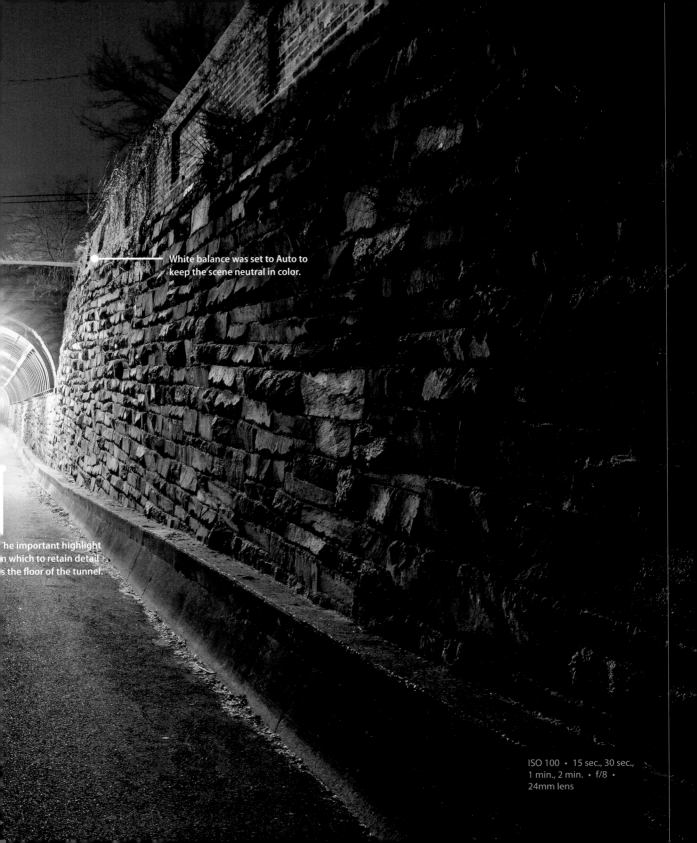

White balance was set to Auto to
keep the scene neutral in color.

he important highlight
n which to retain detail
s the floor of the tunnel.

ISO 100 • 15 sec., 30 sec.,
1 min., 2 min. • f/8 •
24mm lens

Keeping a deep black and
bright white are crucial to a
realistic HDR image.

Antelope Canyon in Arizona is one of the most amazing
land formations I've ever seen. The whirl of sandstone
changes from purple to orange to yellow as it curves and
spins upward toward the sunlight. At times it resembles
the cosmos; at other times, the ocean's waves. The bottom
of the canyon can be so dark you can't see the walls, while
the tops of the canyon are bathed in sunlight. The dynamic
range here can be quite extreme. Almost any view made
with a wide-angle lens requires multiple exposures and
HDR processing.

ISO 200 · 1 sec., 2 sec.,
4 sec., 8 sec., 15 sec. ·
f/11 · 21mm lens

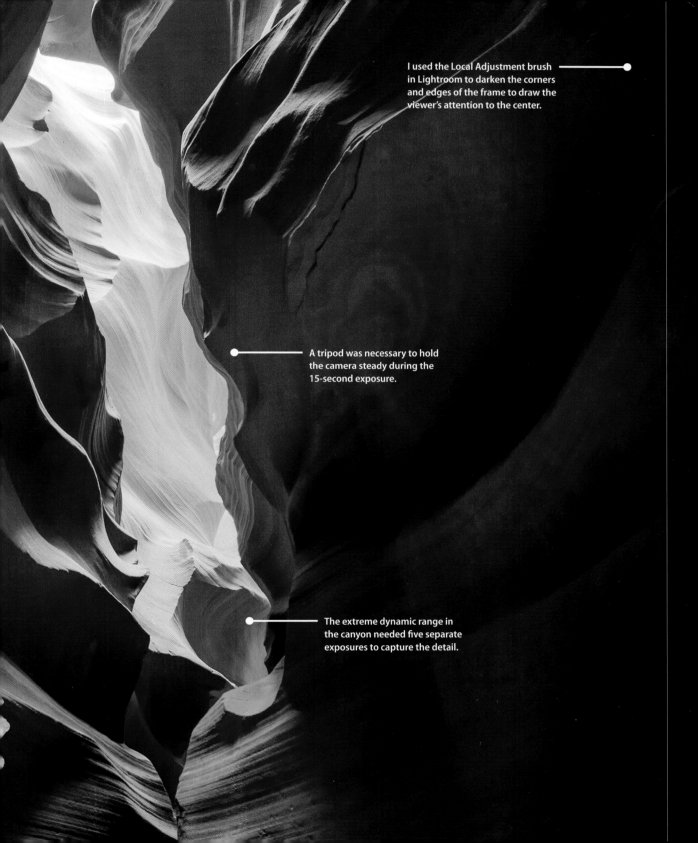

I used the Local Adjustment brush in Lightroom to darken the corners and edges of the frame to draw the viewer's attention to the center.

A tripod was necessary to hold the camera steady during the 15-second exposure.

The extreme dynamic range in the canyon needed five separate exposures to capture the detail.

Photography Equipment

The right tool is essential for any job, and that's especially true for photography. Thankfully, HDR photography requires little more than the basic tools of the trade. A camera with a range of lenses, a good tripod, and a reliable cable release should be a part of any photographer's system. An HDR program is necessary to complete the merge, so you'll also need a computer and monitor to round out the tool kit.

Cameras

Virtually any camera can be used to record images for HDR. Of course, better cameras produce higher-quality images. Mirrorless and DSLR cameras produced since 2012 contain enough pixels to produce high-quality imagery, so megapixels are no longer a consideration. More important than megapixels is the size of the sensor. Bigger is better. Full-frame sensors are the largest sensors and can be found on Nikon, Canon, Sony, and Leica cameras. Full frames are available on mirrorless and DSLR cameras. APS-C sensors (commonly called crop sensors) are the next size down; they are available from Nikon, Canon, Sony, and Fujifilm. The smallest recommended sensor is the Micro Four Thirds; Panasonic and Olympus are the primary manufacturers of this sensor size.

The cost of the larger sensor versus the increase in quality is a topic that many photographers debate. I use a full-frame sensor for my work, but I've seen many a great image produced by cameras with smaller sensors. As with music, it's the talent not the tool.

A couple of advantages to higher-priced APS and full-frame cameras are difficult to measure: bit depth and image processor. More expensive cameras produce 14-bit files, which typically have a larger dynamic range. This means you will see more detail in the shadows, and the highlights may be better defined. Some camera specs don't even list the bit depth.

The image processor is the camera function that creates digital files from the light recorded on the sensor. Higher-end camera models typically employ top-of-the-line image processors. Unfortunately, there is no way to determine the quality of the image processor. Fancy names, such as Dual Digic 5+ or EXPEED 4, are the only hint that manufacturers provide.

Lenses

Lenses are the photographer's link to the world. They help us frame a scene, include and exclude subject matter, and stretch or compress the distance in the scene. Most established photographers have a collection of lenses that cover the three basic focal ranges: wide, normal, and telephoto. For HDR photography, the speed of the lens (widest aperture) is not as important as it is in other disciplines of photography.

Lenses come in a wide range of styles, speeds, and quality. This is one area of photography where you really get what you pay for. In many cases, the decision comes down to quality versus convenience. For sharper images, I recommend purchasing lenses that cover only one or two focal ranges. For example, an 18–200mm is a very convenient lens that covers wide, normal, and telephoto. Although not as convenient, an 18–35mm lens covering only two focal ranges—wide and normal—will be sharper.

Focal Ranges	Full Frame	APS-C
Wide-angle	14–35mm	8–24mm
Normal	35–70mm	24–48mm
Telephoto	70mm+	48mm+

Tripods

HDR software has the ability to blend images that are not perfectly aligned, but it does take the software longer to produce the final results. If the images are too far out of alignment, however, the software may not be able to achieve perfect registration. While you might get lucky with a handheld series of exposures, it's best to ensure perfect alignment by using a tripod. The tripod also allows for the use of smaller apertures for more depth of field. Tripods also provide the photographer an opportunity to contemplate and fine-tune the composition. Here are several reasons why tripods are so important to the HDR photographer:

- We make many images under dim lighting conditions, which require the use of a tripod due to long exposures.

- Raising the ISO to shorten shutter speeds and eliminate the tripod results in lower-quality images due to high ISO noise.

- Using a tripod and cable release helps ensure perfectly aligned images. HDR programs produce better images that process faster when all the exposures are well aligned.

- Thoughtful composition and speed are like oil and water. Tripods allow you to slow down and really perfect the composition. Enjoy your time behind the camera. Time spent in the field should bring as much pleasure as the final photograph. Quality over quantity!

I've seen many wonderful experiences ruined by hastily purchased, subpar tripods. Using a tripod is easy and fun when you're working with one you like. Find a store that has plenty of available styles, a knowledgeable staff, and a no-hassle return policy. Then take your time looking through them. Unfold them, set them up. Break them down. Mount

your camera on them. Put them through their paces. If you don't like the head that comes stock on the tripod, consider purchasing the legs and head separately. Most importantly, don't skimp. Just as with lenses, you get what you pay for. You'll need to spend a couple of hundred dollars to get into the bottom range of quality tripods (**Figure 2.1**).

Figure 2.1
Oben's CT-3461 carbon fiber tripod is perfect for traveling light.

Cable releases

Now that you are using a tripod, you may as well squeeze that last bit of stability out of the system by using a cable release. Even the gentle pressure of your finger depressing the shutter button can be enough to cause a small amount of camera shake. The cable release, also known as a remote switch or remote shutter release, allows you to trip the shutter without handling the camera.

Remote switches come in wired and wireless varieties. I prefer the wired models for their reliability and lack of batteries. That being said, my Shutter Boss timer remote, which I use for timed exposures, runs on batteries. It is, however, still wired.

Be sure to match the cable release with your specific camera model. Many models, even within the same camera manufacturer, use different connections. Because of their size and application, it's not uncommon for me to lose a couple of releases a year. For this reason, I tend to purchase the less expensive after-market varieties such as Vello rather than pay full price for the camera brand (**Figure 2.2**).

Figure 2.2
Vello cable release.

Monitors and calibration

Accurately rendering beautiful and realistic HDR imagery starts with a quality computer monitor. Although the high-end monitors used by professionals start at a thousand dollars, the avid photographer can find reasonable alternatives for half that amount. Determining the quality of a monitor by reading the specifications can be challenging. I recommend consulting a knowledgeable salesperson to help with your decision. Be sure to mention that you want to use the monitor for photography, and stick with name-brand monitors such as NEC, Apple, and Eizo.

Having a good monitor is the first step; next you have to calibrate it. One look at the line of flatscreen TVs in your local electronics store will demonstrate the visual difference in high-quality products. Even among the better monitors, contrast, color, and brightness can all vary. Calibrating your monitor puts the display into what's called a "known space," meaning that the contrast, color, and brightness are set to agreed-upon standards. The good news is that calibrating your monitor is easy.

To calibrate your monitor you'll need to purchase a calibration kit. This includes both hardware and software. The hardware device (called a *puck* or a *spider*) plugs into your computer and hangs over your monitor. From there, it's able to measure the color and brightness patches supplied by the software. Once the measurements are taken, the software calculates a solution (called an ICC profile) to bring your monitor to the known space. To begin calibrating, simply launch the software and follow the onscreen instructions. The whole process takes no more than 5 minutes and you are coached through the entire session.

Typically, most calibration manufacturers have a couple of options from which to choose. The least expensive options fall below $100. These models will calibrate only your monitor. The intermediate styles calibrate your monitor and printer (and in some cases, a digital projector) and list for $120 to $300. Even if you don't plan to calibrate your printer, I recommend this choice because the hardware and software are usually higher quality. X-Rite and DataColor are quality brands.

My favorite gear for HDR photography

- Nikon D4
- Nikon 14–24mm f/2.8
- Nikon 35mm f/2
- Nikon 50mm f/1.8
- Sigma 70–200mm f/2.8

- Gitzo GT 1544T carbon fiber tripod
- Oben CT-3461 carbon fiber tripod
- Manfrotto 410 Junior Geared head
- Vello cable release
- B&W polarizing filter

Camera Settings

Modern DSLRs have an abundance of controls and settings. Some have migrated from film cameras, and others are new to the digital format. Given the number of controls, it's incredible to realize just how few are actually used in everyday photography. Here are several of the most important controls.

File types

These days, most photographs are produced from files rather than film. Common file types include JPEG, TIFF, and raw. While less expensive cameras shoot only in JPEG, advanced models provide a choice.

JPEGs are referred to as a "lossy" file format. This means that once the images are captured, the data is compressed into a file that is smaller than the original. Raw files remain uncompressed and contain much more information than JPEG files. More image information allows more options when it comes to blending your images together. HDR programs will process JPEG files, so uploading your old images is not an issue. For the most latitude in processing your images, however, set your camera to shoot in raw. And if your camera provides options for raw file sizes, choose the uncompressed version.

ISO

The ISO (International Standards Organization) setting on your camera determines the sensitivity of your sensor. Higher ISOs, such as 800 or 1600, are more sensitive to light, meaning you can use faster shutter speeds, smaller apertures, or both.

Slower ISOs, such as 100 or 200, are less sensitive to light, meaning you have to use slower shutter speeds, larger apertures, or both to capture the same scene. For the highest-quality imagery, use a slower ISO. Higher ISOs will result in an excess of noise (a gritty, sandpapery look) in your photos.

White balance

Setting your white balance correctly when shooting saves time when you're back on the computer. While you can adjust the white balance with most editing programs, it's best to get as close as possible in the field. Large shifts in white balance on the computer are unnecessary and can lead to a posterization of color. When setting your camera's white balance, consider the main source of illumination. If the sun is your main source, set your camera to Direct Sun on Nikon or Daylight on Canon. If you are shooting on an overcast day, simply set your camera's white balance to Cloudy. I reserve the use of Auto white balance for scenes that contain primarily artificial light sources.

Manual focus

Using autofocus while shooting images is common but can cause problems. For this reason I often use the camera's autofocus initially but then turn it off when it's time to shoot. In a perfect world, using autofocus shouldn't be a problem, but it does have the potential to throw you off. To ensure good focus throughout your series of exposures, begin by autofocusing on the desired subject in the scene. Once focused, turn off your autofocus button. Now, as you continue to shoot your series of exposures, the camera will not need to focus in between shots. Using this method also saves on batteries and allows the camera to shoot faster.

F-stops and shutter speeds

The f-stop and shutter combination is a personal decision as well as a matter of good exposure. You can use faster shutters and larger apertures (f/2, f/4, f/5.6) when a shallow depth of field is desired (only a small area of the scene is sharp). By using slower shutters and smaller apertures (f/11, f/16, f/22), you can capture images with a greater depth of field (more of the scene is sharp). Most scenes that require HDR usually benefit from a deep depth of field.

Depth of field is controlled by three factors:

- Aperture. The smaller the aperture, the more depth of field you achieve.

- Distance to the subject. The closer you are to the nearest subject, the less depth of field you will have. If the closest subject in your scene is 3 feet away from the camera, you will need to stop down to f/16 or f/22 to get the entire scene sharp. If your subject is 100 feet from you, a deep depth of field will be easier to obtain. In this case, you may only need f/8 or f/11.

- Focal length. Wide-angle lenses (shorter focal lengths) provide more depth of field. Telephoto lenses (longer focal length) provide less depth of field.

You should refrain from simply setting your aperture at f/22 for every scene. While this may seem like an easy way to always ensure deep depth of field, it will adversely affect your image quality. The smallest aperture on the lens will provide the most depth of field, but it also softens the overall image.

The sharpest apertures on a lens are the ones closest to the center of the f-stop range. These are typically f/5.6, f/8, and f/11. To achieve the sharpest images possible, use the aperture that is closest to the center of the lens and that will provide the *necessary* depth of field. The necessary depth of field can be difficult to determine, so using a depth-of-field calculator application is recommended. There are many popular apps for smartphones that don't require a signal to operate and are well worth their price of a few dollars.

Metering the Scene

Shooting for HDR boils down to making a series of exposures that capture the full range of tones present in the scene. The simple way of doing this is to get one good exposure for the highlights and then open up one stop (add more light via the shutter speed) to make another exposure. Then open up again and make another exposure. Continue this until the shadow areas are captured on the histogram.

Figure 2.3 is an example histogram of the first shot, where the highlights are properly exposed. This was 1/200 of a second at f/14. Notice that the shadows are crawling up the left side of the histogram, indicating that they are quite underexposed. **Figure 2.4**, shot at 1/100 of a second at f/14, is the second shot. In this histogram both the shadows and highlights are clipped. **Figure 2.05** was made at 1/50 of a second at f/14; the shadows are still clipped. **Figure 2.06** was made at 1/25 of a second at f/14; the shadows almost have enough exposure, but not quite. **Figure 2.07** shows the final image, made at 1/13 second at f/14; here you can see a histogram that represents full shadow detail.

Not all scenes will require five separate exposures to capture the full tonal range. Some will require three or seven or perhaps only two. Every scene is different, and each needs to be analyzed separately. In order to make different exposures, you'll need to change the shutter speed to allow more light to enter the camera. This is accomplished in different ways, depending on the metering mode you are working with.

Figure 2.3 **The first exposure, ensuring good highlight detail: 1/200 of a second at f/14.**

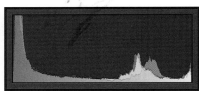

Figure 2.4 **The second exposure: 1/100 of a second at f/14.**

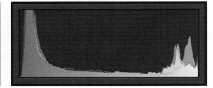

Figure 2.5 **The third exposure: 1/50 second at f/14.**

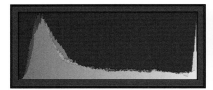

Figure 2.6 **The fourth exposure: 1/25 second at f/14.**

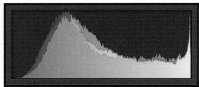

Figure 2.7 **The fifth exposure, ensuring good shadow detail: 1/13 second at f/14.**

Metering modes

The metering mode in your camera determines how the camera will set the f-stop and shutter speed. A typical list of metering modes contains the following:

- Green Square
- Program
- Aperture Priority (A or Av)
- Shutter Priority (S or Tv)
- Scene modes, such as Landscape, Portrait, and Shutter Priority
- Manual

While any of the modes can potentially work for creating a series of different exposures, Aperture Priority and Manual function best. Both allow the shutter speed to be changed to alter the amount of light entering the camera. When you're working with Aperture Priority, changing the exposure compensation setting alters the shutter speed. When you're working in Manual, you simply adjust the shutter to your desired speed.

Aperture Priority

The Aperture Priority setting is marked as A on a Nikon camera and as Av on a Canon. When you're using Aperture Priority, moving the Command dial (near the shutter release) alters the aperture setting. The camera then chooses the appropriate shutter speed to make a correct exposure. Moving the Command dial again simply changes the aperture and shutter to a different combination that allows the same amount of light to hit the sensor. So 1/4 of a second at f/16 and 1/2 of a second at f/22 allow exactly the same amount of light in.

To change the exposure you must use the Exposure Compensation button. Setting this button to the plus allows more light in, while moving it to the minus allows less light in. Typically, changing the exposure is accomplished by depressing the button while you rotate one of the camera dials. (Check out your camera's manual for exact directions for your model.) In this way you can create a series of images with different exposures. Here's a simple example.

1. Frame your shot and take your first exposure at 1/60 at f/11. After viewing the histogram, you decide that the highlights are exposed correctly.

2. Take another shot with one more stop of exposure. This exposure should be 1/30 at f/11. Press the Exposure Compensation button and dial in +1. Your camera now shoots at 1/30 at f/11. You look at your histogram and your shadows are still clipped.

3. Time for another exposure. Press the exposure compensation button and dial in +2. This time your camera will shoot at 1/15 of a second at f/11. Examination of the histogram reveals well-exposed shadows. Your series is finished and you can move on to the next scene.

This simple example shows the basic steps to capture the necessary series of exposures. It's also a more manual, time-consuming method. Further along, we'll discuss how to automate this process with auto-bracketing. For now, let's take a look at how the same series would be captured using Manual mode.

Manual

In Manual mode it's necessary for you to set both the aperture and shutter. This means you have to pay close attention to the exposure on every shot. With the automatic modes, such as Aperture Priority and Shutter Priority, the camera is always set to give you a good exposure—something we call being "zeroed out." In Manual, however, the camera simply shoots at the current f-stop and shutter speed, regardless of whether they'll produce a good exposure or not.

This means it's up to you to adjust your f-stop and shutter until the camera is zeroed out. When you put your camera in Manual mode and look through the viewfinder, you'll see the Indicated Exposure meter. **Figure 2.08** is an illustration of an Indicated Exposure meter on a Nikon camera. **Figure 2.09** shows the same display on a Canon camera. Both of these meters are currently zeroed out (hash mark in middle).

Figure 2.8 **Nikon's Indicated Exposure meter.**

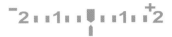

Figure 2.9 **Canon's Indicated Exposure meter.**

The Indicated Exposure meter is usually visible only while you are in Manual mode, although some cameras display the meter in other modes. This meter informs you of over- and underexposure. When the hash mark is in the center, it's zeroed out, indicating a good exposure. If the hash mark is toward the plus, it means the image will be brighter (**Figure 2.10**), and toward the minus indicates a darker exposure (**Figure 2.11**). Adjusting the f-stop or shutter speed, or both, moves the hash mark along. For scenes that typically require HDR, depth of field is your primary concern, so it's common to set that first.

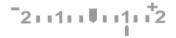

Figure 2.10 **Meter indicating overexposure.**

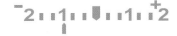

Figure 2.11 **Meter indicating underexposure.**

1. Frame your shot and set your aperture to f/11. Next, adjust your shutter speed until you zero out the hash mark. Your camera now reads 1/60 at f/11. You view the histogram and decide your highlights are exposed correctly.

2. Take another shot with one more stop of exposure. Adding a stop of light is called "opening up one stop." This can be done with either the shutter or aperture, but with HDR photography we want to use the shutter. Opening up one stop from 1/60 of a second is 1/30 of a second, so adjust your shutter to read 1/30 of a second. Your Indicated Exposure meter will now display +1. Take the shot and check your histogram. If the shadows are still clipped, it's time for another shot.

3. Open up again to shoot at 1/15 at f/11. Your Indicated Exposure meter will now read +2. If the histogram reveals well-exposed shadows, your series is finished.

Just like the previous example, this is a more time-consuming approach to making a series of exposures, but understanding the basic operation is critical to capturing the correct exposures when you move on to auto-bracketing.

Auto vs. Manual

Using either Aperture Priority or Manual mode gets you to the same exposure. The only difference is how you get there. With Aperture Priority, you simply rotate one dial to alter the aperture and shutter simultaneously. Whichever combination you choose, the meter will always be zeroed out. To alter the exposure, you need to use the Exposure Compensation button. In Manual mode, you have to move both the aperture and the shutter to get the indicated exposure meter to zero out. To alter the exposure, you can then choose to adjust either the f-stop or shutter speed.

Matrix metering

Your camera determines the proper exposure by using an internal light meter. By default your camera is set to a multi-segment metering pattern, which gives excellent results for most situations. Nikon calls this pattern the Matrix meter, whereas Canon calls it the Evaluative meter. The meter basically divides the frame into segments and averages together the readings from each. It provides excellent results in common situations, but it can fail when faced with scenes that contain a wide array of image brightness. Because this metering pattern is the most commonly used, however, let's look at how it works.

The multi-segment meter generally tries to preserve highlight detail. This is good, because when shooting for HDR you want to begin by making an exposure that's good for your highlights. When the meter is faced with a high dynamic range scene, however, it's likely to somewhat overexpose the highlights. This happens because the meter is trying to preserve some detail in the shadows as well. Remember, though, that once your highlights are overexposed, it's nearly impossible to bring them back.

Regrettably, the only way to be sure of a good exposure when using a multi-segment meter is to shoot a frame and then check the histogram. But there is another exposure aid that can be helpful. It's called the overexposure warning, commonly referred to as the *blinkies*. When you review your image on the rear LCD with the overexposure warning active, areas of overexposure will be highlighted by a blinking color. Some cameras show the blinkies on all review screens; others show it only when you are on a specific screen. Consult your camera's manual for directions on how to display the overexposure warning.

Spot metering

The Spot meter is another type of meter included on many cameras. Instead of looking at the entire frame, it takes a meter reading from only a very small portion of the frame (1 to 2 percent of the viewfinder). This means it can be extraordinarily accurate. If the Spot meter is used improperly, however, the results are very unpredictable. In short, you should use spot metering only if you are willing to spend extra time on every shot. It's also worth mentioning that using the Spot meter is more convenient in Manual mode than in Aperture Priority mode.

The Spot meter works by trying to make whatever it sees into an average tone. For example, if you place the Spot meter over an average tone in a scene and then zero out your meter, you'll end up with a good exposure. If, however, the Spot meter is located over a light tone in that scene and you zero out your meter, you are essentially making that light area into an average brightness—exactly what you don't want.

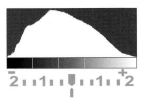

Figure 2.12 **The tones of the histogram aligned with the Indicated Exposure meter.**

Having a good understanding of the Indicated Exposure meter and histogram is essential to using the Spot meter, so let's take a look at how they compare. **Figure 2.12** demonstrates how the Indicated Exposure meter aligns with the histogram.

When your Spot meter is over a tone and you zero out the meter, that tone will be rendered as an average tone (middle gray). If you adjust your shutter speed, your aperture, or both to set the hash mark at +2, the tone will rendered white but still have detail (**Figure 2.13**).

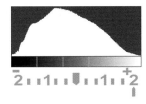

Figure 2.13 **The Indicated Exposure meter set to +2.**

The Spot meter is a great way to analyze the different tonalities in your scene, but you must make a conscious effort while using this tool. Here's a basic workflow for metering a scene using a Spot meter.

1. Decide the composition and determine the necessary aperture to achieve the desired amount of depth of field.

2. Find the brightest part of the composition that needs to have detail. Place the Spot meter over this tone.

3. Adjust the shutter speed until the hash mark is at +2. This exposure will render the brightest white tone, but with detail.

4. Take your shot.

5. Open up your shutter speed by one stop and shoot again. Check the histogram for shadow detail. If the shadows are clipping, continue to open up stop by stop and shoot until you get a frame where the shadows have detail.

Retaining Detail

Determining which highlights should retain detail takes a little practice. Remember that not every bright area in the scene needs detail. Typically, light sources themselves can do without detail. It's also unreasonable to expect to get detail from the bright sun. Likewise, reflections from light sources in glass, mirrors, or metal should be ignored. Of course there are always exceptions. A very ornate lampshade or chandelier will benefit from proper exposure. The areas where we want to see detail are things such as skies, bright clouds, bright buildings, and window details in night scenes. The main idea is to keep larger, important bright areas from blowing out (overexposing).

Similarly, don't concern yourself with the blackest black. Most images benefit from a pure black somewhere in the scene. As with the highlights, determine which areas are truly important. Trying to get detail in every black and every white will result in an image series that becomes difficult to process correctly.

Bracketing

Bracketing is a technique in which different exposures are made for one scene. The auto-bracketing function on the camera will automatically shoot a series of exposures for you. Auto-bracketing can be set to shoot in 1/3-, 2/3-, or 1-stop increments, with some cameras having even more options. A simple example would be for you to set the camera to Aperture Priority, then engage auto-bracketing at a one-stop increment. When your camera is set to 1/125 of a second at f/16, the camera will shoot this exposure, and then it will shoot 1/160 at f/16 and 1/250 at f/16. This gives you the first exposure, another exposure one stop darker, and a third exposure one stop brighter.

In Aperture Priority mode, the aperture is the most important setting, so the camera makes changes to the shutter to alter the exposure. In Shutter Priority mode, the shutter stays set while the aperture moves. Most cameras will change the shutter when you're bracketing in Manual mode.

The typical auto-bracketing setting would be 0, +1, and −1. This would shoot with the following settings:

- The camera's setting (0)
- One stop over the camera setting (+1)
- One stop under the camera setting (−1)

The camera may also shoot 0, −1, then the +1. This is fine, as the order in which the exposures are captured is irrelevant. Some cameras allow for more exposures per bracket. A five-stop bracket would be 0, +1, +2, −1, −2. A seven-stop bracket would be 0, +1, +2, +3, −1, −2, −3.

Auto-bracketing can be a real time-saver. It also allows you to shoot without having to manipulate your camera between shots, which increases the likelihood of better registration when you process the images. Look to your individual camera, though. Auto-bracketing can differ between each camera manufacturer and sometimes even between models in the same line. Some cameras shoot all three frames when you press the shutter release button, whereas others need to be manually depressed three times. Some cameras allow you to bracket only on either side of your camera's setting (as described above), and others allow you to shoot 0, +1, +2 or 0, −1, −2. Practice with your camera and consult your manual to determine your particular model's operation.

Although it's a real convenience, auto-bracketing by itself does not necessarily capture the correct series of images for HDR work. You need to set the camera properly and then set the appropriate bracketing to capture the necessary frames. This is where working in Manual mode using the Spot meter can be very helpful. Let's build upon our basic workflow from the last section.

1. Decide the composition and determine the necessary aperture to achieve the desired amount of depth of field.

2. Find the brightest part of the composition that needs to have detail. Place the Spot meter over this tone.

3. Adjust the shutter speed until the hash mark is at +2. This exposure will render the brightest tone white, but with detail.

4. Now, instead of taking your shot, note your camera settings. Let's say they are 1/30 at f/16. This is the darkest exposure of the series, the one that will render good detail in the highlights.

5. Next, place your Spot meter over the darkest part of the scene that needs to have detail. Adjust the shutter speed until the hash mark is at –2. This exposure will render the darkest areas black, but with detail. Note your exposure settings. Let's say they are 1/8 at f/16. You now know that you need to capture 1/30 for your highlights and 1/8 for your shadows.

6. When shooting exposures to be blended, use one-stop increments with your brackets. So, in this example you would need to shoot 1/30, 1/15, and 1/8. Manually set your camera to 1/15 at f/16.

7. Set your auto-bracket to shoot 0, +1, and –1. Your camera will now shoot 1/15, 1/8, and 1/30.

Here's one more example: You place the Spot meter over a highlight and set the hash mark to +2; it reads 1/15 at f/11. Then you place the Spot meter over the important shadow area and set the hash mark to –2; it reads 1 (one second). With this scene you need to capture five exposures: 1/15, 1/8, 1/4, 1/2, and 1. Set the camera to 1/4 at f/11. Next set your auto-bracket to 0, +1, +2, –1, and –2.

Because bringing home the correct exposures is an important step in creating realistic HDR imagery, you should always double-check your histograms before leaving the scene. Remember that the darkest image should have a histogram that looks like **Figure 2.14**. This will provide good highlight detail. The lightest image should have a histogram that looks like **Figure 2.15**. This will provide good shadow detail. The other exposures will be one stop apart. Sometimes, three exposures will suffice. Other times you may need five or even seven exposures to cover the range.

Figure 2.14 **Good highlight detail .** Figure 2.15 **Good shadow detail .**

Bracketing tips

Many scenes don't require exactly three-, five-, or seven-stop brackets. They might need four or six. In these cases it's easier to set auto-bracketing to capture more images than are necessary and delete the unnecessary images back at the computer.

If you are unsure about your metering or histograms, hedge your bet by capturing more images. It's better to come home with extra images that are too light and too dark than to wish you had those images while you're processing your HDR.

Use the self-timer. Some cameras when auto-bracketing will not shoot all the exposures at once. This means you have to press the shutter release button or cable release for each shot. It's not terribly time-consuming, but it would be nice if the camera would simply fire them all with one press of the shutter. Try setting your camera to self-timer. In many cases, pressing the release once will trigger the camera to shoot the whole series of brackets automatically.

Consider using Continuous High Speed Release mode on a Nikon or Continuous Shooting mode on a Canon. By default, pressing the shutter release button shoots a single frame. In Continuous mode, your camera will continue to shoot until you release the button. This mode can be used to capture a series of exposures in rapid succession, eliminating subject movement between shots.

Chapter 2 Assignments

What you see is what you get

Investigate the various screen calibration solutions on the market. You don't need to spend a lot of money—the middle-of-the-road price range will do. You'll work with confidence knowing that what you're seeing is what you'll get!

Use Manual mode

When shooting for HDR, many photographers choose to use Manual exposure mode. Practice using this mode until your familiarity with it fosters confidence and speed. Compare Manual mode to the Auto modes. Notice their similarities and differences.

Learn to use the spot meter

Start by setting your aperture for the scene. Next, place the spot meter over the most important highlights. Alter your shutter speed until the Indicated Exposure meter reads +2. This setting will ensure good highlight details. Note the aperture and shutter combination. Then place the spot meter over the important shadow area. Change the shutter until the Indicated Exposure meter reads −2. This will ensure good shadow detail. Note the shutter and aperture combination. The highlight setting and the shadow setting mark the ends of your exposures. Set the camera to shoot for the highlights, open up a stop on your shutter, and shoot again. Continue opening up your shutter until you have reached your shadow combination. Alternatively, set your auto-bracket feature to cover all the calculated exposures. For in-depth instruction on using your spot meter, check out my training video Perfect Exposure for Digital Photography, at www.timcooperphotography.com/store.

Test your camera

Camera manufacturers are continually trying to expand the dynamic range of their sensors. Higher-end models often have higher dynamic range than their less expensive counterparts. Typical cameras will show detail in the highlights and the shadows at +2 and −2, respectively. Test yours out. It may reveal detail in +3 or −3! Set up a gray card, an area of fabric, or some other texture with a simple pattern. Shoot a series of exposures ranging from −4 to +4. Examine the results and note where your camera stops recording detail. The shots should be −4, −3, −2, −1, 0, +1, +2, +3, +4. Finding out the true dynamic range of your camera may save you from making extra exposures.

Share your results with the book's Flickr group!
Join the group here: www.flickr.com/groups/hdr_fromsnapshotstogreatshots/

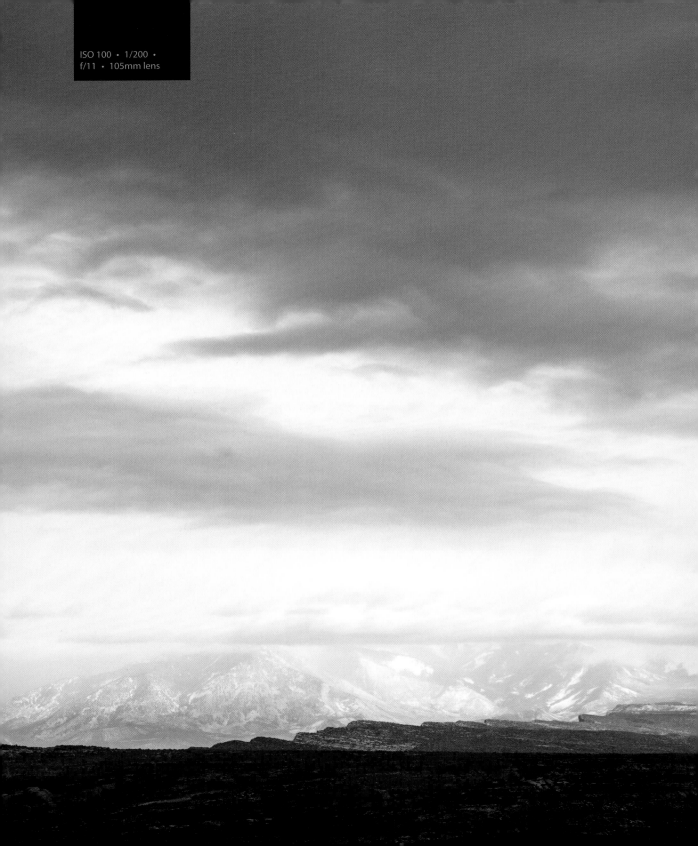

ISO 100 • 1/200 •
f/11 • 105mm lens

3
Visual Perception

Learning to See

Just as when learning to play a musical instrument, we need to retrain ourselves when learning photography. With music, our hands are learning unfamiliar formations and movements. At first they seem impossible, but with a little practice our hands and fingers adjust. With photography, it's our eyes and brain that need retraining. We need to learn to ignore some things and recognize others. While our eyes shape our perception of the scene, the camera captures it, so a familiarity with the way the camera sees is paramount. In this chapter, we'll compare our visual perception to the camera's capture and study the strengths and weaknesses of both.

This beautiful sandstone wall is on the
West Fork Trail, just outside Sedona, Arizona.
The morning light is wonderfully soft on the wall,
and the direct sun hits the background, making for
a very contrasty scene. I merged the images by using
Lightroom's Merge to HDR function.

Water is typically one stop darker
than what it is reflecting. It's easy
to make it overly bright.

ISO 200 • 1/30 sec.,1/15 sec.,
1/8 sec.,1/4 sec. • f/11 •
24mm lens

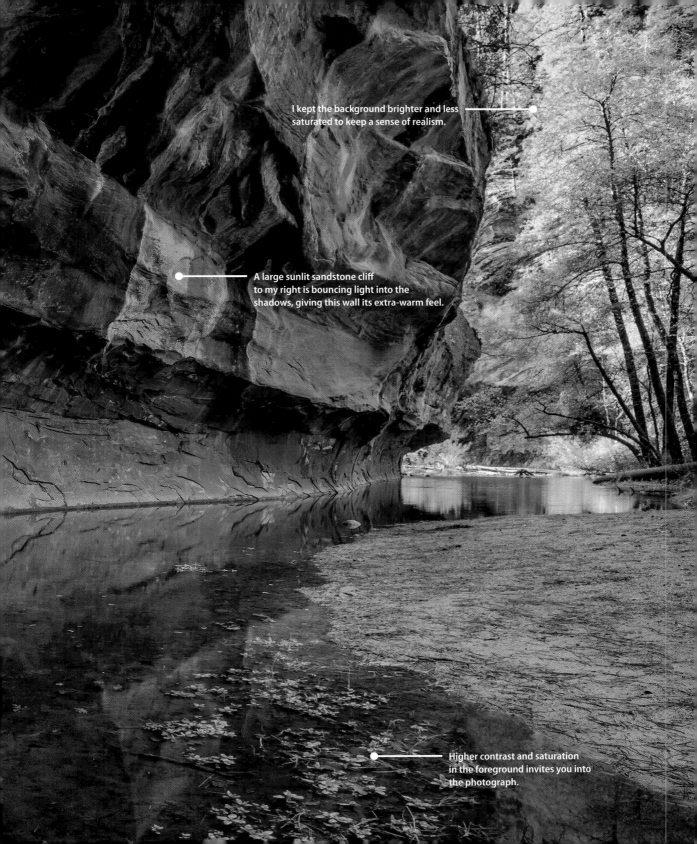

I kept the background brighter and less saturated to keep a sense of realism.

A large sunlit sandstone cliff to my right is bouncing light into the shadows, giving this wall its extra-warm feel.

Higher contrast and saturation in the foreground invites you into the photograph.

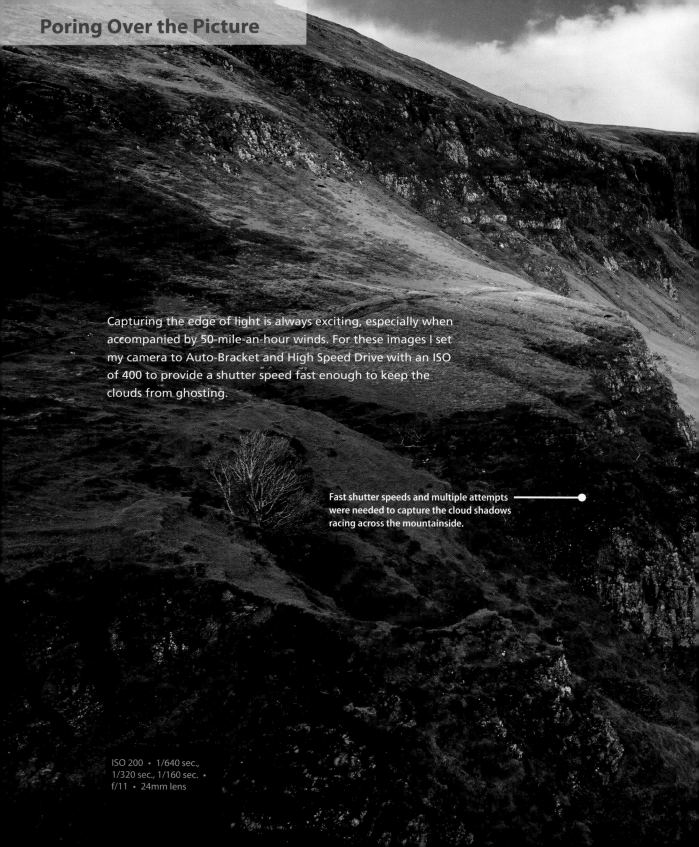

Capturing the edge of light is always exciting, especially when accompanied by 50-mile-an-hour winds. For these images I set my camera to Auto-Bracket and High Speed Drive with an ISO of 400 to provide a shutter speed fast enough to keep the clouds from ghosting.

Fast shutter speeds and multiple attempts were needed to capture the cloud shadows racing across the mountainside.

ISO 200 · 1/640 sec., 1/320 sec., 1/160 sec. · f/11 · 24mm lens

Polarizers can completely remove a rainbow if you are not careful to spin them to the correct angle.

I put the highlight in the distance so that the eye has something to move toward in the frame.

How Our Eyes and Cameras See the World

Our eyes are fascinating and mysterious tools. Although much is known about the basics of vision, there remains much to be learned. We do know that what we see is an interpretation as opposed to hard-and-fast data. *Perception* is probably a more accurate term for our vision than *seeing*.

The cornea is the transparent coating at the front of the eye that covers the iris and pupil (**Figure 3.1**). The colored part of the eye, called the iris, uses tiny muscles to contract and expand the hole in the center of the eye. This black hole is called the pupil. The size of the pupil controls how much light enters the eye. In very bright situations, the pupil is quite small, allowing very little light to enter. Dim situations require a larger pupil to allow enough light in. Next comes the lens. Along with the cornea, the lens focuses light onto the light-sensitive retina at the back of the eye. Using millions of photoreceptors, the retina converts the light into electrical impulses. These signals of brightness, darkness, and color are sent through the optic nerve to the brain, which then interprets what we see.

This process is actually remarkably similar to how a camera captures a photograph. The aperture (f-stop) is similar to the eye's pupil in that it's a hole that allows light to enter. The lens in the camera is similar to the lens in our eye. They both focus the light entering through the hole. Our lens focuses the light onto the retina, whereas the camera's lens focuses the light onto the sensor. The sensor and retina both capture light and convert it into a usable signal.

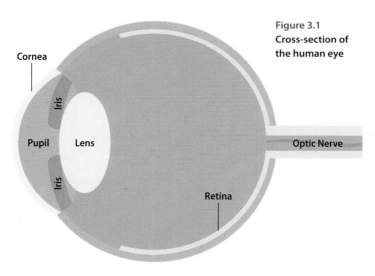

Figure 3.1
Cross-section of the human eye

Shutter Speed

Although there are many similarities between our eyes and the camera, the few small differences that do exist account for a huge disparity between what we perceive and what the camera captures. Among these differences are shutter speed and image processing.

The shutter speed of the camera determines how long a certain amount of light is allowed to impress on the sensor. The aperture controls that amount of light. The two work in tandem. The camera can have a short shutter speed with a large aperture or a longer shutter speed with a smaller aperture. For example, the amount of light hitting the sensor with a setting of 1/2000 of a second at f/2.8 equals the amount of light hitting the sensor at 1/30 at f/22. The relationship between these two settings is *reciprocal* and is demonstrated in the table below. Each of these combinations allows the same amount of light to hit the sensor.

Reciprocal Settings							
SHUTTER SPEED	1/2000	1/1000	1/500	1/250	1/125	1/60	1/30
F-STOP	f/2.8	f/4	f/5.6	f/8	f/11	f/16	f/22

A suitable combination of the f-stop and shutter speed is necessary for the camera to produce a good exposure. Within that exposure, the shutter speed controls the look of the motion and the aperture determines the depth of field. This is significantly different from how our eyes perceive the world. We are unable to "see" motion the way the sensor can record it. **Figures 3.2** and **3.3** show how the sensor can record motion in a way that our eyes cannot perceive.

Figure 3.2 **1/800 of a second freezes action.**

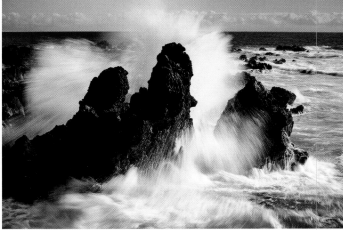

Figure 3.3 **1/8 of a second shows the motion of the action.**

The fast shutter speed of 1/800 of a second stops action in a way we never see. Our vision would perceive the water with a slight blur as opposed to the individual droplets of water frozen in time. Likewise with the 1/8 of a second exposure. Our eyes could never witness the tracking of the wave over this length of time. The camera, however, records it faithfully.

The reason for this difference is that our pupils never close, and we really don't have a shutter that opens and closes. The only time our retina (sensor) is closed to light is when we blink. This means we don't have a shutter speed like a camera. We do, however, have some lag time between the light being captured and the image being formed in our brain. The amount of lag time and the resulting impression is a matter of much debate. For the sake of simplicity, though, we can say that the lag time produces images that appear as if they have been shot at approximately 1/30 of a second. Again, this can be witnessed when looking at photographs of moving water. In **Figure 3.4** you can see that the 1/250 image freezes the water in a way that we can't see. The 1-second image blurs the motion in a way that we can't see. The 1/30 image looks very much like our impression of the falling water.

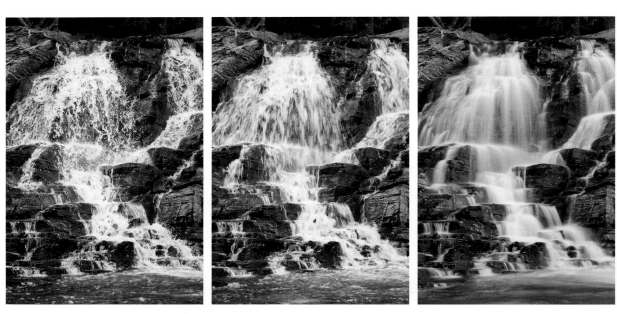

Figure 3.4 **From left to right: 1/250 of a second, 1/30 of a second, and 1 second.**

The rendering of motion is not the only or even most important difference between our eyes and the camera. The lack of shutter speed also means our eyes gather light differently from the camera. The camera's shutter opens and closes once for every exposure. Only a certain amount of light is let in for each exposure. Our pupils, on the other hand, automatically open and close to adjust for the current lighting situation. As we scan a scene, our pupils contract to view the brighter region and expand to view the darker region. This happens so quickly that the two "exposures" allow us the impression of full detail throughout the scene. The camera can only take a shot with a smaller or larger aperture. This is one of the reasons that the camera's dynamic range is not as large as ours. Take, for example, a dark room with a large window looking out on a daylight scene. As we look into the corners or darker areas of the room, our pupils enlarge to let more light in. As we gaze out the bright window, our pupils close down. Both of these instances combine to form one impression of the scene (**Figure 3.5**). The camera, of course, can only take one exposure or another. If the exposure is correct for the windows, the dark areas are underexposed (**Figure 3.6**). If the exposure is correct for the dark areas, the windows are overexposed (**Figure 3.7**).

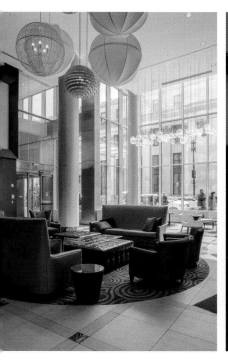 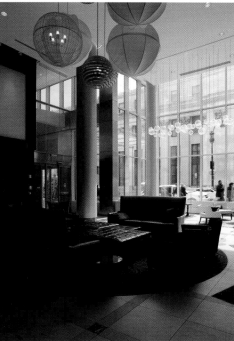

Figure 3.5 **The scene as our eye perceives it.**

Figure 3.6 **A good exposure for the windows produces shadows that are too dark.**

Figure 3.7 **A good exposure for the shadow areas produces windows that are too light.**

In Chapter 1, I noted that the dynamic range of our eyesight is about 11 stops (estimates range from 10 to 15 stops). This is an accurate figure for our instantaneous dynamic range. When you take into account that our eyes scan the scene and our pupils open and close to adjust, our dynamic range extends into the neighborhood of 24 stops! That's quite an advantage over the camera's range of five to seven stops.

Processing and Interpretation

Clearly, our visual perception holds an advantage in dynamic range over the instantaneous capture of the camera. The advantage decreases, however, when it comes to color and contrast. Both the camera and our eyes have processors that convert the RAW data of color, contrast, and brightness into an image. Our eyes' processor is our brain, whereas the camera uses its onboard computer. Each method has its advantages and disadvantages.

Our visual perception has developed over time to provide us with the necessary tools to navigate our world. This doesn't mean it is always accurate, just that it's beneficial for us. For example, we are exceptionally good at recognizing patterns (**Figure 3.8**), perhaps to distinguish nourishing plants from those that are toxic. Recognizing contrast is another strong suit that enables us to evaluate distance, steer clear of danger, and simply walk. This heightened awareness for contrast and pattern does not exist in the camera but does come back into play when we are looking at photographs—more on that a little later.

Figure 3.8
Our eyes are great at recognizing patterns.

Our color vision is also fascinating. Although good at separating colors, we are terrible at remembering what colors we have actually seen. For example, very early painters used shades of black in their shadows until it was discovered that shadows could be made more lifelike by adding color. Indeed, many people today might assume that shadows lack color until they are told. **Figure 3.9** shows the blue in the cast shadow on the floor of Death Valley. This type of shadow is called open shade. It's where the clear blue sky is illuminating the "open," or uncovered, shadow. Open shadows typically have the cyan (blue-green) hue of the sky. Closed shadows, those that are covered, are less influenced by this color.

Shadow color is the type of subtle color that's often hard for us to recognize. It's not that we can't see it, it's just that our eyes and brain tend to ignore it. Perhaps it doesn't rank high on the survival scale. The camera in this case renders it faithfully. So while our eyes are better at adjusting to circumstances, this adaptation can supply us with false or misleading information. The camera, by contrast, is not biased by memory. Its renditions are a bit more set in stone.

Figure 3.9
Our eye ignores color in the shadows, but the camera captures it faithfully.

So we have seen how our brain's image processor is biased toward contrast and pattern while putting less emphasis on color. The camera's processor is designed to record scenes more faithfully throughout this range of characteristics. Today's digital cameras are remarkably good at emulating reality, but like our brains, their processors can also alter the tones and colors. They do this using something called picture styles (Canon) or picture controls (Nikon).

Picture Styles and Picture Controls

Picture styles and controls are the modern equivalent of using different films. Before DSLRs we would choose a film type depending on the subject matter or job. Kodak Portra 160 was a great portrait film that lowered contrast and created beautiful skin tones. Kodak EPN was a neutral film that rendered very accurate colors and contrast, and Fuji Velvia was the go-to film for landscape photographers wishing to increase color saturation and contrast. Today's digital photographer can set the style/control in their cameras for each shot rather than having to shoot a whole roll of film.

All photographs made on DSLRs are captured as RAW images. This means the data is not processed at the time of capture. Once the image is captured, it moves to the camera's onboard processor before it's stored on the memory card. It's here that the camera applies sharpening and increases or decreases contrast and saturation. The amount of change to the image is governed by the picture style or control that you have chosen. By default, cameras are set to Camera Standard. This gives a slight boost to contrast and saturation and a touch of sharpening. The following table includes common settings found on most manufacturers' cameras.

Picture Style/Control	Contrast	Saturation
Standard	Increased	Increased
Neutral	Decreased more	Decreased more
Portrait	Decreased	Decreased
Landscape	Increased more	Increased more

Each manufacturer has its own interpretation of the following settings, but the table above supplies a rough guide to the settings' effects. For non-HDR photography, my advice is to set the style or control for the type of image that you're shooting. If you are shooting for HDR, the program you use to blend the images together will dictate which, if any, picture style or control you'll use. Recommendations for these settings can be found in Chapter 4.

The picture style/control settings are permanently applied only to JPEGs. If you are shooting JPEGs, I recommend that you choose wisely before snapping the shutter. If you're shooting RAW, the setting is noted in the sidecar (.xmp) file that travels along with your RAW image. The only time you would see this setting applied is when you're opening your RAW image in your camera manufacturer's processing program, such as Nikon's Capture NX 2 or Canon's Digital Photo Professional. Programs such as Adobe Lightroom and Photoshop are locked out of most of the sidecar settings. Therefore, if you open a RAW image that was shot with the Landscape picture style in Lightroom, you would not see the effects of that setting. And converting the RAW image into Lightroom's .dng file format would not help.

Thankfully, Adobe has created its own interpretation of the camera's style settings. These can be found inside the Camera Calibration panel. Clicking the double-headed arrow next to Profile supplies you with Adobe's interpretation of your camera's styles. **Figure 3.10** shows the contextual menu for a Nikon camera. Because Adobe recognizes each camera make and model, it's able to offer the specific styles associated with that model. Understandably, Adobe doesn't have profile options for every make and model on the market, but they do their best to cover the most popular options. It's worth noting that these options are available only on RAW files; JPEGs have these settings baked into the file, so there is no need to repeat them in the profile, and they simply show the word *embedded* next to their profile in this box.

Figure 3.10
The Profile options for a Nikon camera.

Interpretation Summary

There are many similarities between our eyes and the camera. In some cases, our eyes are more accurate, whereas in others, the camera supplies the more realistic rendition. We are much better at seeing detail over a wide range of brightness values, and the camera is better at recording accurate colors. The camera also has the ability to record motion in ways that we can't see. Picture styles/controls on the camera allow for a variety of interpretations of a scene. Experimenting with these settings will expand your control over the final image. The most important difference for HDR photography, however, is the camera's inability to capture as much detail as our eyes see. We must learn to recognize the scenes that outpace our camera's capability. The exercises at the end of this chapter will help you practice seeing the world the way your camera sees it.

Visual Distractions and Attractions

The manner in which our eyes are drawn to certain areas of a scene is another aspect of our vision worth exploring. As we look around, our gaze is automatically drawn to areas that our brain feels are important. We'll ignore some things and be immediately attracted to others. Again, we suspect that our visual perception has developed over time to prioritize certain aspects of a scene. The following are some items that it finds particularly attractive:

- Bright areas
- Areas of high contrast
- Areas of sharpness
- Areas of high saturation

Each of these items has the power to draw our eye, which means they could also distract us from the area we should be looking at. I call these areas *distractions* and *attractions*. Because we look at photographs in much the same way we look at the world, these distractions and attractions are important considerations. It's difficult to say with certainty which, if any, of these has the strongest pull. Every scene contains different subject matter and has different compositional elements, so the power of the distractions and attractions varies from photo to photo.

The attractions and distractions should be considered during the initial composition as well as when you edit your images. When composing, be sure that your main subject isn't in competition with the brightness of a secondary subject. For example, **Figure 3.11** has a white patch of rock in the lower-left corner. This competes with the brightness of the stream and waterfall. In **Figure 3.12**, I recomposed the shot and removed the white patch of rock. Your attention immediately moves to the water and doesn't get hung up by the bright patch of rock.

Notice how difficult it is to look at the giraffe in **Figure 3.13**. The bright areas of the sky showing through the trees are a real distraction. **Figure 3.14** shows a photo I took after I maneuvered to a location where I was able to shoot the giraffe against an area of trees that had no sky showing through. When the photos are placed side by side, it's easy to see that the bright areas compete with the main subject.

Figure 3.11 The white patch in the lower-left corner distracts the eye.

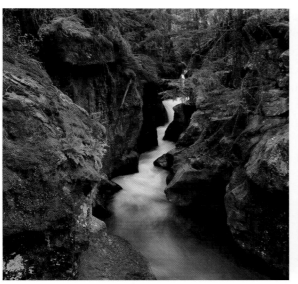

Figure 3.12 Removing the white patch creates a more visually pleasing composition.

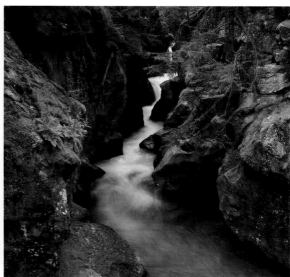

Figure 3.13 The bright areas of sky are a visual distraction.

Figure 3.14 Recomposing the scene eliminates the patches of sky for a stronger main subject.

The same approach to composition can be applied while editing your photographs. **Figure 3.15** is my ode to Henri Cartier-Bresson. I saw this brick façade and knew I wanted to capture a blur of action in the alley behind. The day was overcast with even light, so I set up my tripod, set my shutter speed to 1/8 of a second to blur the action, and waited. After several attempts I caught the action I was looking for. The only problem was that the front entryway was brighter than my subject area in the alley. This is the exact opposite of the tones I was hoping for. **Figure 3.16** shows the image after editing in Photoshop and Lightroom. I darkened and desaturated the front while brightening, saturating, and increasing contrast in the back. Before the edits, your eye gets held up in the front. After the edits, your eye quickly moves to the rear and the heart of the photo. This is a classic case of strengthening the main subject while downplaying the secondary subject through tonal and color edits.

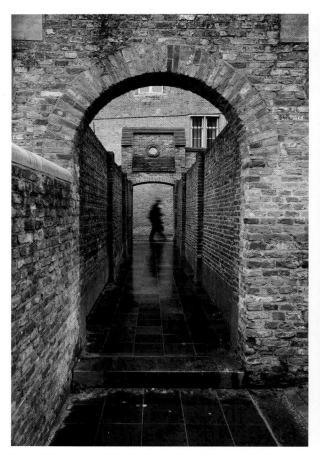

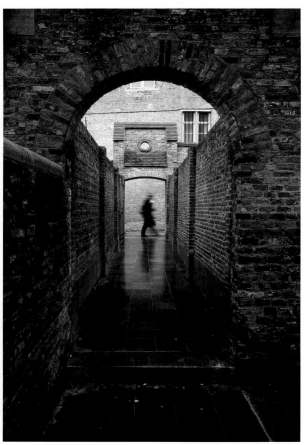

Figure 3.15 **The bright brick face catches the eye and holds the eye, making the main subject less powerful.**

Figure 3.16 **Darkening and lowering contrast and saturation allows the eye to bypass the front and quickly move to the subject in the back.**

These attractions and distractions can also become problematic when processing HDR images. Some of the side effects of processing are highlights that are too dark, shadows that are too bright, too much contrast in the distance, oversaturated highlights, and too little or too much local contrast. Our eyes are accustomed to seeing the world in a specific way, and we don't have to stray very far with our editing to make an image appear overprocessed and fake. **Figure 3.17** is a perfect example. The sky (highlights) is much too dark. In fact, it is a little darker than the foreground. This rarely happens in the natural world. The foreground is too bright and overly saturated, and tonal compression makes it seem low in contrast. Compare that with the tones and color of **Figure 3.18**. The foreground is darker than the sky, which is natural—higher contrast in the foreground, and a background that's not overly saturated. So distractions and attractions are as important during processing as they are during composition. Later chapters on landscape, architecture, and night photography go into more detail on how to control specific areas of the image while creating images with impact that are still believable.

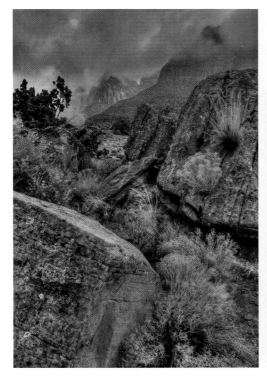

Figure 3.17 **Overprocessed HDR image.**

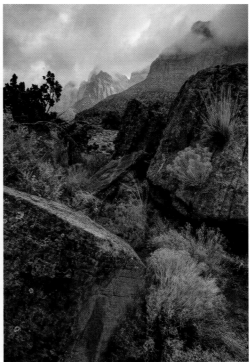

Figure 3.18 **Here, I've processed the image so that it's more lifelike.**

Figure 3.19 is an example of an image that required a light touch. Scenes like this can get out of hand very quickly, going from a magical moment to a garish cartoon with a few adjustments. The trick is to remember how our eyes expect the scene to appear. The morning sun filtering through the light mist and trees creates a very bright background, but much of the foreground remains very dark. This is a relationship that needs to be retained. Foregrounds should have more contrast and saturation. Typically, distant objects in landscapes will be lower in contrast because of the haze in the atmosphere. Here, the mist tends to reduce the contrast. With lower contrast comes lower saturation. It's unusual to find higher saturation in highlights and areas of low contrast.

Figure 3.19
Higher contrast and saturation in the foreground make this image feel more realistic.

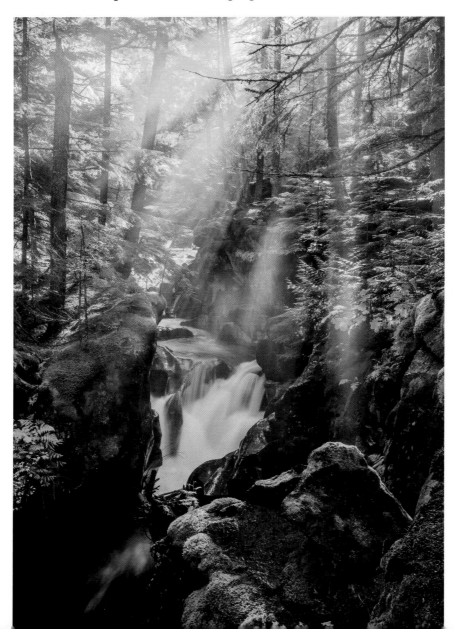

Chapter 3 Assignments

Learn to see the way the camera sees

The camera can't always capture all of the detail that we can perceive. Practice seeing like the camera. Find scenes that are both low in contrast and high in contrast. Examine them before taking the picture. Do you think your camera will lose shadow or highlight detail? Shoot and check the histogram. If the histogram is clipped, practice shooting multiple images to blend together in PhotoMatix or Lightroom.

Shadow color

Practice seeing color. Find a scene with a fair amount of shadow. Expose normally and then make some brighter exposures. Back on the computer, look at the brighter shadows to see if there is a colorcast present. Could the colorcast be from the skylight? Or perhaps it's reflected light from a bright object nearby.

Change picture styles while shooting

Get to know your picture styles or picture controls. Find a scene that is typical of your style. Shoot the image with your camera's style or control set to Standard. Shoot another frame with it set to Landscape. Continue shooting until you've captured the image with all the settings. Examine them back in Lightroom for the subtle or not-so-subtle differences.

Study the value and color of light

The master painters were masters of studying light. Take a cue from them and begin to see light with new eyes. Notice that contrast is higher in subjects near to you and that it decreases with distance. Discover whether color saturation follows the same pattern. Notice that bright objects draw the eye, whereas you tend to ignore the darker areas of a scene. Squint while examining a scene to approximate how your camera will render the shadows and highlights.

Share your results with the book's Flickr group!
Join the group here: www.flickr.com/groups/hdr_fromsnapshotstogreatshots/

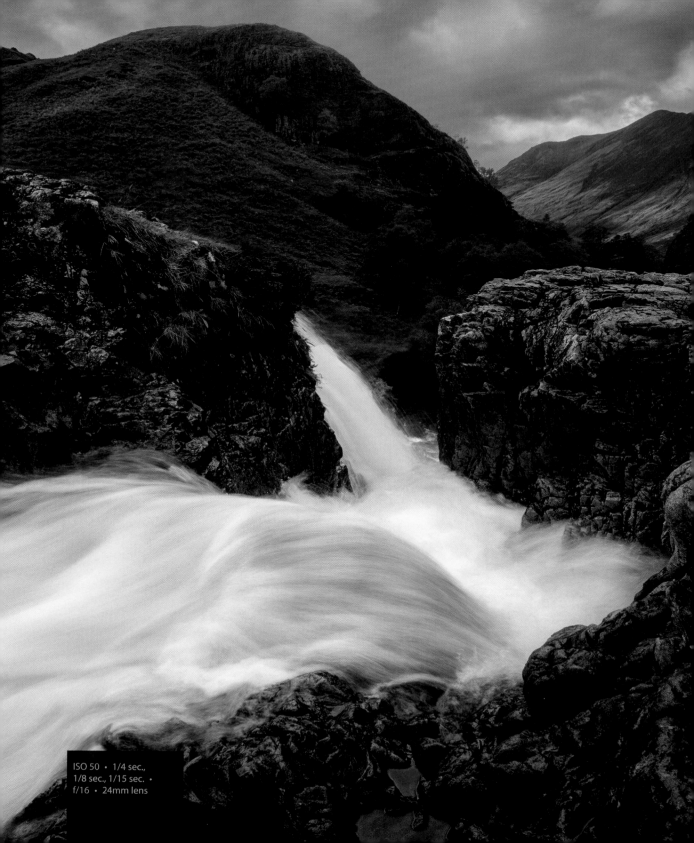

ISO 50 • 1/4 sec.,
1/8 sec., 1/15 sec. •
f/16 • 24mm lens

4

Starting and Ending in Lightroom

Preparing Your Images for Success

Once you've captured your images, it's time to perform magic on the computer. Modern HDR programs shave hours off the time it used to take a photographer to manually blend images in Photoshop, and days off the time it took to achieve similar results in the darkroom. There are many HDR programs, and they all operate a little differently. All, however, can produce both surreal and realistic results. The surreal look is relatively easy to achieve without any coaching; creating a realistic image is more of a challenge. In this chapter, I show you how to prepare your images for the HDR process using Adobe Lightroom. In the next chapter, I delve into creating HDR photos using Lightroom and Photomatix.

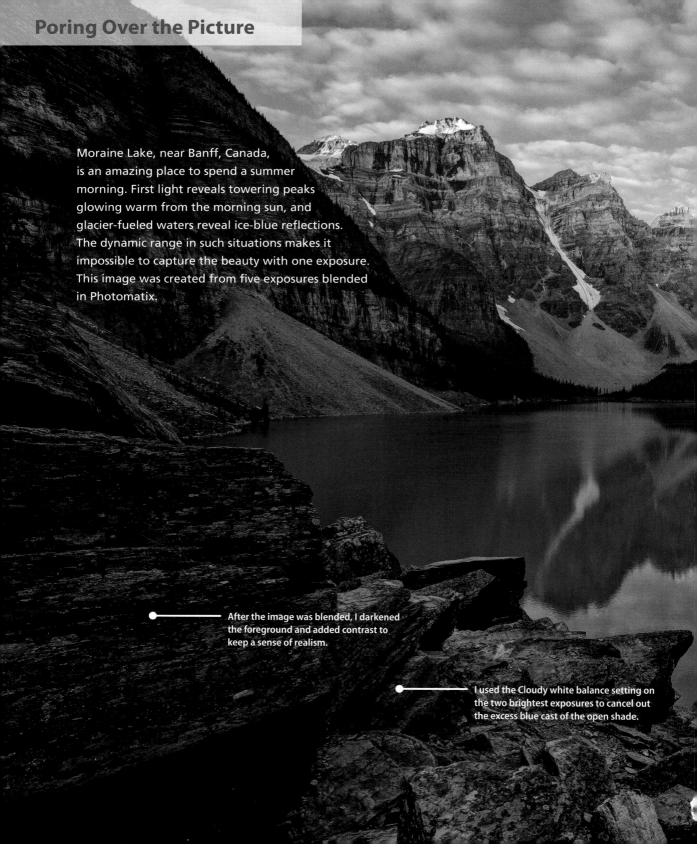

Poring Over the Picture

Moraine Lake, near Banff, Canada, is an amazing place to spend a summer morning. First light reveals towering peaks glowing warm from the morning sun, and glacier-fueled waters reveal ice-blue reflections. The dynamic range in such situations makes it impossible to capture the beauty with one exposure. This image was created from five exposures blended in Photomatix.

After the image was blended, I darkened the foreground and added contrast to keep a sense of realism.

I used the Cloudy white balance setting on the two brightest exposures to cancel out the excess blue cast of the open shade.

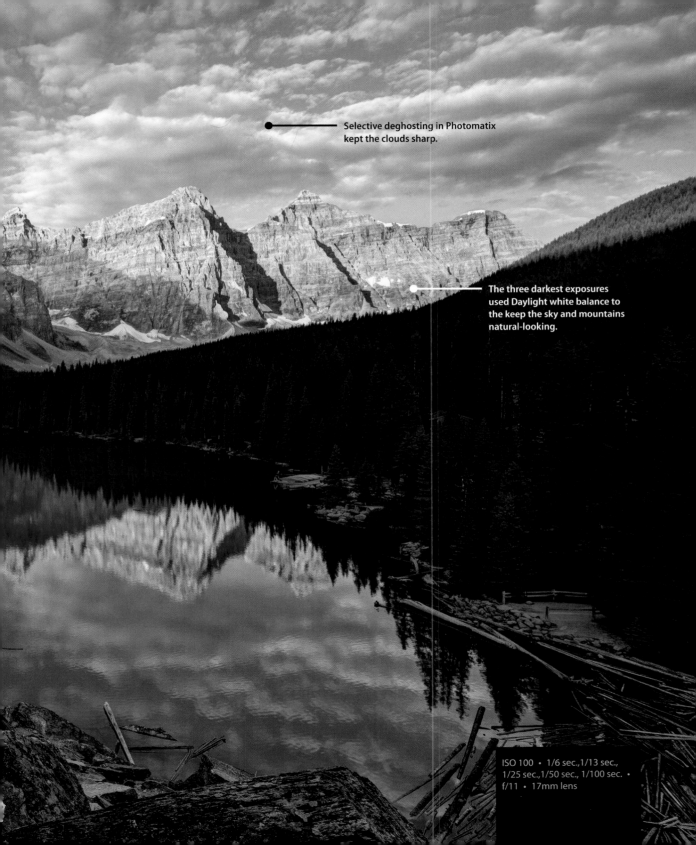

Selective deghosting in Photomatix kept the clouds sharp.

The three darkest exposures used Daylight white balance to the keep the sky and mountains natural-looking.

ISO 100 • 1/6 sec.,1/13 sec., 1/25 sec.,1/50 sec., 1/100 sec. • f/11 • 17mm lens

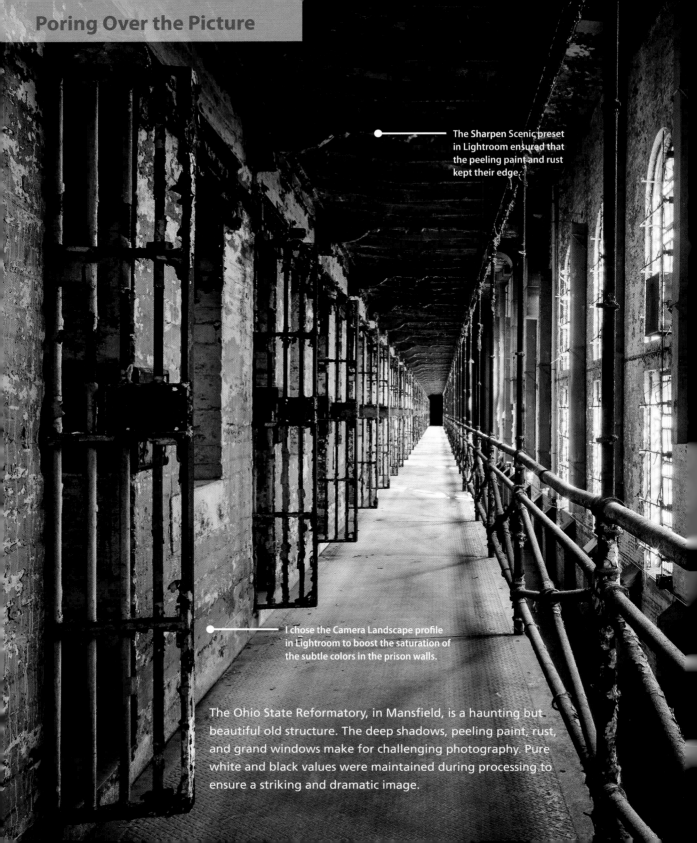

The Sharpen Scenic preset in Lightroom ensured that the peeling paint and rust kept their edge.

I chose the Camera Landscape profile in Lightroom to boost the saturation of the subtle colors in the prison walls.

The Ohio State Reformatory, in Mansfield, is a haunting but beautiful old structure. The deep shadows, peeling paint, rust, and grand windows make for challenging photography. Pure white and black values were maintained during processing to ensure a striking and dramatic image.

Too much clarity made the image feel false, so I increased it only slightly to accentuate the textures.

Areas of pure white and black were retained during processing for a dramatic feeling.

ISO 100 · 8 sec., 4 sec., 2 sec., 1sec. 1/2 sec., 1/4 sec. · f/16 · 24mm lens

Preparing Images in Lightroom

For the most part, HDR programs are standalone programs that operate independently of your primary editing software. Most will also "plug in" to many of the more popular editing programs, such as Photoshop and Lightroom.

Editing programs

A plug-in allows an HDR program to work in concert with your base software. For example, you could download, organize, and edit your images using Lightroom. When you want to blend a series together using HDR, you would export the series into an HDR program such as Photomatix. Photomatix then blends the images and sends the final image back into Lightroom.

Using these programs as plug-ins is a real time saver and helps keep your photographs organized. HDR software typically comes with the plug-in module. Look for the directions on how to install the plug-in for your particular computer and program. If you missed this step or are unable to find the plug-in, a trip to the manufacturer's website will supply you with step-by-step directions for the installation process. Lightroom 6/Lightroom CC has an HDR feature built right into the program. I discuss the pros and cons of Photomatix versus Lightroom in the next chapter.

Lightroom and Photoshop are professional-level programs that have a great deal in common. With these programs you can download images from your camera, organize, edit, export to email, create books and slideshows, and, with Lightroom, even prepare a website.

I use Adobe Lightroom for its rich feature set and intuitive interface. This means I start and end my images in Lightroom. Here is a sample of a basic workflow:

1. Import using the Lightroom Import dialog.
2. Add keywords, labels, and ratings in the Library module.
3. Use the Library module to organize photographs.
4. Perform basic and advanced global edits in the Develop module.
5. Create an HDR image either by using Lightroom's Photo Merge > HDR command or by sending images to Photomatix via File > Plug-in Extras > Export to Photomatix Pro.
6. Use Lightroom or Photoshop to further edit the completed HDR file.
7. Use Lightroom to export images to email, Web, or print.

Import settings

Whichever program you use, you will need to get the images from your camera onto your computer. There are many ways to accomplish this, but I prefer to use Lightroom's Import module. The Import module allows you to rename images, generate thumbnails for them, and import them into a folder of your choice in any location you desire. More importantly, it allows you to import your images with a Develop preset. This means that the moment the images are imported, they have already been edited to your specifications! For the most part, each image will need individual attention, but the following edits can be applied to every image:

- Applying clarity

- Removing chromatic aberration

- Applying sharpening

The Clarity slider is similar to sharpening. It performs a separate function, but the look is similar. I apply a little extra clarity to almost all of my landscape and architectural images—regardless of whether they will become HDR images. Negative clarity is great for portraits.

Chromatic aberration is the presence of a colored fringe around edges in your photograph. Although it may not be noticeable at small magnifications, such as on a website, it becomes glaring when you make larger prints. Removing chromatic aberration is accomplished in the Lens Corrections panel.

There are two types of sharpening: input sharpening and output sharpening. Input sharpening is applied to fix the inherent image softness that accompanies image capture. No lens creates perfectly sharp images, and all photos are a little soft the moment they are made. Input sharpening, then, corrects the photo's initial inherent lack of sharpness. Output sharpening is applied to images that have lost softness due to enlargement. Downsizing an image to, say, a JPEG for email, a Web page, or a 5x7 print rarely requires output sharpening. Upsizing an image to a 16x20 print, however, will result in a loss of sharpness. This is where output sharpening comes in. But we're interested in input sharpening at this stage.

Input Sharpening

JPEG files are sharpened in-camera, whereas RAW files are not. For this reason, it's unnecessary to apply input sharpening to JPEGs.

Creating a preset is easy, and applying the preset during import is even easier. Start by choosing an image that is already imported, and move to the Develop module.

1. In the Basic panel, set Clarity to +8 (**Figure 4.1**).

2. In the Lens Corrections panel, click the Basic tab and then select the Remove Chromatic Aberration checkbox (**Figure 4.2**).

Figure 4.1 (left)
Setting Clarity to +8

Figure 4.2 (right)
Removing chromatic aberration

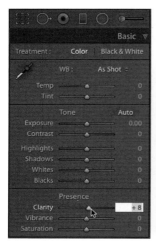

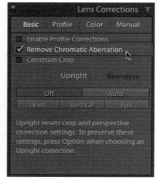

3. Input sharpening can be done in the Detail panel, but it's much easier to apply a ready-made preset. The Presets panel is on the left side of the screen (**Figure 4.3**). Click the arrow next to Lightroom General Presets, then click Sharpen–Scenic. This moves the Sharpening sliders to preset positions (**Figure 4.4**) that work well for scenics, landscapes, nature, and architecture. I apply this preset to all images but portraits.

Figure 4.3 (left)
The Sharpen–Scenic preset

Figure 4.4 (right)
The Detail panel after clicking the Sharpen–Scenic preset

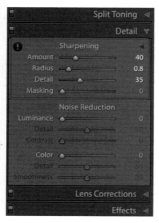

Once you have made these adjustments, it's time to make the preset. Return to the Presets panel and click the + button in the upper-right corner (**Figure 4.5**). A dialog opens that allows you to choose which of the adjustments you would like to include in the preset. Begin by giving the preset a name that will make sense to you. I have named this preset *Scenic Import Preset* (**Figure 4.6**). Next, click the Check None button at the bottom. Finish by selecting the Clarity, Sharpening, Chromatic Aberration, and Process Version checkboxes. (You should always keep the Process Version checkbox selected to keep all your images looking the same.) When your New Develop Preset dialog looks like Figure 4.6, click Create.

Figure 4.5
Creating a preset

This preset can be applied in many ways. I primarily use it when importing images, but it can be applied at any time. In the Develop module it can be found under User Presets in the Presets panel. In the Library module it can be found in the Quick Develop panel under Saved Preset > User Presets. When importing, you'll find the preset under Develop Settings in the Apply During Import panel (**Figure 4.7**).

Figure 4.6 **The New Develop Preset dialog**

Figure 4.7 **Applying the preset during import**

Initial Edits

Not all HDR programs recognize changes made to a RAW file in Lightroom. Because these edits are important to any image, I apply them across all scenic shots regardless of whether they will be processed in HDR. Photomatix recognizes these edits, and that's one of the primary reasons I use this software. Lightroom's Photo Merge > HDR function creates a RAW file, so it is irrelevant whether you apply this setting before or after merging.

Labeling and stacking

Shooting for HDR generates a lot of images that look similar. You may shoot a series of five images and then change your composition and shoot five more. If the light gets better, you may even shoot another five. At this point, recognition of the individual series becomes important. Get into the habit of taking a picture of your hand in between series. This acts as a marker when you review your images on the computer. Just remember to reset your bracket after the hand image or your next series will be off.

Once back at the computer, you can distinguish the individual sets of images in two ways: labeling and stacking. Labeling is simply adding a color to the thumbnail. **Figure 4.8** shows a folder of images that I captured while the sun came up over a mountain in Glacier National Park. I shot three separate sets of images (seven in each set). The first set is labeled red, the second green, and the third blue. Labeling the images in this way makes it much easier to differentiate between sets.

Figure 4.8
Color-labeled images

Try the following to add a color label to a set of images:

1. Select the images. Click the first image, then Shift-click the last image of the series (this is called a contiguous selection and selects all the images in that series). To select non-adjacent images, click the first image, hold down the Option/Alt key, and continue to click the desired images.

2. Choose Photo > Set Color Label, and select red, yellow, green, blue, or purple.

 Use the number keys on your keyboard as a shortcut to the menu. Press 6 for Red, 7 for yellow, 8 for green, and so on.

If the colors do not appear on your thumbnails, adjust your view options. In the Library module, choose View > View Options. Adjust your view options as seen in **Figure 4.9**.

Stacking your images is another way to alleviate confusion. This takes selected images and "stacks" them together (**Figure 4.10**).

1. Select all images in the series.

2. Choose Photo > Stacking > Group Into Stack. The shortcut is Command-G on a Mac and Ctrl-G in Windows.

Figure 4.9 **The Library View Options dialog**

Figure 4.10
**A folder organized
into stacks**

Stacking is a great way to reclaim window space in the library. A couple of tips for working with stacks:

- The number in the upper-left corner of each image indicates how many images are in the stack. To ensure that this number is visible, in the Library module choose View > View Options and select the Thumbnail Badges checkbox in the Library View Options dialog (**Figure 4.11**).

- Clicking the number in the upper-left corner of an image expands the stack; click again to collapse the stack.

- When a stack is selected, press the S key to expand or collapse the stack.

Figure 4.11 **Ensuring that stack numbers are visible**

- The first selected image appears at the top of the stack. If you want a different image to show at the top of the stack, click that image and press Shift-S.

- Move images up or down in a stack by pressing Shift-[or Shift-], respectively.

Synchronizing settings

When you're working with programs such as Photomatix to create HDR images, the edits you make in Lightroom can produce drastic or subtle changes to the final file. For example, you many want to change the white balance or increase saturation. Changes can be made to individual images within a series, but typically you'll want to sync the change across all images. To sync changes:

1. In the Develop module, make the desired changes to one of the series.

2. While holding the Command (Apple) or Ctrl key (Windows), select the remaining images in the series.

Notice that, although all the images are selected, the one you made the changes to is a little brighter. This indicates that it is the active image and that the changes from this image will be applied across the others.

3. Press the Sync button in the lower-right corner of the screen.

 The Synchronize Settings dialog appears.

4. Click the Check None button.

5. Select the checkboxes of the edits that you have made. Click the Synchronize button to apply the edits to the selected images.

Syncing Adjustments for Photomatix

I recommend making and syncing the appropriate adjustments when you send your images to Photomatix. When blending your images using Lightroom's Photo Merge > HDR command, there is no reason to make adjustments before blending. This is covered in depth in the next chapter.

Adjusting Images in Lightroom

Understanding the primary adjustments in Lightroom is key to developing realistic and powerful imagery. For those working only in Photoshop, Adobe Camera Raw has exactly the same adjustments. The techniques described here apply to both Lightroom and Camera Raw.

Many HDR programs do not detect changes made to files in Lightroom. Instead, they import the absolute RAW data and perform their merge with this information. I find this to be a bit limiting, which is why I use Lightroom 6/CC's Photo Merge > HDR command, as well as Photomatix. Photomatix recognizes the edits you perform in Lightroom and incorporates them into the merge. Lightroom 6/ CC incorporates most of the edits you perform, with the exception of tonal adjustments.

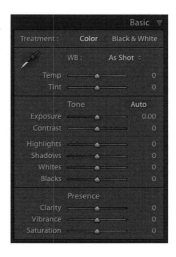

Figure 4.12
The Basic panel

In the next chapter, I make recommendations for specific adjustments that should (or should not) be made to the files before sending them to the HDR program. For now, let's focus on an overview of the more important edits performed in Lightroom. The primary tonal and color adjustments to your images happen in the Basic panel (**Figure 4.12**). This is where you will do most of your heavy lifting.

The Basic panel

- The **White Balance** setting adjusts the image for different lighting conditions and removes any color cast that is present. From the White Balance drop-down menu, choose the option that most closely resembles the conditions you were in when you made the image, such as Cloudy, Shady, Incandescent Light, and so on. If you are working on a JPEG rather than a RAW image, you will see only the options As Shot, Auto, and Custom.

- Use the **Temp** (Temperature) slider to fine-tune the color settings. Move the slider left to create a cooler, bluer tone, and move it to the right to create a warmer, more orange or yellow tone.

- Use the **Tint** slider to adjust the tint of the image: left for greener and right for more magenta.

- Use the **Exposure** slider to adjust the overall luminosity (brightness) of the image. This is kind of like giving more or less exposure at the time of capture. Move the slider to the right for more exposure and to the left for less exposure. To reveal image clipping, hold down the Option (Mac) or Alt (Windows) key while moving the Exposure slider; the spots that are revealed are the very brightest or darkest points of the image.

- The **Contrast** slider does just what you think it will—adds or decreases contrast. It adds contrast primarily in the midtones, however. I typically leave this slider at 0 for HDR images.

- The **Highlights** slider brings back detail in the highlight areas. You may find that when you increase the Exposure slider until the whole image looks good, you end up with some clipping. By moving the Highlights slider to the left, you can bring some highlight detail back! This slider may not work on overexposed images, so you still need to pay attention to your exposure in the field. If you have trouble getting good highlight detail using Photomatix, close out of that image and return to Lightroom. Adjust the highlights down on the darker images, and then reimport the newly adjusted series into Photomatix.

- The **Shadows** slider lightens or darkens the dark areas of your photograph. It's designed to work on the darker areas of the photo but not on the deepest blacks. If you move this slider too far to the right to lighten, the result will look fake. Use with care.

- The **Whites** slider is the counterpoint to Shadows. It lightens or darkens the brighter areas of the photo, but will try not to affect the brightest whites.

- The **Blacks** slider brightens or darkens the deep blacks while having less influence on the midtones and highlight values. Hold down the Option (Mac) or Alt (Windows) key while moving the slider to reveal shadow clipping.

- The **Clarity** adjustment increases or decreases the overall contrast above the shadows and below the highlights. It's similar to the Contrast slider but tighter. It separates tones that are very close together. Think of this slider as bringing out texture in the image.

- The **Vibrance** slider adds saturation in a whole new way. It affects the least saturated areas in your photo first. As you continue to move the slider, the more saturated areas begin to gain in saturation. This lets you increase saturation across your image without oversaturating the already intense colors.

- Moving the **Saturation** slider to the right increases the overall saturation of the image. Use sparingly! Oversaturation is a sure sign that your image was digitally manipulated.

The Tone Curve panel

The Tone Curve panel allows further fine-tuning of your tonal values (**Figure 4.13**). Many photographers ignore this panel altogether and do most of their heavy lifting in the Basic panel. This is certainly understandable given the power of those sliders. The curve becomes invaluable, however, when processing files created by Lightroom's Photo Merge > HDR command. Many times you won't be able to extract the desired tones using the Basic panel alone. Once you've exhausted the capabilities of the Basic panel, it's time to move to the Tone Curve panel. Adobe has made curves much easier with the introduction of the Parametric curve.

Figure 4.13
The Tone Curve panel

The sliders at the bottom of the box are used to adjust their respective areas. A close look at the shading under the sliders hints at the result. The slider is darker on the left and lighter on the right. Moving any slider to the right lightens that tonality, whereas sliding it to the left darkens it. The Parametric curve is designed so that moving the slider the full amount in either direction should not create posterization and unrealistic tonal values. That being said, work these sliders with care, especially when you are nearing the maximum values.

The HSL panel

The HSL panel allows you complete control over the color in your photographs (**Figure 4.14**). Whereas White Balance adjustments affect the overall color cast, HSL works on aspects of individual colors. Across the top of the panel you see the words Hue, Saturation, Luminance, and All. Click the word Hue to reveal the Hue adjustments, click the word Saturation to reveal the Saturation adjustments, and so on.

Figure 4.14 **The HSL panel**

- Hue: The name of the color, such as red, blue, or orange. Look at the color behind the slider to give you an idea of which direction you will be pushing that hue.

- Saturation: The intensity of the color. Move to the right for more intensity and left for less intensity of that individual color.

- Luminance: The brightness of the color. Brightens or darkens the chosen color.

The HSL panel can also be used to create great-looking grayscale images. Click the B&W tab at the top of the panel to create a grayscale photograph. The sliders will now brighten or darken the shade of gray that corresponds with each color.

The Lens Corrections panel

As you saw earlier in this chapter, the Lens Corrections panel is used to remove chromatic aberration. It can also be used to fix other inherent lens aberrations, such as barrel and pincushion distortion and light falloff. **Figure 4.15** shows the Basic section of the Lens Corrections Panel. Here is where you will select the checkbox Remove Chromatic Aberration. Just above that you'll see Enable Profile Corrections. Select this checkbox to apply a solution that fixes any aberration your lens may have.

Figure 4.15 **The Lens Corrections panel**

Click the Profile tab in the upper part of the box to switch sections. The Profile section of the Lens Corrections panel (**Figure 4.16**) displays the solution Lightroom has automatically chosen. Adobe has a long list of cameras and lenses for which it has developed profile corrections. Click the double-headed arrow to the right of any of the dropdowns to reveal the various choices. I've never had Adobe fail in the correct choice of camera and lens, but the cautious can always double-check!

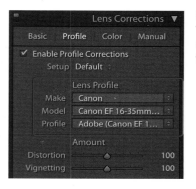

Figure 4.16
The Profile section of the Lens Corrections panel

Keep The Vignetting

Most lenses experience some amount of light falloff at the corners of the image. This means the corners are somewhat darker than the middle. I find this to be a pleasant form of vignetting when it's not too obvious. You can keep some of this natural vignetting and still fix the other aberrations by sliding the Vignetting slider (located at the bottom of the panel) to the left—all the way to the left means unfixed, darker, natural corners.

The Camera Calibration panel

The Camera Calibration panel (**Figure 4.17**) alters the way Adobe translates your RAW file. If you are shooting JPEGs, you can ignore this panel. If you are shooting RAW, however, the adjustments here can be quite significant.

Figure 4.17
The Camera Calibration panel

Process, at the top of box, refers to the processing engine Adobe uses to process the file. The choices here are 2003, 2010, and 2012 (current). Any new files that are imported into Lightroom will automatically get the latest 2012 process version. Older images that have been imported in past versions of Lightroom may have older process versions. Update the process version of your older images to the latest 2012 version for the best translation and access to the latest adjustments.

Just below Process, you'll see Profile. This is where the magic happens. By default, your images are displayed with the Adobe Standard profile. This is Adobe's interpretation of what that file should look like. Click Adobe Standard to reveal the options associated with a particular camera brand. **Figure 4.18** shows the options for Nikon cameras. Canon cameras may have a slightly different list.

These profile options are built into Lightroom and will automatically appear with Nikon and Canon cameras. You may not see these options when working with other brands. Although Adobe Standard is a great place to start, you may like the look of your images when Camera Landscape or Camera Standard is applied. Every image is different, and I'm often surprised to find that one profile looks better than another. I recommend experimenting with these profiles to determine which best translates your particular image.

Figure 4.18 **Camera-specific profile options**

Basic HDR Theory

Over the years, I have used just about every method available to fine-tune my photographs. From burning, dodging, and contrast masks in the darkroom to channel selections and layer masks in Photoshop. Today there are many methods and programs that are far more powerful than anything we've had before, and most of these programs are far easier to use! I have settled on Lightroom and Photomatix to produce the look that I find most realistic.

Photomatix was one of the first HDR programs on the scene and has continued to upgrade its product to provide an array of options to satisfy any photographer. Adobe's early attempts at including HDR processing in Photoshop were less than satisfactory. However, now with the ability to merge and process 32-bit images in Lightroom, the results are fabulous.

Before we get into the specifics of how to use each program, let's examine the basic HDR process.

1. Load multiple exposures into the HDR program.

2. The HDR program aligns the images and merges them into a new 32-bit file.

3. All tones in the 32-bit image are translated into a visible range. This is commonly called tone mapping, although there are other methods of translating the tones.

4. Export or save the file.

As mentioned, you'll have more leeway when shooting and uploading RAW files. RAW images are 16-bit files, which contain much more information than JPEGs, which are 8-bit files.

Loading the files into the HDR program can be accomplished in several ways:

- If you own only Lightroom 6/CC, select the series in the Library module and choose Photo > Photo Merge > HDR.

- If you own only Photomatix, choose Open and navigate to the images via the Finder (Mac) or Explorer (Windows) window.

- If you have any version of Lightroom and Photomatix, select the images and then choose File > Plug in Extras > Export to Photomatix Pro.

A 32-bit file contains an astronomical amount of information, which allows all the detail in the uploaded series to be contained in a single file. This single 32-bit image, however, contains more information than our eyes can see or the computer monitor can display. This is the only true HDR image. For this reason, you have to translate all the information into viewable tonalities. This translation process is commonly called tone mapping, and it's the part of the process in which you move the various sliders to adjust the look of the image.

There are other processes that will translate the tones into a visible range. One of those processes is called exposure fusion and is found in Photomatix. Although this is technically not an HDR process, it's the one that I find produces the most realistic results.

Figure **4.19** is a classic case of adjusting the RAW images before blending them in Photomatix. I used the Camera Landscape profile to boost saturation and contrast in the bricks. Keeping the white balance set to Daylight allowed the walkway to retain its blue hue from the sky. The darkest and middle image had the highlights reduced to darken the sky. An increase in clarity adds a crisp feeling to the walkway.

Figure 4.19
Image blended in Photomatix with pre-adjustments to initial RAW images

ISO 100 · f/9.5 · 6 sec., 3 sec., 1.5 sec. · 18mm lens

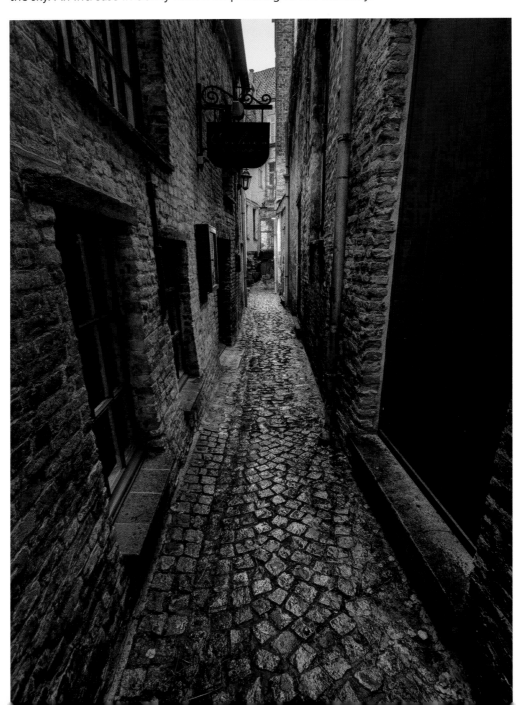

Chapter 4 Assignments

Download the latest version of Lightroom

Lightroom 6/CC is the latest and greatest. It's no longer necessary to send your images to Photoshop to create panoramas and blend images into HDR. Lightroom 6/CC now incorporates Merge to HDR and Merge to Panorama all within Lightroom! Take a trip to www.adobe.com to upgrade your older version of Lightroom. Another option is to join Creative Cloud (CC), where, at the time of this writing, you can subscribe to Photoshop and Lightroom for $9.99 a month.

Download Photomatix Pro

While I love Adobe Photoshop and Lightroom, their Merge to HDR functions aren't flawless. I still use Photomatix Pro (www.hdrsoft.com) about 75 percent of the time. Its default settings are much more to my liking, and the deghosting feature is the best I've used. Use my name as a coupon code upon checkout for 15 percent off the retail price: TimCooper (all one word; capital *T* and capital *C*).

Practice editing your images

A large part of creating beautiful imagery revolves around using Lightroom's Develop module either before or after processing your HDR images. Familiarize yourself with the tonal and color adjustments the program offers. Visit the Adobe website for free tutorials and lessons on how to use the Develop module to its full capacity. Other locations for training include the following:

- www.photographersbreakthrough.com
- www.timcoopersphotocircle.com
- www.photoshopcafe.com

Share your results with the book's Flickr group!
Join the group here: www.flickr.com/groups/hdr_fromsnapshotstogreatshots/

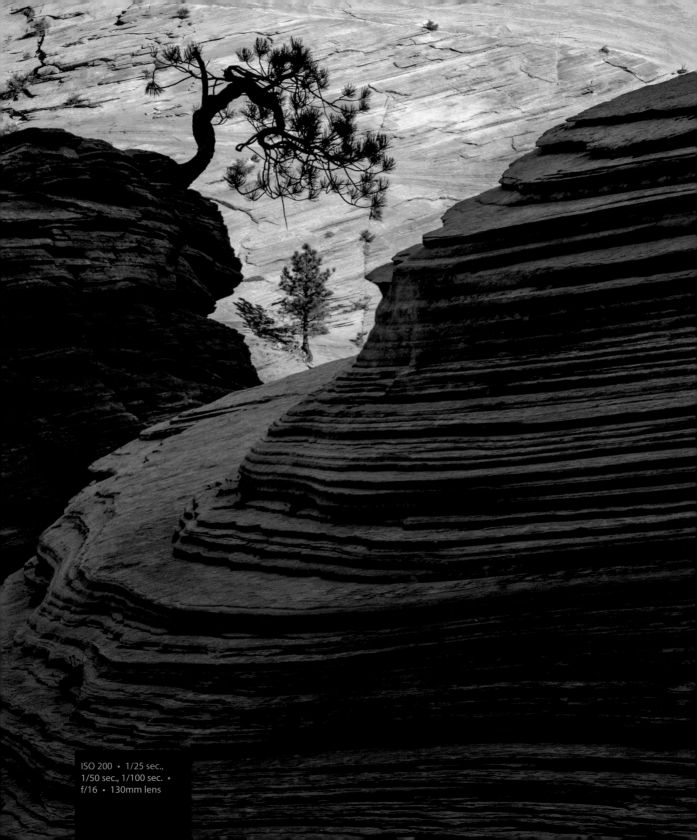

ISO 200 • 1/25 sec.,
1/50 sec., 1/100 sec. •
f/16 • 130mm lens

5
Using HDR Software

My Favorite HDR Programs

After years of working with different HDR programs, I have narrowed down my favorites to Photomatix Pro and Adobe Photoshop Lightroom and its new Photo Merge capability. Both programs are easy to use and create very lifelike results. Each also has its pitfalls. I choose the program that best fits the image type and desired results. In this chapter, I demonstrate the pros and cons of each program and provide step-by-step directions for creating dynamic and realistic photographs.

The Columbia River cuts a beautiful gorge between northwest Oregon and southern Washington state. Waterfalls, canyons, and wildflowers abound during the spring months. While most of the scenery is best admired from the valley floor, some of the higher overlooks afford a magnificent view.

Photomatix's exposure fusion blended the three photographs.

ISO 100 • 1/4 sec., 1/8 sec., 1/15 sec. • f/10 • 35mm lens

Contrast in the sky was carefully adjusted to retain a natural look.

I captured three exposures to retain detail in the dark shadows and in the clouds illuminated by the setting sun.

The blue shadows and warm highlights of sunset create an appealing color contrast.

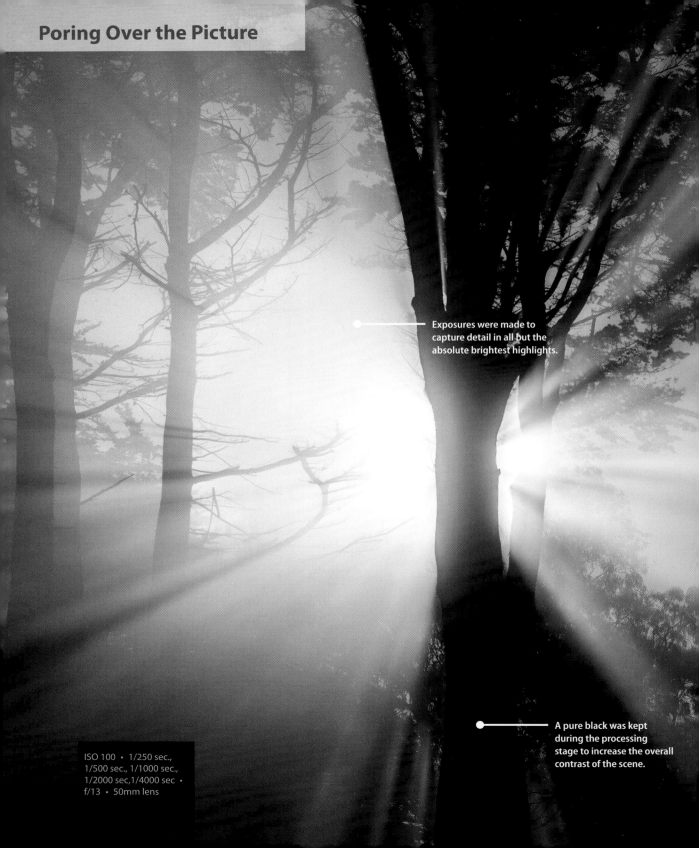

Poring Over the Picture

Exposures were made to capture detail in all but the absolute brightest highlights.

A pure black was kept during the processing stage to increase the overall contrast of the scene.

ISO 100 · 1/250 sec.,
1/500 sec., 1/1000 sec.,
1/2000 sec,1/4000 sec ·
f/13 · 50mm lens

Lightroom's Photo Merge > HDR command blended the five exposures.

Summer in San Francisco can be as cold as winters elsewhere, but the magical light can more than make up for the discomfort. Catching the sunbeams as they radiate through the fog can be a magical experience. Retaining detail in the silhouettes is not as important as capturing well-defined highlights.

I added clarity after blending to increase the impact of the sun rays.

Lightroom

In the past, Lightroom users wanting to merge exposures to create HDR imagery needed to purchase a separate HDR program or export their images into Photoshop. With the release of Lightroom CC/6, photographers now have the ability to merge their images completely within Lightroom. This feature is a great addition to the program and is accompanied by the equally welcome ability to merge images into a panorama.

Adobe has designed an especially simple and effective HDR process that takes advantage of Lightroom's ability to tone map HDR files. In the past, we selected images and exported them to Photoshop to merge the files into an HDR image. Next we would reimport the HDR file into Lightroom and use the powerful Develop module to translate the file into visible tonalities. Now we can accomplish the whole task in Lightroom itself. Here's the easy workflow:

1. In the Library module, select the exposures that you want to blend.

2. From the Photo menu, choose Photo Merge > HDR.

3. In the HDR Merge Preview dialog, choose a Deghost Amount and click the Merge button (**Figure 5.1**).

 Your newly created HDR is appended with the suffix –HDR.dng.

4. Process the image using Lightroom's Develop module.

Figure 5.1
**The HDR Merge
Preview dialog.**

Let's take each step in turn. Begin by selecting the images. Click the first image, then Shift-click the last image of the series (this is called a contiguous selection and selects all the images in that series). To select non-adjacent images, click the first image, hold down the Option/Alt key, and continue to click the desired images.

Although Lightroom (and most HDR programs) will merge JPEGs, using RAW files is a better choice. With their high bit depth, RAW files withstand more severe editing and produce photos with smoother tonal gradations. For this reason, most professional photographers shoot RAW files.

Once the images are selected, choose Photo > Photo Merge > HDR (**Figure 5.2**). You'll notice the keyboard shortcut Control-H listed to the right. (On Apple computers, the ^ symbol designates the Control key.)

Figure 5.2 **Choosing Photo > Photo Merge > HDR.**

Your separate exposures are sent to Lightroom's HDR Merge function. The HDR Merge Preview dialog appears, showing you the merged file (Figure 5.1). Adobe has done a great job of keeping this preview box uncluttered and easy to use.

- Select the Auto Align checkbox. This function performs just as promised. If your images are slightly out of alignment, this option attempts to align them. For best results, use a tripod when capturing your exposures. If you are unable to use a tripod, ensure that your camera is set to High Speed Drive and Auto Bracket. This helps minimize the difference in alignment.

- Selecting the Auto Tone checkbox allows Lightroom to initially set the exposure and contrast controls. These applied settings are not permanent and can easily be adjusted in the Develop module. **Figure 5.3** shows the Basic panel of a file that had the Auto Tone checkbox selected. To reset the settings to their default values, double-click the word Tone (**Figure 5.4**). For photographers just starting out, keeping the Auto Tone box selected is a good way of learning the various tonal adjustments. Advanced users may wish to keep this box unselected so they can adjust their images from scratch.

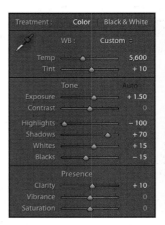

Figure 5.3 **The Auto Tone settings in Lightroom.**

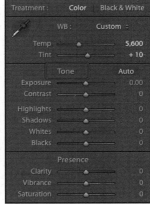

Figure 5.4 **Double-click the word Tone to reset the sliders to their default positions.**

- Deghost Amount is the next option. Ghosting occurs when objects such as blowing leaves, moving clouds, or people are in different places in different frames. If blended without deghosting, those objects appear semi-transparent and ghostlike. The process of deghosting, then, is to identify the areas where ghosting may occur and fill in those regions with data from one of the images.

The first part of this process occurs when you choose a Deghost Amount option. Clicking None identifies no areas of ghosting. The Low option is fairly conservative in identifying areas that will be ghosted; this means that only obvious areas of motion are identified. The High setting is less discerning and will choose more areas that could cause ghosting. Select the Show Deghost Overlay checkbox to see a red overlay where the deghosting will occur. Each time you click another Deghosting option, Lightroom takes a few moments to refresh the preview. **Figure 5.5** shows an image with the Low deghosting setting. **Figure 5.6** shows the same image with the more aggressive High setting chosen.

The second part of the deghosting process happens behind the scenes. After choosing a Deghost Amount setting, click Merge at the bottom of the HDR Merge Preview dialog to begin the processing. At this point the Low, Medium, and High settings don't make a difference. Lightroom is now filling each identified region with image data from one of the uploaded photos. The source for each region is chosen to minimize noise without clipping the highlights. Unlike in Photomatix, we have no choices at this stage. Simply click Merge and Lightroom performs its magic.

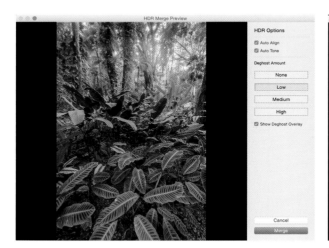

Figure 5.5 **The Low setting picks up almost no ghosting.**

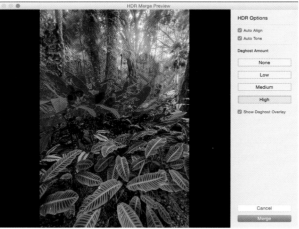

Figure 5.6 **The High setting identifies more motion in the leaves in the center.**

Once you click Merge, the preview dialog disappears and Lightroom begins processing your image. Progress is marked by the taskbar in the upper-left corner of the screen (**Figure 5.7**).

Figure 5.7 **The progress taskbar.**

The newly created HDR file can now be found in the folder with the source images. Look for it next to the last or first image in the group. In **Figure 5.8**, you see that the new file is named DSC_3179-HDR.dng. Lightroom automatically took the last filename in the series and added -*HDR*, which makes it easy to differentiate it from the surrounding files. You'll also notice that the new image is a DNG (.dng) file, which is Adobe's RAW file format. This is a great new feature in Lightroom's HDR workflow. Most (if not all) HDR programs will return either a TIFF or a JPEG file. Returning a 16-bit TIFF file is fine when the tone mapping/tonal adjusting is occurring in the HDR program. This means that most of the heavy lifting has already been done. When blending with Lightroom, however, the Merge command simply includes all the tones of the various source images in one file. This HDR.dng image is now ready for tonal adjustments in the Develop panel.

Figure 5.8
The newly created image in the Library module.

Display File Name in Grid View

I prefer having the image name above the thumbnail in Grid view to easily identify my photos. Because Lightroom does not include this information by default, you have to alter the View options. Press G to get into Grid view in the Library Module. Next, choose View > View Options. Select the Show Grid Extras checkbox and choose Expanded Cells from the menu (**Figure 5.9**). Under Expanded Cell Extras select the Show Header with Labels checkbox and choose choose File Name from the menu.

Figure 5.9 **The Library View Options dialog.**

Developing Your HDR file

The fact that Lightroom returns a DNG file makes for a very flexible workflow. This means it is unnecessary to make any changes to the images before merging them. Every possible edit you can perform before merging can be performed after. When using Lightroom to merge, I prefer to leave my images unedited before blending. Once the HDR.dng returns, I treat it as I would any other RAW image.

If you selected the Auto Tone checkbox, your image may already look pretty good. If you left it unselected, you may see an image that shows very little or no shadow detail (**Figure 5.10**). No problem. The HDR file contains plenty of information that the sliders in the Basic panel can retrieve.

Figure 5.10
Unadjusted file in Lightroom's Develop module.

1. In **Figure 5.11**, I have adjusted the Exposure to +1.20 and the Highlights to –100. Think of the Exposure slider as a brightness adjustment. Are your midtones too dark? Raise the Exposure slider. Too light? Lower the Exposure slider. Here the image contains highlight detail but is overall a bit dark.

Figure 5.11
Increasing the Exposure to +1.20 and decreasing the Highlights to –100.

2. As you raise the Exposure slider, you are likely to see the highlights start to overexpose. Increase the Exposure slider until the midtones are satisfactory, and then lower the Highlights slider. If the Highlights slider goes to –100 and the highlights are still blown out, you may need to lower the Whites slider. Care should be taken with lowering the Whites slider, however. Decreasing this control too much reduces the overall impact of the photo. Take a close look at the histogram. Notice how the highlights are retaining detail without being overly dark. It's important to keep a bright white with detail in most photographs.

3. The midtones and highlights now look good, but the shadows are still a bit dark. In **Figure 5.12,** I raised the Shadows slider to +89. This move makes shadows look good, but now I lack a deep black. Just as it's important to keep a bright highlight, it's also important to keep a nice rich black.

Figure 5.12
Raising the Shadows slider to +89.

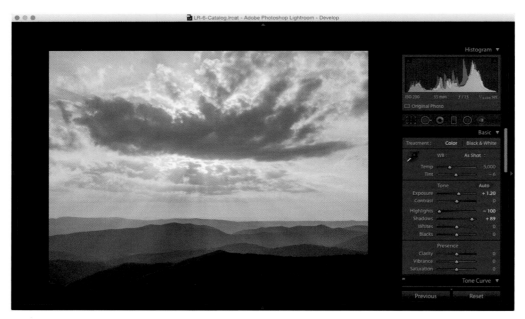

4. Next I move the Blacks slider down to –53 to anchor the blacks. Don't be afraid to clip the blacks. Let there be some black without detail in your images. The last tonal adjustment is to increase the Whites slider to +8 to ensure a crisp, bright white. The Histogram in **Figure 5.13** shows the whites coming right down into the corner, and some clipping in the blacks, but well within our tolerance.

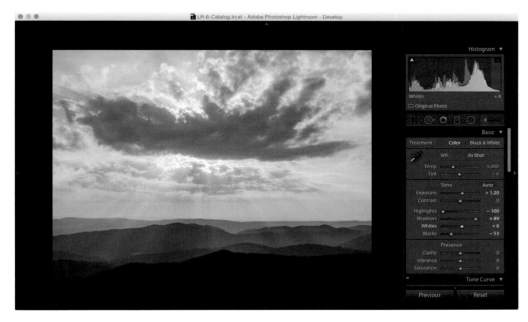

Figure 5.13
Adjusting the Blacks to –53 and increasing the Whites to +8.

The tonal adjustments should always be made first, as they have a significant effect on saturation. Increasing exposure and whites and decreasing blacks is another form of adding contrast into an image. Adding contrast to an image always increases saturation. The engineers at Adobe placed the Saturation slider at the bottom of the panel so that we adjust the tones before we adjust the saturation.

As you might realize, making adjustments as dramatic as these to a typical RAW image or to a JPEG could really reduce the image quality. Because this is a RAW file created from an HDR merge, though, the file remains pristine.

For this next example we'll blend six exposures made in a tunnel in Bruges, Belgium (**Figure 5.14**). Our eyes perceive this tunnel as dark with a very bright courtyard. Our adjustments back in Lightroom need to enhance this perception while still providing important detail.

Figure 5.14
A series of six images to be blended using Lightroom.

Figure 5.15 shows the image after returning to Lightroom. In this case, the shadows have a bit of detail but the highlights are too bright. I feel that overall my brightness is about right, so I'll skip the Exposure slider. My first step adjusts the Shadows to +88 and Highlights to –40. As you can see in **Figure 5.16**, this gets the histogram looking good, but the image still feels a little flat.

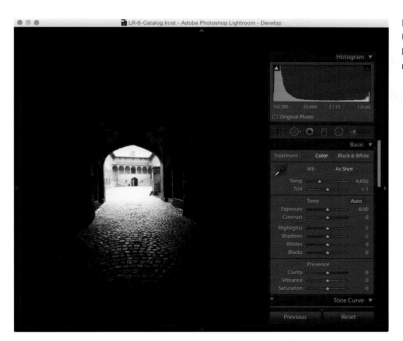

Figure 5.15
Unadjusted file in
Lightroom's Develop
module.

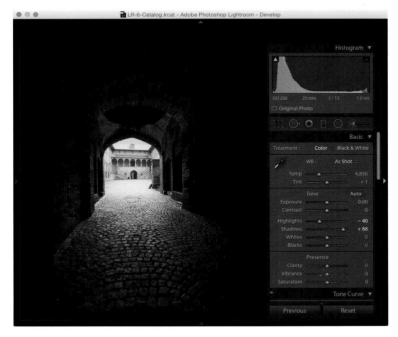

Figure 5.16
Shadows increased
to +88 and Highlights
decreased to –40.

Increasing the Whites +20 and decreasing the Blacks to –30 increases the overall contrast (**Figure 5.17**). The histogram now shows some clipping in the shadows. As mentioned earlier, a little clipping in the shadows is just fine. Clicking the Shadow Clipping Triangle (**Figure 5.18**) shows a blue overlay to indicate exactly where the shadows have lost detail.

Figure 5.17
Decreasing the Blacks to –30 and increasing the Whites to +20.

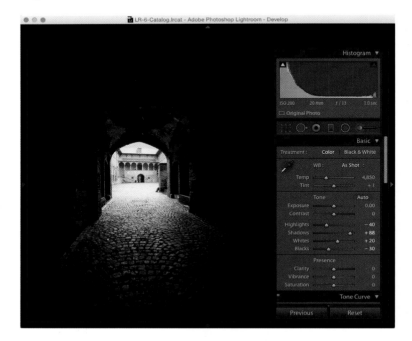

Figure 5.18
The Shadow clipping warning turned on.

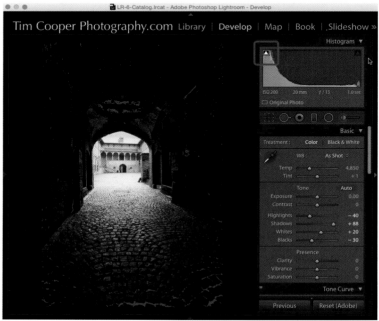

As you can see, this small loss of detail occurs in unimportant areas but does add the pure black necessary for a dynamic image. Local contrast is another consideration when processing your images. Setting a deep black and bright white with the Blacks and Whites sliders sets the overall contrast. Local contrast is controlled by the Contrast slider and the Clarity slider. The Contrast slider increases or decreases contrast in the midtones of the image. The Clarity slider increases or decreases contrast around tight edges. It is similar to sharpening but not as refined. I typically add from 5 to 20 points of clarity on most of my images. Too much, however, gives your images that crunchy look. **Figure 5.19** shows the final image after adding +5 Contrast and +16 Clarity to increase the local contrast. I also used the Local Adjustment Brush tool to lower the contrast in the courtyard. Highlights in an image (especially those at a distance) should be lower in contrast and saturation than midtones and shadows. This helps keep the sense of reality.

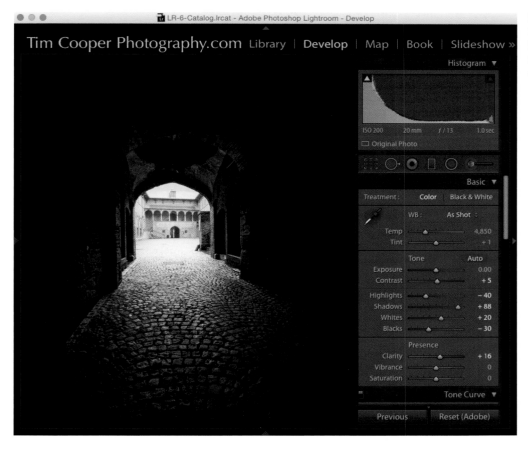

Figure 5.19
Final image after increasing Contrast to +5 and Clarity to +16.

Using Photoshop and Lightroom together to blend and process images is a powerful way to capture high dynamic range scenes. The Photoshop portion of the workflow is effortless, and the adjustments back in Lightroom are intuitive. So why then would you need anything else? A couple of answers come to mind. First and foremost, the deghosting function in Lightroom's Photo Merge > HDR function does not work as well as I would like.

Figure 5.20 shows a comparison of the image from Figure 5.6. The same series of images were merged in Lightroom and Photomatix. The enlargement on the left, showing obvious artifacts, was blended using Lightroom. The clean image on the right was blended with Photomatix Pro. In both cases, I had fixed chromatic aberration before merging. The Lightroom merge was the best choice from a series where I had tried Low, Medium, High, and None for deghosting.

Figure 5.20
Photomatix Pro (right) is better at reducing ghosting artifacts.

The second reason to use Photomatix Pro is the ability to adjust the tonality of photos in Lightroom *before* they are merged. This ability allows for an unprecedented amount of control over the final image. When either of these considerations becomes an issue, I turn to Photomatix Pro.

Photomatix Pro

Whether you are using Lightroom or Photomatix Pro, the first step to creating realistic HDR imagery is capturing the right images. Keeping an eye on your histogram while shooting is critical. Remember that it is better to return with more images than necessary. It's easy to delete or not use a file, but much harder to create an HDR with images that lack the necessary detail.

Like Lightroom, Photomatix aligns and merges images into a 32-bit file. Whereas Lightroom returns a RAW file, Photomatix returns a 16-bit TIFF, which contains plenty of image information to continue adjusting your photograph in Lightroom.

Unlike Lightroom, Photomatix recognizes tonal adjustments made before merging, allowing for an amazing amount of control over the final product. Photomatix also effectively deghosts an image by allowing you to choose specific areas to target, and it allows you to choose which exposure to use as the source image. Finally, through exposure fusion, Photomatix provides a relatively simple set of controls for you to translate the tones before heading back to Lightroom.

While the controls in exposure fusion are not overly difficult to master, I still have an easier time understanding the intuitive tonal controls of Lightroom. For this reason, my goal for working in Photomatix is to do as little work as possible.

I find that the most realistic images are created when the least amount of adjusting is done in Photomatix. For this to happen, you have to upload the proper exposures. **Figure 5.21** shows a series ready to be exported to Photomatix. **Figure 5.22** shows the image in Photomatix with the default exposure fusion settings. Notice that the image appears too bright? The shadow parts of the scene should have some deep black in them, and the sky is overly bright as well.

Figure 5.21
Images ready
to export to
Photomatix.

Figure 5.22
The images blended
with the default
exposure fusion
settings.

When you load the correct images into Photomatix, the exposure fusion option should present a fairly good image at its default settings. The brightest image in that series was simply unnecessary. When faced with an image that is not close, I simply close Photomatix and return to Lightroom. Then I load up the same series, but without the brightest image. **Figure 5.23** shows the image in Photomatix without the brightest exposure. This photograph needed only two images to cover the range. This image appears more natural, with darker shadows and good highlight detail. Whether choosing the correct images to export to Photomatix or adjusting the images in Lightroom before exporting, the proper series makes your time in Photomatix effortless.

Figure 5.23
Removing the brightest image from the series results in a more realistic blend.

Exporting to Photomatix

1. In Lightroom's Library module, select the series of images to be processed.

2. Choose File > Plug-In Extras > Export to Photomatix Pro. (You can also right-click any image in the series and choose Export > Photomatix Pro.)

Photomatix launches and begins the merging process.

Photomatix settings

When Photomatix launches, a dialog appears that controls how the images will be merged and how they will be exported back to Lightroom (**Figure 5.24**). Starting at the top of the box:

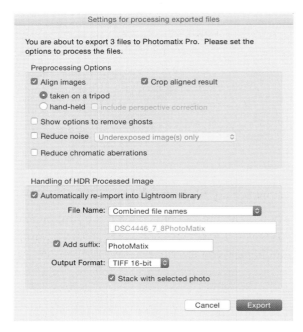

Figure 5.24 **Photomatix processing dialog.**

- **Align Images.** This checkbox should be selected for proper alignment. If you were using a tripod while capturing the images, click the Taken on a Tripod option. Click the Hand-Held option if you were holding the camera.

- **Select the Crop Aligned Result checkbox.** This will leave your images with nice clean borders if the alignment was slightly off.

- **Show Options to Remove Ghosts.** This feature allows you to selectively remove ghosting from your final image. Select this checkbox when you have a subject that moves in between exposures, resulting in a different location in each frame. If nothing was moving in your frame, leave it unselected.

- **Reduce Noise.** When this box is selected, Photomatix will attempt to reduce the amount of noise in your final image. My experience leads me to shoot with a tripod at low ISOs (whenever possible). In these cases, noise is never a problem, so I leave this box unselected. If you have captured images at higher ISOs, select this checkbox to help alleviate the effects. Experiment with this before creating your masterpiece. Many photographers choose to fix noise in Lightroom or another program before blending into Photomatix.

- **Reduce Chromatic Aberrations.** I fix chromatic aberrations in Lightroom before exporting my images to Photomatix. This saves some processing time. If you have not fixed your chromatic aberrations beforehand, select this checkbox.

- **Automatically Re-Import into Lightroom Library.** Select this checkbox if your images have come from Lightroom. It's a real time-saver. Once finished with your image, it magically appears back in Lightroom.

- **File Name.** I use the default setting here to name my newly created file. Feel free to change it to suit your taste.

- **Output Format.** Your choices here are JPEG (8-bit), TIFF 8-bit, and TIFF 16-bit. Choose TIFF 16-bit. This choice allows for the most leeway in post-processing. Although Photomatix does a great job of translating the tones in an HDR, it is very common to make further adjustments in Lightroom. Working with a 16-bit TIFFs will result in higher image quality.

- **Stack with Selected Photo.** If you like to stack your photos in Lightroom, choose this option.

Tone Mapping and Exposure Fusion

When Photomatix opens, you'll notice the three distinct areas: Adjustments (on the left), Preview (in the center), and Presets (on the right) (**Figure 5.25**). The Preview panel displays your image with the current adjustments. Clicking any of the presets on the right (not recommended) applies a preset series of adjustments to your image. While some of these may be tempting, you are better served learning how to manually adjust your images. The Adjustments panel is where you will translate the tones into your final image.

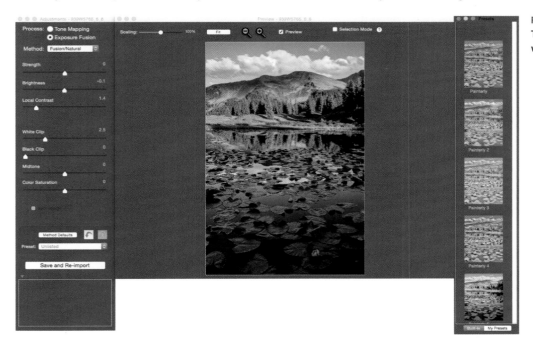

Figure 5.25
The Photomatix work environment.

You can change the size of the preview image by moving the Scaling slider at the top of the Preview panel. Clicking the Fit button enlarges the image to fit on your screen. I often find it helpful to view a histogram as I adjust my images; to do so, choose View > 8-Bit Histogram.

At the top of the Adjustments panel you see the two primary ways to translate your tones in Photomatix: tone mapping and exposure fusion. Tone mapping is very powerful but also notoriously difficult to control. Once mastered, this powerful process can produce all manner of creative results. But it can be challenging to create natural-looking images using this method. Exposure fusion, on the other hand, lends itself nicely to creating realistic imagery. Simple adjustments and a different processing engine make this the choice of those looking to re-create the look of traditional imagery.

Begin by clicking the Exposure Fusion radio button. From the Method menu, choose Fusion/Natural. This presents the options you see in **Figure 5.26**.

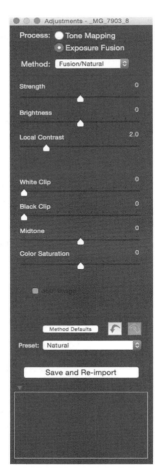

Figure 5.26 **Exposure fusion processing sliders.**

- **Strength**—This slider adjusts the strength of all sliders below it. In many cases, simply adjusting this slider is all you need to produce the desired result. Other times, you'll need to adjust the other sliders first and then return to Strength to fine-tune the image. Moving it to the right tends to brighten the shadows and provide more detail in the highlights.

- **Brightness**—This slider chooses which image(s) will have more influence over the final merge. Moving this slider to the right lets the brighter image(s) have more influence, whereas moving to the left lets the darker image(s) exert more influence.

- **Local Contrast**—This slider controls contrast in between tones that are very close together. This is the slider that enhances texture in your photos. Less is more. Too much, and your images begin to look fake.

- **White Clip**—This controls the brightest tones in the photograph. By raising this slider, you will make your whites brighter and increase overall contrast in the image.

- **Black Clip**—Controls the darkest parts of the photograph. By raising this slider, you will make your blacks blacker and increase the overall contrast of the image.

- **Midtone**—This slider adjusts midtone brightness. Moving it to the right brightens the midtones and decreases contrast. Moving left darkens the midtones and increases contrast.

- **Color Saturation**—This does just what you think it will do: increase color saturation. I prefer to leave this alone or make minimal adjustments. Saturation can be controlled more accurately in Lightroom.

- **360° image checkbox**—Keep unselected. This is used to eliminate the seam in panoramic images viewed in a panoramic viewer. It's not for individual frames or for basic HDR work.

- **Method Defaults**—This button resets the sliders to their default positions.

- **Preset menu**—This allows you to choose from some of the presets on the right, but also allows you to save your current settings as a preset or apply other presets that you have saved during other sessions.

- **Save and Re-import button**—This function applies the above changes to the file, converts it to a 16-bit TIFF, and reimports it back into Lightroom.

Unlike when you work with Photoshop, in Photomatix you are actually translating the tones. Photoshop is outputting a 32-bit file that you'll adjust in Lightroom; Photomatix is outputting a 16-bit file. Both programs have something in common, though: the resulting images will still need to be adjusted in Lightroom. For the 32-bit Photoshop file, *all* of the adjusting will be done in Lightroom. For the 16-bit Photomatix file, *some* of the adjustments will be done in Lightroom. As mentioned, I try to do as little work as possible in Photomatix. If I am unable to quickly achieve decent tonalities, I close out the image, readjust the necessary images in Lightroom, and reimport them for another attempt.

Missing HDR images

If you happen to select and export your images while in the Previous Import section (**Figure 5.27**) of Lightroom's Library module, you will not see your HDR image when you return. Photomatix will return the finished image back to the folder from which it came. The Previous Import section simply shows you the last images that were imported; it does not necessarily show you the contents of a folder. To locate the new HDR image, right-click a photo in the series that you just exported, and choose Go to Folder in Library. You will be taken to the folder and will see your HDR image among your series of images.

Figure 5.27 The Previous Import view in Lightroom's Library module.

Let's take a look a few examples. **Figure 5.28** shows four images ready to export to Photomatix. The histograms show that this series should make an easy blend. The right image shows good shadow detail. The two middle images are the intermediate images one stop apart, and the left image shows the shadows clipped but the highlights looking good. **Figure 5.29** shows the image with the exposure fusion defaults. While not a bad blend, the image appears a little dark. Note the histogram in the lower-left corner. Typically my first adjustment is to slide the Strength slider all the way to the right. This brightens up the shadows somewhat, but not quite enough. Then I move the Midtone slider up to 2.9. This helps brighten the shadows but leaves the image a little low in contrast. Next, I raise the Black Clip slider to 2.1 to bring back a deep black. **Figure 5.30** shows the final image. The increase in the Strength and Midtone sliders has pulled the brightness of the shadows, and the increase in the Black Clip slider anchors the deep black. These adjustments, however, have not significantly altered the brighter tones of the photo.

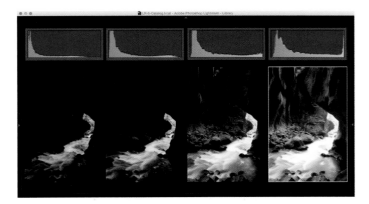

Figure 5.28
Images ready to export
to Photomatix.

Figure 5.29
The resulting blend with
exposure fusion defaults.

Figure 5.30
Increasing the Strength
and Midtone sliders
brightens the shadows
while marginally affect-
ing the highlights.
A deep black is anchored
with an increase in the
Black Clip slider.

This deep canyon at dusk required five exposures to capture the detail in the deep shadows and in the bright, sunlit clouds. In **Figure 5.31**, you see the darkest image displaying good highlight detail and the lightest image showing good shadow detail. **Figure 5.32** shows the default image with bright shadows but with no highlight detail in the clouds.

Figure 5.31
Good histograms on the brightest and darkest exposures.

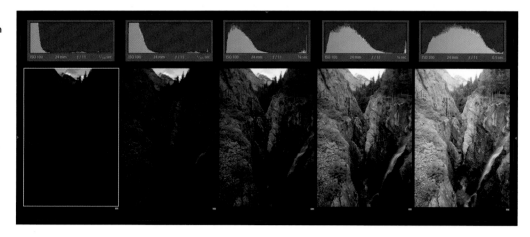

Figure 3.32
The resulting blend with exposure fusion defaults.

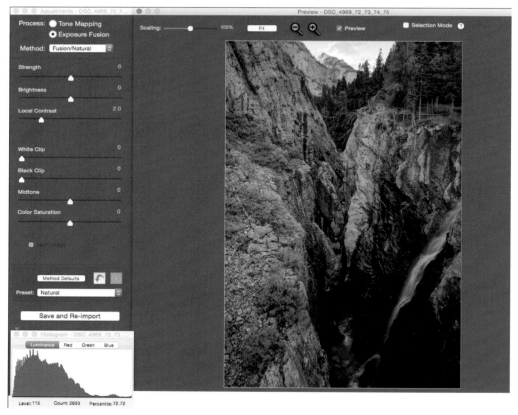

Increasing the Strength slider will not help in this case, as it will mostly brighten the shadows. My first step was to decrease the Brightness and Midtone sliders to attempt some highlight recovery. **Figure 5.33** shows that the shadows have darkened appreciably, but the highlights are still blown out. If I decrease the Midtone or Brightness sliders any more, I will begin to lose detail there as well. As mentioned, Photomatix's exposure fusion is not as powerful as its tone mapping. This is a perfect example of how you can sometimes get the right exposures in the camera but still be unable to pull out the tones in exposure fusion. Exposure fusion is the more realistic method of blending, however. For this reason, I found that the best solution for this photo was to close out the image and adjust the RAW files in Lightroom.

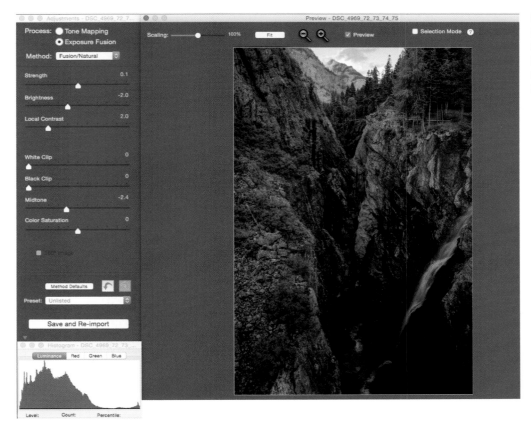

Figure 5.33
Lowering the Brightness and Midtone sliders to try to retrieve highlight detail.

Selecting the darkest image in Lightroom, I reduced the Whites slider to –100. I then moved to the next darkest image and reduced the Highlights slider to –50. This made the highlights darker than I would like but will work well for the blend. **Figure 5.34** shows the result of the new blend after lowering the Midtone slider to –5.9.

Figure 5.34
The final image after readjusting the RAW files in Lightroom and reimporting into Photomatix.

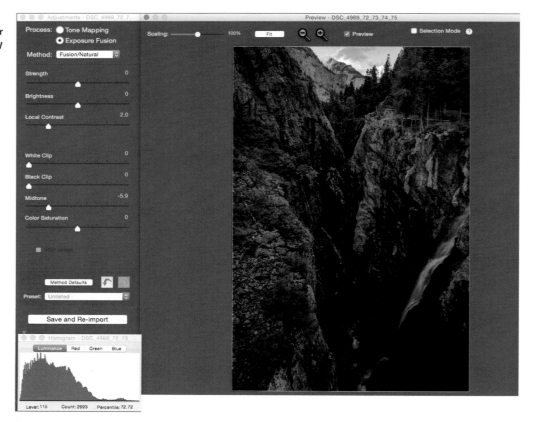

Preadjusting RAW images can accomplish more than just correction. You can decrease saturation on lighter images while increasing saturation on the darker images. This helps give the highlights the feeling of older film. Decreasing the clarity of the lighter images while increasing that of the darker images can also lend an air of realism to your images.

In **Figure 5.35**, I have blended the images without any preadjustments. While the tones are acceptable, the sky is low in saturation and suffers from a pink/gray cast. I immediately closed out of the image and returned to Lightroom. There I selected the brighter images and moved the Temperature slider toward blue. I then went to the HSL panel and increased the blue saturation. This made the brighter tones of the sky a more saturated blue. For the darker images I pushed the Temperature slider toward yellow, increasing the warmth in the rocks.

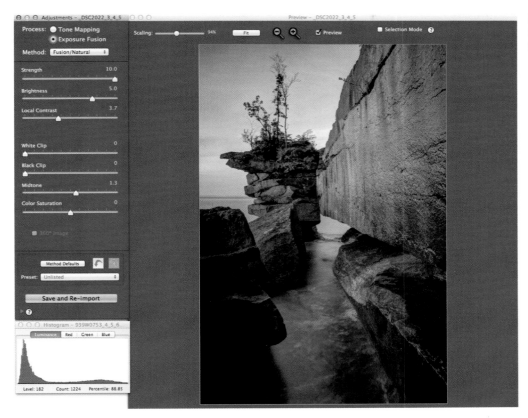

Figure 5.35
Initial blend of six images.

Figure 5.36 is the result of the blended images using exposure fusion. Experiment with the preadjustments. In this example, the subtle changes made to the RAW images increase the color separation without overly saturating the image.

Figure 5.36
Final blend after preadjusting the RAW images.

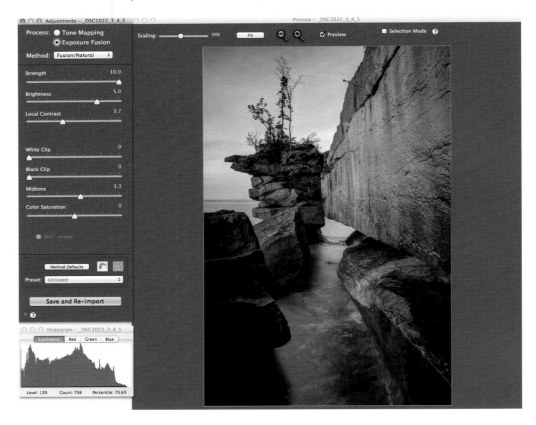

The ability to preadjust images before exporting to Photomatix is an overlooked and powerful technique that can really help you fine-tune your imagery. The other very powerful tool in Photomatix is the ability to selectively deghost an image.

Deghosting

Ghosting is caused when a subject moves in between exposures. This can be a person walking through the frame as you make your exposures, clouds moving across the sky, or moving traffic. **Figure 5.37** shows a series of images in which the chefs have moved in between shots. If left untreated, each image would overlay another, creating a ghosted look in the final blend. This type of scenario can cause real problems for HDR software. I have found that many of the "auto deghosting" features do not live up to their claims.

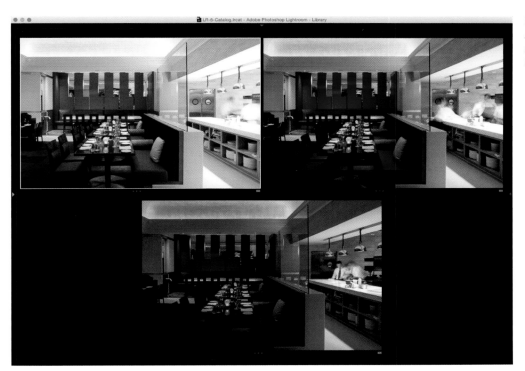

Figure 5.37
A series showing a
subject moving in
between exposures.

I have, however, had great success with
the selective deghosting feature in
Photomatix. To engage this feature, select
the Show Options to Remove Ghosts
checkbox in the initial processing dialog
(**Figure 5.38**). When this box is selected,
you will be met with an intermediary
dialog (**Figure 5.39** on the following page)
before getting to the primary workspace.

Figure 5.38
Selecting the Show
Options To Remove
Ghosts checkbox.

Figure 5.39 **The Deghosting Options dialog.**

In the Deghosting Options dialog, choose Selective Deghosting at the top left. Just below, you'll find links to tutorials that you may find helpful, although the directions below are straightforward.

Working with the Deghosting Options dialog

1. The first step instructs you to "Drag your mouse over the image to select a ghosted region." This should say drag your mouse around the area that needs to be deghosted. In Figure 5.39, you can see the selection that I have drawn around the chefs. Be sure to encircle the whole area without including too much area that has no movement.

2. Once you have enclosed your circle, right-click (Windows) or Control-click (Mac) inside the selected area to mark it as ghosted. Click the Preview Deghosting button to get a preview of the results.

 Don't worry about the tonality and color of your image at this point, as it may look a little off. Simply inspect the region for ghosts. For the most part, you'll find that Photomatix has done a good job removing them. If not, right-click (Windows) or Control-click (Mac) inside the circle and try again. Your choice is to remove the

selection and make another selection or choose another image for the deghosting process. Photomatix usually chooses a good exposure to use, but sometimes a darker or lighter version may work better.

3. When satisfied, click OK.

Your deghosted image is now ready for final blending (**Figure 5.40**).

Figure 5.40 **The image after deghosting.**

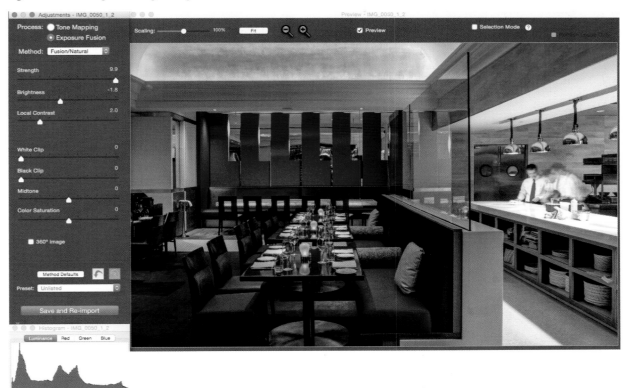

Black and white images benefit from HDR just as much as color photographs. For **Figure 6.41** I blended three exposures together using Lightrooms Photo Merge > HDR. Typically with moving subjects such as the clouds, you would want to choose some amount of deghosting. If you are careful to shoot your images fast enough however, this becomes unnecessary. Before taking the first exposure, I calculated the range and decided on the exposures of 1/8 of a sec., 1/15 of a sec., and 1/30 of a sec. Next I set my camera to auto-bracket, and high speed continuous release mode. This meant the images where shot in a quick succession when held down my shutter release.

I find that when shooting moving water I rarely need to deghost. The resulting waterfall here looks natural to my eye. If your water begins to take on an unnatural look, return with the same exposures and re blend the images.

Figure 5.41
The moving water of the three exposures blend together to create a natural look. No deghosting was used.

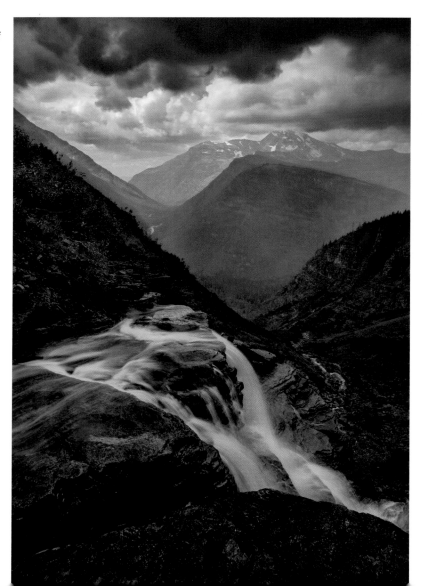

Chapter 5 Assignments

Creating a realistic HDR photo largely depends on your ability to analyze a scene and translate your impressions into a photograph. We have seen that our eyes perceive things much differently than the camera. Learn to study your subject and become familiar with tonalities, contrast, and color. The art world changed forever when observant painters began adding color into shadows rather than just using black. These exercises will help guide your hand while you are creating your HDR images.

Experiment with the software

Don't be afraid to play. While subtlety is always appreciated, moving the sliders in big jumps to watch the effect can be very instructive.

Experiment with contrast

Distant subjects have less contrast than subjects nearer the camera. HDR programs and Lightroom give us the ability to completely control contrast, so it's tempting to make all subjects equally high in contrast. Allow items in the distance to be somewhat lower in contrast.

Avoid too much Local Contrast

Local Contrast in Photomatix (called Clarity in Lightroom) brings out the texture. When applied with a heavy hand, it has the effect of overwhelming the viewer. Far better to apply this in specific areas rather than across the entire image.

Don't be afraid of deep blacks

Most images that are to be blended into an HDR will usually benefit from a deep black somewhere in the scene. Scenes that don't have a deep black appear low in contrast and lack punch.

Share your results with the book's Flickr group!
Join the group here: www.flickr.com/groups/hdr_fromsnapshotstogreatshots/

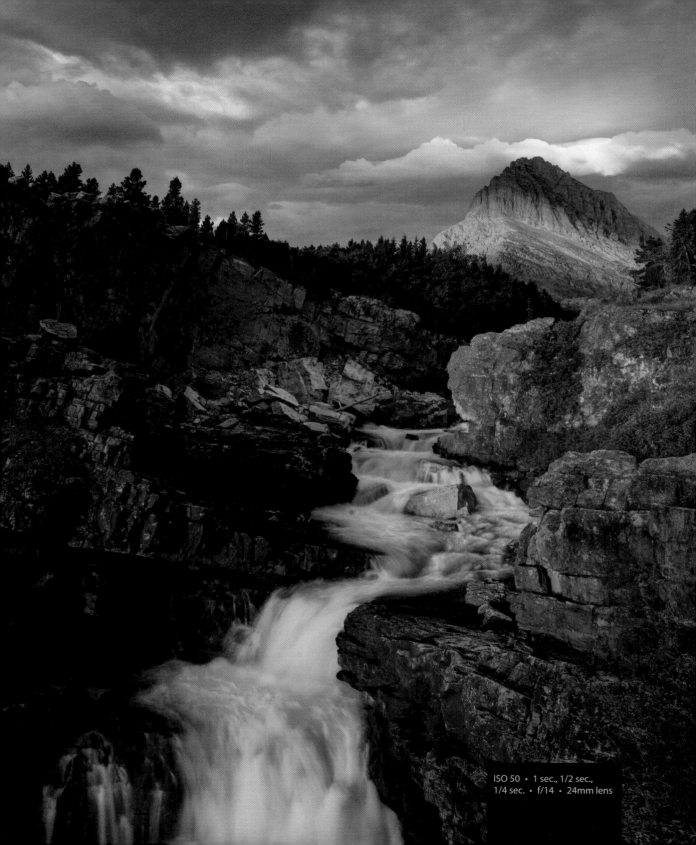

ISO 50 • 1 sec., 1/2 sec.,
1/4 sec. • f/14 • 24mm lens

6

Landscape Photography

Photographing Our Natural World

Mountains, forests, deserts, oceans, and plains—the natural world provides endless opportunity for the outdoor photographer. Unforgettable experiences and treasured photographs await those who like to escape the confinement of four walls. The trick to capturing the beauty of nature is timing. In this chapter, we'll cover the tools and techniques to bring home photographs that last a lifetime.

I blended the images in Photomatix and used selective deghosting for the sky and sun.

A 10-stop neutral density filter allowed a slow shutter speed of 15 seconds.

ISO 100 • 2 sec., 4 sec., 8 sec., 15 sec. • f/11 • 24mm lens

The aperture of f/11 created a star from the sun.

On the west side of the Big Island of Hawaii, it's not uncommon for the sun to rise into a thin blanket of volcanic fog. This "vog," as it's called, creates a beautifully warm and diffuse light. For this image I wanted the rising sun to become a star as it crested Mauna Loa, so I used an aperture of f/11. Smaller f-stops, such as 11 or 16, provide a better star formation than larger f-stops, such as 4 or 5.6. The long shutter speed of 15 seconds allowed the ocean to flow in and out, creating the ethereal motion in the water.

The small aperture provided enough depth of field for the scene to be sharp from front to back.

After blending the images, I lowered the contrast in the sky so that it would not overpower the sunrays below.

The original images were shot and blended in color; I turned them into black and white using Google's Silver Efex Pro.

ISO 100 · 1/60 sec., 1/125 sec., 1/250 sec. · f/11 · 70mm lens

Fast shutter speeds kept the movement between shots to a minimum. No deghosting was needed.

Getting to know an area and its weather helps you predict the best times for shooting. After many years of visiting Glacier National Park, I noticed a tendency for crepuscular rays to form in the late afternoon. Whenever possible, I positioned myself in areas that allowed me to create a good composition. After many attempts, I finally captured the image I had always imagined.

Knowing your subject helps you predict certain phenomenon. These sunrays are not uncommon in the late afternoon in Glacier National Park.

Equipment Considerations

Although your camera and lenses are the most important parts of any system, we learned back in Chapter 2 that tripods and cable releases are also vital to the HDR photographer. They allow us to use longer shutter speeds for dim-light situations, and they permit the use of slower ISOs for higher image quality. They also promote more thoughtful composition and ensure that the separate exposures are properly aligned for better registration in the HDR software. All HDR photography shares these tools, but each photographic discipline has its own unique requirements.

Lenses

Landscape and nature photographers need a wide array of lenses to capture the phenomena and beauty of the natural world. For a complete system, I recommend having lenses that span the three basic focal ranges: wide, normal, and telephoto. A chart in Chapter 2 displays the focal ranges for both full-frame and APS-C cameras. The great masters of landscape photography have left us with a legacy of quality craftsmanship. To keep this tradition, it's necessary to use above-average lenses.

There are two ways to accomplish this. First, only purchase lenses that cover one or two focal ranges. For example, an 18–300mm is a very convenient lens that covers wide, normal, and telephoto. Although not as convenient, an 18–35mm lens covering only two focal ranges—wide and normal—will be sharper. The second way is to purchase the more expensive of two similar options. You can buy a 70–300mm f/4.–5.6 lens for $590. A comparable (but shorter) focal range of 70–200mm f/2.8 will provide a much sharper image but costs over $2,000. This is not to say that you need to break the bank on all your lenses, but be aware that quality increases with price.

Filters

In the days before digital cameras, the outdoor photographer needed to carry a stack of filters to change color, reduce contrast, and increase saturation. Now you can lighten your load by carrying only two basic filters: polarizers and neutral density filters. Like lenses, good filters are necessary to provide a sharp image. I recommend using multi-coated (MC or MRC) filters whenever possible to reduce flare and image ghosting. **Figure 6.1** shows the multi-coated designation.

Figure 6.1 **The multi-coated designation**

Non-coated and single-coated filters do not provide the same level of quality. Although they don't contribute to the quality of the image, filters that are constructed of brass rather than aluminum will last longer and are less likely to bind.

The polarizing filter is the workhorse of outdoor photography. It darkens blue skies, removes reflections, and reduces glare to increase contrast and saturation. For these reasons, when working outdoors, I use this filter about 80 percent of the time! It almost always provides a beneficial change.

Using the polarizer is quite simple. Just screw it onto the front of your lens and rotate the front element. As you rotate the filter, you'll see the changes through the viewfinder or on the rear LCD in Live View. It's just that simple. It's a WYSIWYG filter: what you see is what you get.

Figure 6.2 shows the effect of using the polarizer to darken blue skies. With the sun on your shoulder, you can darken the sky in front of you and behind you. You cannot darken the blue sky when looking directly into the sun or when the sun is directly behind you. You also cannot darken an overcast sky or hazy white sky. It must be blue for the polarizer to darken it. As you can see, darkening the blue sky helps bring out the contrast between the sky and the clouds.

Figure 6.2 With the sun on my right shoulder, I was able to darken the blue sky using a circular polarizer.

The two images in **Figure 6.3** show a before and after using the polarizer. The water on the lily pads in the first image reflects the white overcast sky. The second image shows how efficiently the polarizer can remove reflection.

Figure 6.3 **The polarizer can be very effective at removing reflection.**

Reflections can also occur without water or glass. **Figure 6.4** demonstrates how the polarizer increases saturation by removing glare from vegetation. The angle to the sun is not an issue when removing glare to increase saturation. The polarizer will not be as effective, however, if you are not at a good angle to the subject. Remember that if you spin the polarizer and see no effect, you will not get any from that particular angle. In those cases, you must weigh your composition against the effects of the polarizer.

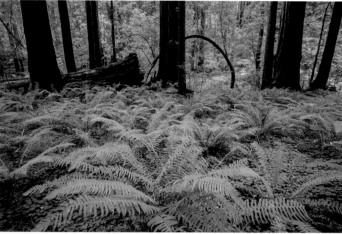

Figure 6.4 **The polarizer increases saturation by removing glare from shiny subject matter.**

Because polarizers block about two stops of light, I recommend removing the filter when you're seeing no appreciable effect. Modern cameras require the use of a circular polarizer as opposed to the linear polarizer that was sufficient for older manual-focus cameras. The polarizer in Figure 6.1 shows the circular designation as well as the multi-coated designation.

The other type of filter I like to carry is the neutral density (ND) filter. The only job of the neutral density filters is to block light. Because landscape photographers prefer smaller apertures, using longer shutter speeds is the primary reason we want to block light. Longer shutter speeds capture the subtle or unsubtle movement in our natural world. Rivers, streams, oceans, and clouds can all produce an ethereal look over long exposures.

Neutral density filters come in fixed strengths as well as variable strengths. Typical fixed strengths are 0.3 (1-stop), 0.6 (2-stop), and 0.9 (3-stop). The polarizer you already own blocks two stops of light and can be employed to extend the shutter speed, so I find these common strengths to be less than useful. You'll achieve much longer shutter speeds with a 1.8 (6-stop) or 3.0 (10-stop) ND filter. The variable filters are more expensive but provide you with a range of densities, such as 1–5 stops, 2–8 stops, or 2–10 stops. Simply rotate the front element of the variable ND filter to change the density and thus your shutter speed. These filters are very convenient when you're attempting to use a very specific shutter speed. I use a Tiffen 2–8-stop variable filter when the light is lower and a B+W 3.0 (10-stop) fixed filter for darker scenes.

In **Figure 6.5**, I used a 10-stop neutral density filter to alter the motion in the scene. Shooting into the rising sun typically calls for faster shutter speeds that tend to stop the action of the waves. I had envisioned the ocean looking like more like a floating cloud rather than broken waves. I set my exposure to 15 seconds at f/11 to render the water like cotton candy. The second exposure of 8 seconds rendered the sky properly. In Lightroom, before I blended the exposures, I increased the yellow and magenta white balance in the underexposed image to warm up the water and match the sky. During the blend, I used the Selective Deghosting feature in Photomatix; I selected the whole sky and chose the darker image as the source image to preventing ghosting in the sun and sky. I also brightened the shadows on the darker image prior to blending in Photomatix.

Figure 6.5
I used a 10-stop neutral density filter to achieve a 15-second exposure.

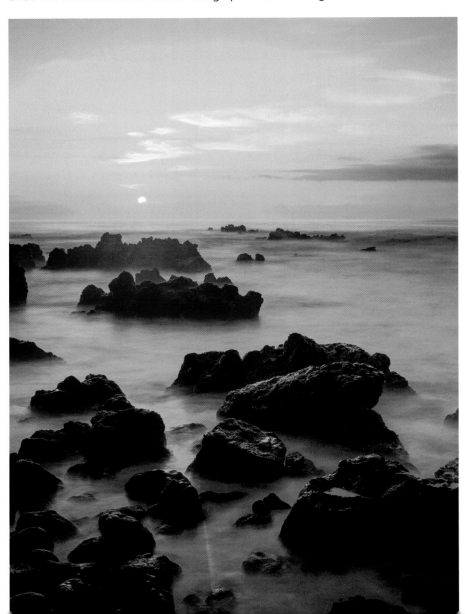

Avoid Light Leaks

Variable ND filters operate best within a range marked on the filters. Spinning the filter outside this range produces uneven lighting across the frame. During long exposures in brighter conditions, light may leak through the viewfinder and discolor or overexpose parts of your frame. Closing the eyepiece cover will eliminate the leak (**Figure 6.6**). If your camera doesn't have an eyepiece cover, simply shade the back of the camera or use your hand to cover the eyepiece.

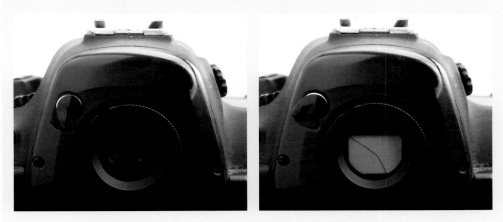

Figure 6.6 **Closing the eyepiece restricts light from entering the viewfinder during long exposures.**

Accessories

Here are few accessories that I can't do without.

Viewing loupe

Bright sunlight on the back of the camera can make it difficult or even impossible to review your images and histogram. The solution? Use a loupe. Hoodman came up with an elegant light-blocking solution (**Figure 6.7**). The rear eyepiece even rotates to adjust for different vision!

Figure 6.7 **The Hoodman viewing loupe allows you to see the rear LCD in bright conditions.**

Multi-tool

It's always disappointing to have gear break when you're miles from your car and the light is perfect. Carrying a multi-tool such as a Leatherman or Swiss army knife can make simple repairs possible. Remember to take it out of your camera bag while flying—I have lost more than one multi-tool to airport security. If your tripod or tripod head has uncommon fasteners, be sure to store the dedicated tool in your camera bag as well.

PhotoPills app

If you have an iPhone you'll love this app. It's a great photo planner that gives you incredible amounts of information on exposure, depth of field, time lapse, and sun and moon times, as well as tools to plan your star shots (**Figure 6.8**). Well worth the $10.

Figure 6.8
PhotoPills is a must-have multi-use app for the iPhone.

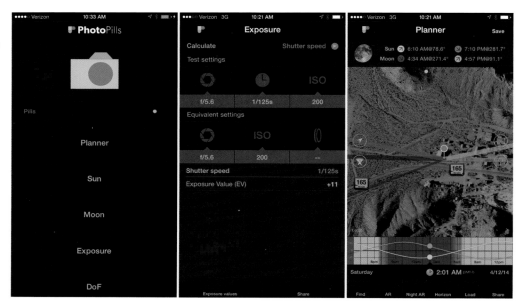

DOFMaster app

Achieving sufficient depth of field in a landscape photograph has always been challenging. Where do you focus? Which aperture to choose? DOFMaster is a depth of field calculator that is super easy to use and very accurate. It's available for both iOS and Android, and once it's downloaded it does not need phone service to operate. It's an essential tool for the landscape photographer. I go over the specifics of DOFMaster later in the chapter.

Camera Settings

Whether you're shooting landscapes, cityscapes, dusk, dawn, or interiors, most camera settings for HDR photography are remarkably similar. There are, of course, exceptions for different disciplines. Here are some of the items I pay close attention to while photographing in the field.

White balance

White balance (WB) controls color cast in your final photograph. While the camera has many WB options, the outdoor or landscape photographer needs but a few. The light outdoors is fairly predictable. The sun rises with warmth, cools off to a neutral clean white light in the afternoon, and sets again with fiery reds and yellows. When the days are overcast, the light has a slight blue cast. When there is no sun shining on the scene and the only source of illumination is the blue sky overhead, the light is very blue.

These types of situations make it easy to set the camera's WB. The Daylight/Direct Sun setting should be used whenever the sun is illuminating your subject (**Figure 6.9**). It should also be used at sunrise and sunset to retain the natural warmth that occurs at this time of day (**Figure 6.10**).

Figure 6.9
The Daylight/Direct Sun setting accurately portrays midday colors.

Figure 6.10
The Daylight/Direct Sun setting also captures the warm hues of the setting sun.

Using Auto white balance will alter and usually ruin the colors in a natural light scene. The image on the left in **Figure 6.11** shows the natural warmth of sunlight filtering through autumn leaves.

Figure 6.11
Daylight/Direct Sun on the left; Auto on the right.

The image on the right is incorrectly "fixed" by using Auto WB. The image on the left in **Figure 6.12** displays the beautiful warmth of a Texas sunset. The image on the right demonstrates how Auto WB drastically changes the colors.

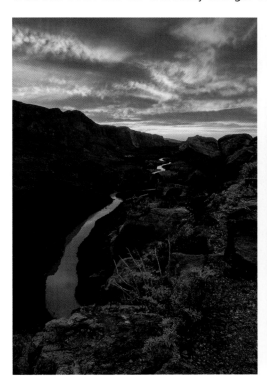 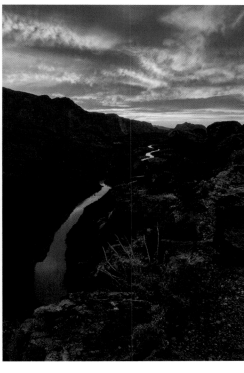

Figure 6.12
Daylight/Direct Sun on the left; Auto on the right.

Figure 6.13 shows how the clouds scatter the sun's rays, producing an excess of blue. The light is warm where the sun comes through, but blue where it is blocked. The color of the underside of these clouds is the same color experienced on an overcast day. Scenes photographed under overcast skies can be fixed by using the Cloudy white balance setting, which essentially adds a yellow cast to cancel out the blue cast. Experiment with this setting, as scenes with cool colors often look better with the Daylight/Direct Sun setting, even on overcast days. Warmer-toned subjects seem to benefit more from the Cloudy setting on overcast days.

The Open Shade/Shade setting adds a warm cast to counter the very blue light that exists when the sky is the main source of illumination. Imagine you are in a deep valley just after sunrise on a clear day. The sun has yet to crest the mountaintop, so the only illumination is the blue sky. The light in this open shade situation is very close to the color of the sky itself. The image on the left in **Figure 6.14** shows an exposure made with the Daylight setting in open shade conditions. The image on the right used the Open Shade/Shade setting.

Figure 6.13
The cool underside of the clouds is the same color cast we experience on a cloudy day.

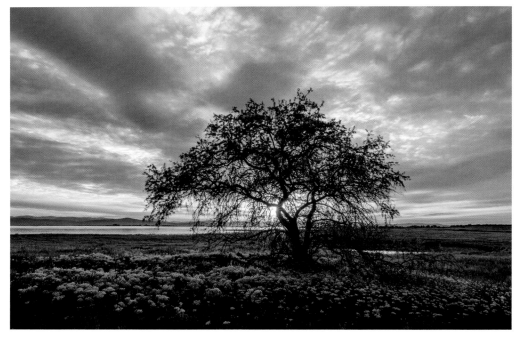

Figure 6.14
Open shade has a very blue cast. Setting the camera's white balance to Shade fixes the cast.

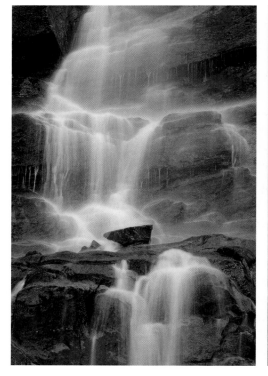

Picture styles

Picture styles (Canon) and picture controls (Nikon) are settings that influence the "flavor" of the resulting image. Before digital cameras, we would choose different films for their various characteristics. When shooting portraits, I would choose a portrait film such as Kodak VPS for its lower saturation and contrast. When shooing landscapes, I would choose Fuji Velvia for its higher contrast and saturation. Modern digital cameras capture only one "flavor": RAW. It's up to us to supply the style to the photograph.

Picture styles/picture controls can be found in your camera's menu system. Typical choices include Camera Landscape, Portrait, Neutral, and Camera Standard. Each will supply a different amount of contrast and saturation to an image. They may also change the way the camera renders certain colors, such as skin tones. The following list is a rough guide to how these settings influence your pictures.

- Neutral—This setting provides the least amount of contrast and saturation.

- Portrait—Provides a moderate amount of saturation; designed to produce balanced skin tones.

- Camera Standard—Slightly higher in contrast and saturation.

- Camera Landscape—Highest in both saturation and contrast.

When shooting JPEGs, it's important to set the correct picture style before shooting, as post-processing should be kept to a minimum. Setting the picture style in-camera will go a long way toward making your images feel more professional. Setting the picture style when shooting in RAW, however, doesn't necessarily ensure that your image will have the same look back on the computer. This is one of those settings that's proprietary, so it isn't picked up by Lightroom. If you download your images through your camera manufacturer's software, the picture style will be applied. If you download your images through Lightroom, it will not recognize the picture style.

When Adobe imports your RAW images, it must interpret them, because Adobe doesn't have access to the entire file. This means that what we are seeing is Adobe's interpretation of our RAW files. Upon import, all RAW files get the Adobe Standard profile, Adobe's standard interpretation of that type of file. Lightroom recognizes the camera your file has come from and offers a list of profiles that match that brand of camera. These can be found by clicking the Profile menu in the Camera Calibration panel (**Figure 6.15**).

Figure 6.15 **Choosing a profile in the Camera Calibration panel.**

I recommend experimenting with these profiles to determine which one best translates your particular image. Each situation is a little different, and your favorite images deserve the time it takes to explore. When you're working with Photomatix, the picture styles will have an outsized influence on the resulting image because Photomatix recognizes and applies all Lightroom settings to the files before blending. Camera Landscape may seem like the appropriate choice for landscape images, but may make it more difficult to create a good blend.

If you are using Lightroom, the profile can be chosen either before or after blending. I wait until the images have been blended before I settle on a profile, and I gravitate toward Camera Landscape and Camera Standard for my landscape images. The increased saturation and contrast complement this type of photography.

Techniques

Creating dimension

One trick to good landscape photography is creating depth. Paintings and photographs can both suffer from trying to depict a three-dimensional world on two-dimensional planes. The result is often flat and not very lifelike. It's up to us, therefore, to create as much depth as possible. One way of doing this is to compose our shots so that they include a foreground, middle ground, and background. This isn't to say that images with only a foreground and background won't work—they can and do. But when given a choice, compose a shot with a middle ground that separates the foreground from the background (**Figures 6.16** and **6.17**).

Figure 6.18 was shot during sunrise in Glacier National Park. Using a 24mm lens, I composed the shot so that the main waterfall was the foreground. The midground is the distant green valley, and the background is the mountains and sun. The first exposure was 1/8 of a second. This gives the waterfalls the cotton-candy look. The following exposures were 1/15, 1/30, 1/60, and 1/125 of a second. Timing can be crucial. It was imperative that I had my camera set and ready to go when the sun crested the mountaintop. After calculating my exposures, I set my camera to Auto-Bracket in High Speed Continuous release mode, ensuring minimal time between exposures. The series was blended in Photomatix using exposure fusion.

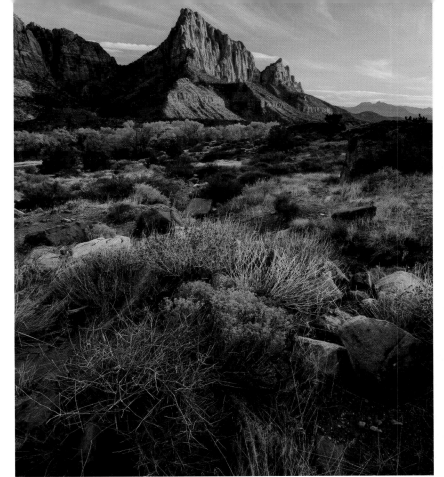

Figure 6.16
This image contains a foreground, middle ground, and background.

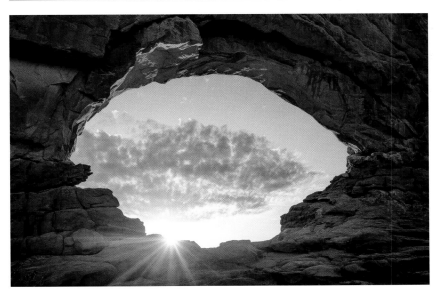

Figure 6.17
This image lacks a middle ground but is still successful.

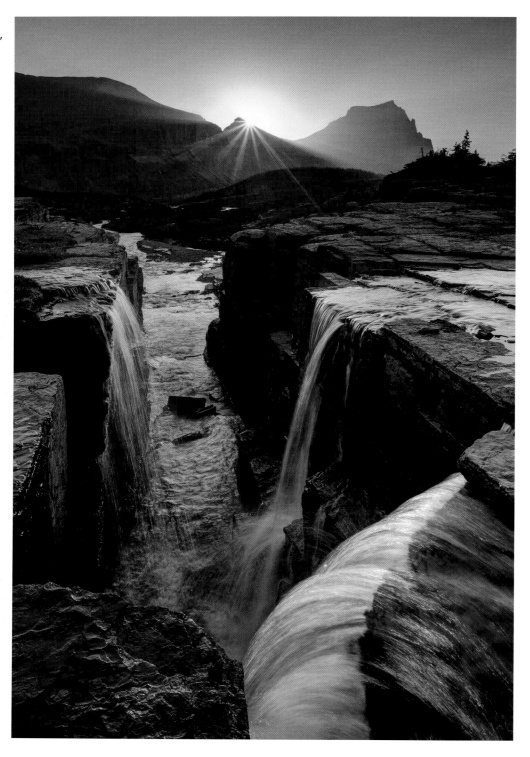

Figure 6.18
Creating foreground, middle ground, and backround

Another classic approach to landscape photography is to use a wide-angle lens and get very close to your subject. Wide-angle lenses make your foreground grow in size, so the closer you get, the larger the foreground elements become (**Figures 6.19** and **6.20**).

Figure 6.19 **Getting close with a 17mm lens enlarges the foreground grasses.**

Figure 6.20 **A 20mm lens 2 feet from the rocks creates a foreground that outsizes the background.**

Depth of field

Depth of field is controlled not just by your aperture but by distance-to-subject and lens length. The shorter the focal length of a lens, the more depth of field it provides. A 14mm lens will give much more depth of field than a 100mm lens. As a landscape photographer using wide lenses, you may think, OK, I can shoot everything at f/8. Not so fast. We saw in Figures 6.19 and 6.20 that getting close to a subject can add depth to a photograph. The problem is that the closer you get to a subject, the less depth of field a lens provides. This means that when you are right on top of your subjects, you will have very little depth of field even if you are using a wide-angle lens. The solution is to focus on the right spot and use the proper aperture.

This is where a depth of field calculator such as DOFMaster becomes imperative. Start by inputting the type of camera you have, the focal length of lens you are using, and the desired aperture. Press the HD button and the app tells you exactly where to focus and how much depth of field you'll get. In **Figure 6.21**, the screen on the right shows that if I focus at 2.27 feet, anything from 1.14 feet (near limit) to infinity will be sharp. The far limit always indicates infinity, although in this case it reads 1388 feet.

Not only does this tool tell us how to get everything sharp, but it also indicates when we can use a larger aperture. Let's take the situation in Figure 6.21 as an example. If my closest subject in this composition is 2 feet away, I don't need to stop down to f/16. I recalculate at f/11 and find that when focused at 3.19 feet, I'll get from 1.6 feet to infinity sharp. This means I can now shoot at f/11 rather than f/16! This allows me to use a faster shutter speed and a sharper aperture closer to the center of my lens.

Figure 6.21
DOFMaster is an easy-to-use and accurate depth of field calculator.

Although the smallest aperture on any lens provides the most depth of field, it doesn't provide the best image quality. Although subjects are technically within the depth of field at f/22, they will have an overall softer quality to them. Photographers looking for the highest quality and maximum depth of field will use the aperture one stop down from the smallest. So if your lens goes to f/22, shoot nothing smaller than f/16. If you can get everything sharp at f/11, shoot at f/11 rather than f/16. It's a sharper aperture. Likewise, choose f/8 if that is all that is needed to get the desired depth of field. Once you begin to get larger than f/8, things start going slightly soft again. **Figure 6.22** is a good example because the closest subject is about 30 feet away; stopping down to f/16 is unnecessary.

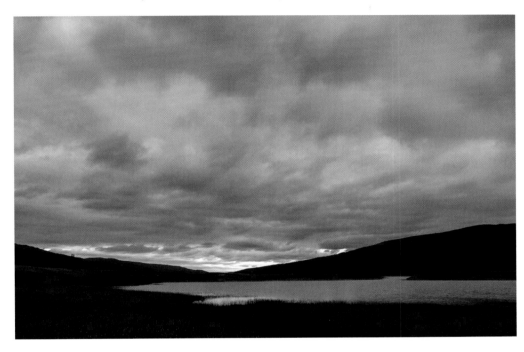

Figure 6.22
An aperture of f/8 provides enough depth of field in this image, where the closest subject is at a distance from the camera.

Clouds

Clouds can make for a dramatic primary subject or even a gentle supporting subject. Whichever the case, care should be taken to include only clouds that make sense with the foreground. It's easy to get caught up in the moment of composing a powerful landscape only to later realize that the clouds actually add nothing to the scene or, even worse, distract from your main subject.

Ensure that you are not just including random clouds because the sky is interesting. Watch the forms of the clouds. Do they complement the foreground or background subject? Perhaps they mimic a shape or the finish of a leading line. Many times you'll

have to wait for the right cloud formations to form. In **Figure 6.23**, I had set up my camera and waited about an hour for these clouds to form. I then carefully composed them to fit within the pond in the foreground. In **Figure 6.24**, I positioned myself so that both the clouds and the stream led to the moon.

Figure 6.23
Clouds carefully composed within the pond.

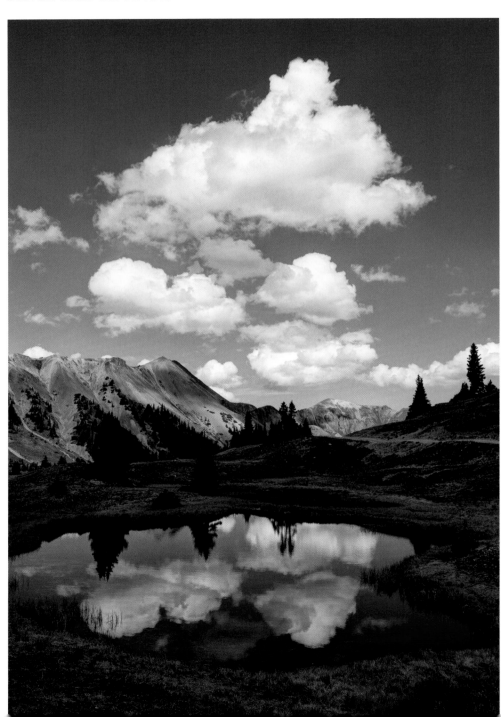

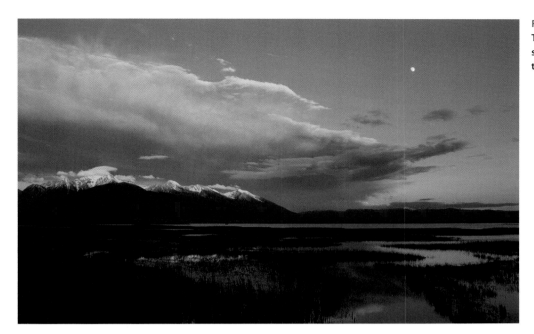

Figure 6.24
The clouds and the stream lead the eye to the moon.

Twilight

Twilight, sunrise, and sunset are some of the most beautiful times of day to shoot. These "magic hours" actually extend for almost three hours on either side of the setting and rising of the sun. When the sun is farther below the horizon, the light is soft, ambient, and lower in contrast. As it rises in the sky, the warm light illuminating the clouds becomes brilliant and saturated. After the sun rises, it bathes our subjects in a beautifully warm and soft light considered by many to be the prime time to shoot landscapes. These subtly different times of day each offer their own magic. They also have their own names: astronomical twilight, nautical twilight, civil twilight, sunrise, and sunset.

Astronomical twilight

As outdoor photographers, we're always concerned with being in the right place at the right time. Understanding the different twilights can help us plan our shoots. About two hours before the sun comes up, we are experiencing a completely dark sky (provided there is no light pollution from nearby cities or towns). This black sky slowly gives way to the rising sun and begins to brighten. The first type of twilight we experience in the morning is called astronomical twilight. This is not a time for typical landscape photography but can be used to shoot star points or star trails. It is, however, a good time marker. It ends about 1 hour and 15 minutes before the sun rises. For planning purposes, it's a good idea to be at your location at the end of astronomical twilight.

Figure 6.25 shows an image created during astronomical twilight. Completely dark at this time of day, an exposure of 15 minutes at f/4 and ISO 200 was necessary to record the stars as they streaked across the sky. Astronomical twilight begins approximately 1 hour and 15 minutes after sunset.

Figure 6.25
An exposure of 15 minutes was necessary to record the light of the stars during astronomical twilight.

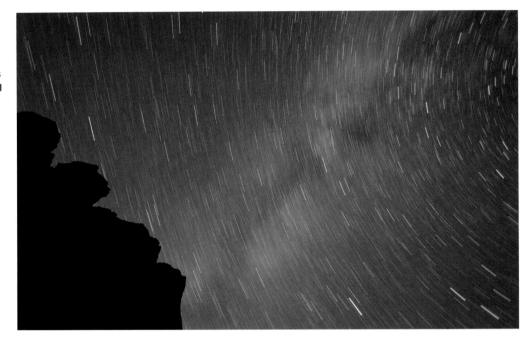

Nautical twilight

As the sky brightens, we change from astronomical twilight to nautical twilight. This is really when it all starts to happen. This twilight occurs approximately an hour before sunrise proper. This is the time to be in the field and ready to go. It's just light enough to walk around, and pre-scouted locations can be found with the help of a flashlight. This time of day was made for the HDR photographer: The sky is somewhat bright, but the foreground is nearly black, and it's impossible to capture both the foreground and the sky in a single exposure. This is also the time to check out the current atmospheric conditions. Are there clouds to the east that may block the sun? Are there clouds to the north or south that may be enhanced by the use of a polarizer? Are the clouds high in the sky? These will get color earlier. Are there lower clouds nearby? Lower clouds will take longer to illuminate and may not receive any light until about 15 minutes before sunrise. Being on location at nautical twilight allows you to assess the current situation and even fine-tune compositions that you have already planned.

Nautical twilight is commonly called the "blue hour" because of the abundance of blue light being scattered across the sky and illuminating the landscape. This time of day can

be a bit lower in contrast than civil twilight, and depending on the subject matter, compositions can sometimes be captured with one exposure. **Figure 6.26** demonstrates this profusion of blue light. This image was created about 40 minutes after sunset, with the sun on my left as I was facing due north. An ISO of 100 and aperture of f/16 was used for this single 30-second exposure.

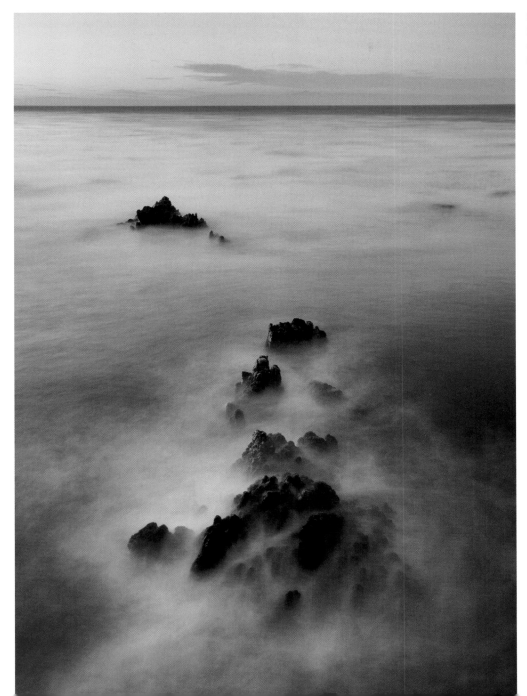

Figure 6.26
Monterey Bay during the blue hour, nautical twilight.

Figure 6.27 shows an example made during the end of nautical twilight in the morning. Arriving at Dead Horse State Park about an hour and a quarter before sunrise allowed me time to scout for a location at this overlook. Approximately 45 minutes before the sunrise, the rock formations began to glow. In this example, the deep canyons and brighter sky made shooting for HDR necessary. I made three exposures of 6 seconds, 3 seconds, and 1.5 seconds at ISO 100. Because I was using a medium-wide lens of 35mm and because the nearest subject was so distant, an aperture of f/8 was sufficient to keep the entire scene sharp. The images were blended using the Fusion/Natural setting in Photomatix.

Figure 6.27
Multiple exposures blended together re-create the glow near the end of nautical twilight.

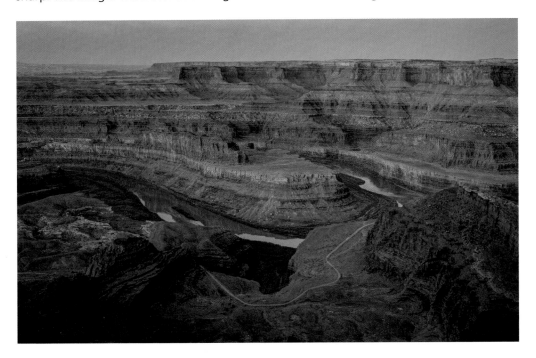

Civil twilight

About half an hour before the sun rises, nautical twilight gives way to civil twilight (reportedly named by the armed services because "civilians" can see unaided at this time of day). Civil twilight is when the clouds really begin to get colorful. If you've ever come back from a shoot thinking you captured an excellent sunrise, chances are you shot an excellent civil twilight. The light changes rapidly at this time of day, so it's best to be prepared before this time arrives. As with nautical twilight, the contrast at this time of day is severe, with very bright skies and dark foregrounds. Multiple exposures are a must!

High clouds begin to see color at the beginning of civil twilight, whereas lower clouds become illuminated toward the end. **Figure 6.28** shows a sunset shot near the end of civil twilight. This image was made on Madeline Island, one of the gorgeous Apostle Islands,

in Wisconsin. Four images were made one stop apart, from 1/30 of a second to a 1/4 of a second. The ISO was 100 and the lens 24mm. Blending the images together in PhotoMatix, I used the Selective Deghosting feature to eliminate movement in the clouds. Although the brightest exposure shows plenty of detail in the shadows, I was careful to keep the shadows quite dark while post-processing in Lightroom. Our eyes recognize this as a scene in which there should be some silhouette. Rendering the foreground much brighter would make the image seem somewhat fake. For this composition I got very low to the ground to make the small rivulet of water seem like a large lagoon. The area of water at the base of the photograph was actually small enough to step across. Having the 24mm lens close to the subject enlarged the water, thereby filling the bottom of the frame with the color of the sky rather than an excess of darker sand. In reality, reflections are typically one stop darker than the subject they are reflecting, so it's important when blending images with reflections to keep the reflection darker than or equal to the subject being reflected.

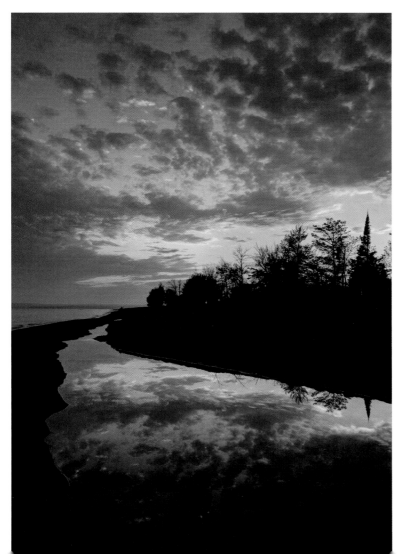

Figure 6.28
Including a reflection fills in the foreground with a lighter subject.

At the height of civil twilight, the clouds can resemble a fire in the sky. The color at this time of day comes from the lack of blue light penetrating the atmosphere. When the sun is just below the horizon, the angle requires the light to travel though much more of the atmosphere than it does in the middle of the day (**Figure 6.29**). This extra atmosphere tends to scatter the shorter blue wavelengths of light so that the longer red wavelengths dominate the color scheme.

Figure 6.29 **Low sun angles mean the light must travel through more of the atmosphere.**

The photograph in **Figure 6.30** demonstrates how the excess of red at sunset influences the color of the clouds. Looking directly into the sunset at this time of day creates scenes with very high dynamic range. Images like this typical "sunset" shot rarely need HDR, however. If the clouds are your main subject, you can make one exposure that's correct for the sky. This, of course, means that your foreground will be pure black, so find interesting landforms and keep the silhouetted foreground to a minimum.

Figure 6.30
Clouds at the height of civil twilight.

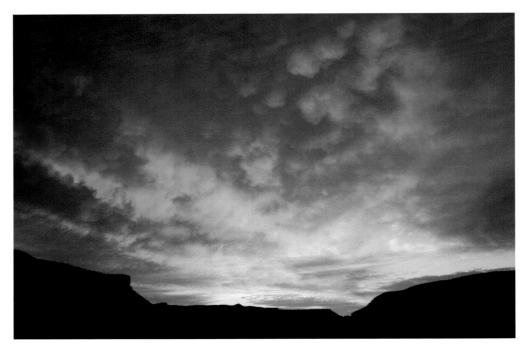

This time of day also produces another type of shot that is often ignored: the landscape illuminated by clouds. **Figure 6.31** shows the landscape that was directly behind me when I was shooting Figure 6.30. The brilliant red and orange of the clouds illuminate Mount Kinesava in Zion National Park. Including the landscape in these conditions means shooting for HDR. This image was made from three exposures blended in Lightroom's Photo Merge to HDR command. I kept the image darker in post-processing to retain the feeling of dusk.

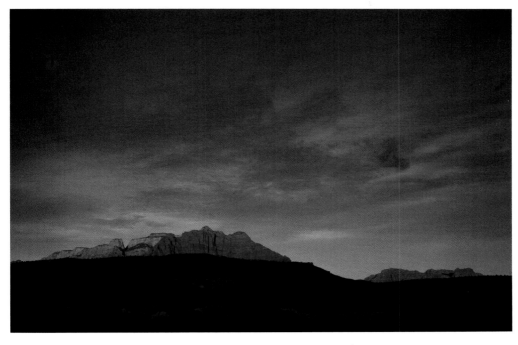

Figure 6.31
The scene that the clouds in Figure 6.30 were illuminating.

Figures 6.32 and **6.33** show a similar example. Once again I was looking right into the clouds during civil twilight. Figure 6.32 required five images to cover the dynamic range. The brightest exposure, to reveal detail in the dunes, rendered the sky pure white. The darkest exposure, to place the sunset clouds into midtone value, rendered the foreground dunes pure black. Blends like this are tricky to keep realistic. In order to make the sky look like sunset, the values need to be middle-toned. Too much brighter and we begin to lose that rich color. But our eyes know that the sky is brighter than the foreground, so we need to keep the foreground somewhat darker. In cases like these, the final blends often end up with oversaturated shadows and highlights. To avoid this, I blend the images thinking mainly of the tonalities, knowing that the colors might be a little off at this stage. Having a bright white in the sky is OK as long as the bulk of the sky looks good. It's also OK if the foreground is a little brighter in the blend, because it can be darkened

in post-processing. In this image, I had to desaturate the distant mountains, which took on an unreal blue color, by using the Adjustment Brush tool in Lightroom. I also used the Adjustment Brush to darken and add contrast to the foreground dune.

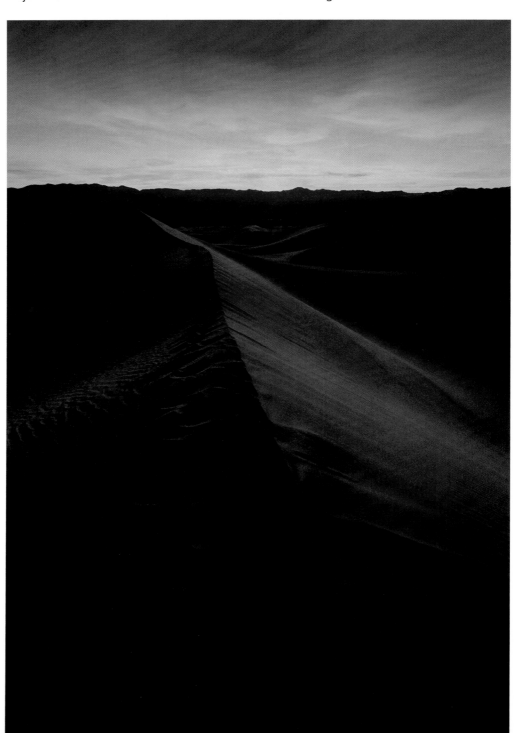

Figure 6.32
Civil twilight on the dunes in Death Valley National Park.

Figure 6.33, shot about 10 minutes after Figure 6.32, shows the view directly behind me. The contrast was somewhat lower at this point, but it still took three exposures to cover the range. A "full" moon is best shot two to three days before the actual full moon. On those days, the moon rises over the landscape before the sun sets over the horizon, which means the landscape and moon are both illuminated by the sun. It also means the dynamic range is much lower. On the day of the full moon, the moon rises well after the sun has set (as it has in Figure 6.33)—the moon is still being illuminated by the sun, but the landscape is not. In other situations this wouldn't be a problem—simply shoot enough exposures to cover the range. The problem here is that the exposures at this time of day are long enough that the moon moves through the frame. Blending the images and deghosting a subject as bright as the moon is very difficult. Instead of trying to get every detail in the moon, I opted for fewer exposures. This meant that the foreground was well exposed but the moon lost its recognizable face. The exposures of 4 seconds, 2 seconds, and 1 second were made with an ISO of 100 at f/8.

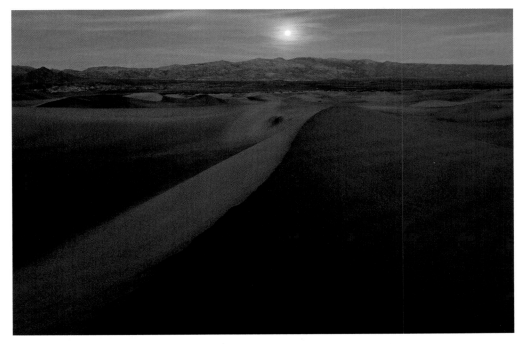

Figure 6.33
Moonrise atop the dunes.

Civil twilight ends when the upper disc of the sun reaches the horizon: sunrise. At that point, depending on the conditions, we have another hour or so of interesting light before the sun becomes too high and begins to flatten out the contrast. And of course, the same twilights happen in reverse at the end of the day: sunset, civil twilight, nautical twilight, and finally astronomical twilight. **Figure 6.34** was made during the last 2 hours of the day, just before sunset. The last hours of the day or the first hours of the morning receive slanting sidelight that enhances shapes and textures. This light is far more interesting than the flat overhead light of midday.

As you can see, knowing the exact time of the different twilights can be very helpful for planning and executing great outdoor photographs. Photographic apps such as PhotoPills or Sun Seeker can make it easy to look up the twilight, sunrise, and sunset times.

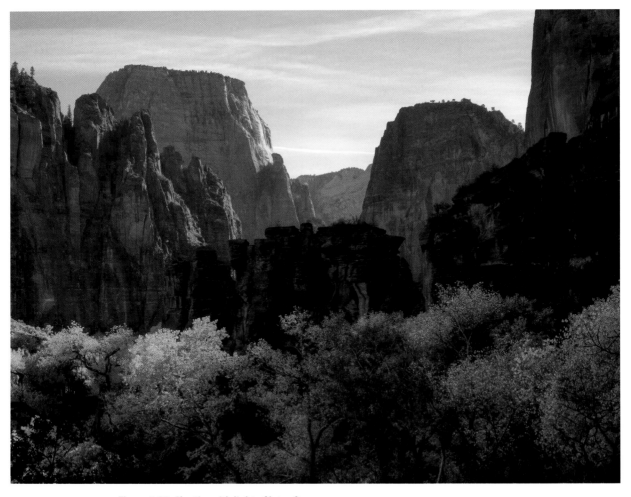

Figure 6.34 **Slanting sidelight of late afternoon**

Chapter 6 Assignments

Create dimension

Consider composing foreground, middle ground, and backgrounds in your photographs. No need to travel to exotic locations—practice around the house and in the backyard. Pay attention to how raising and lowering your tripod allows you to include more or less of the middle ground.

Use a wide-angle lens

Put on the wide-angle lens and get close. The closer you get, the bigger the foreground becomes. It's easy to ignore this phenomenon while looking through the eyepiece, so take a new picture each time you get a little closer. Reviewing the images on the computer will better demonstrate the change in size. Also notice that you begin to lose depth of field the closer your camera gets to the subject.

Try out some apps

If you don't already own any photography apps for your smartphone, now is the time to get them. PhotoPills is the Swiss army knife of apps—it can do just about anything. (Unfortunately, it's currently available only for iOS.) DOFMaster just calculates depth of field, but it does so in an easy-to-use interface and is available for both iOS and Android.

Spend an evening outside

Our busy lives don't often allow for a lot of free time. Treat yourself. Use an app to determine the time of sunset, civil twilight, nautical twilight, and astronomical twilight. Watch as the sun sets, the magic hours unfold, and the day gives way to night.

Share your results with the book's Flickr group!
Join the group here: www.flickr.com/groups/hdr_fromsnapshotstogreatshots/

ISO 100 · 1/2 sec., 1/4 sec. ·
f/8 · 19mm lens

7
Architecture and Interiors

Symmetry and Lines

Architectural photography is an exacting discipline that appeals to the orderly photographer. The natural symmetry found in architecture and the lines that dominate the frame create powerful and dramatic subject matter. In addition to paying attention to exposure and processing, care must be taken to level the camera correctly, align subjects, and find the best place to locate the camera. For folks who like to keep things neat and organized, architectural photography is a very gratifying endeavor.

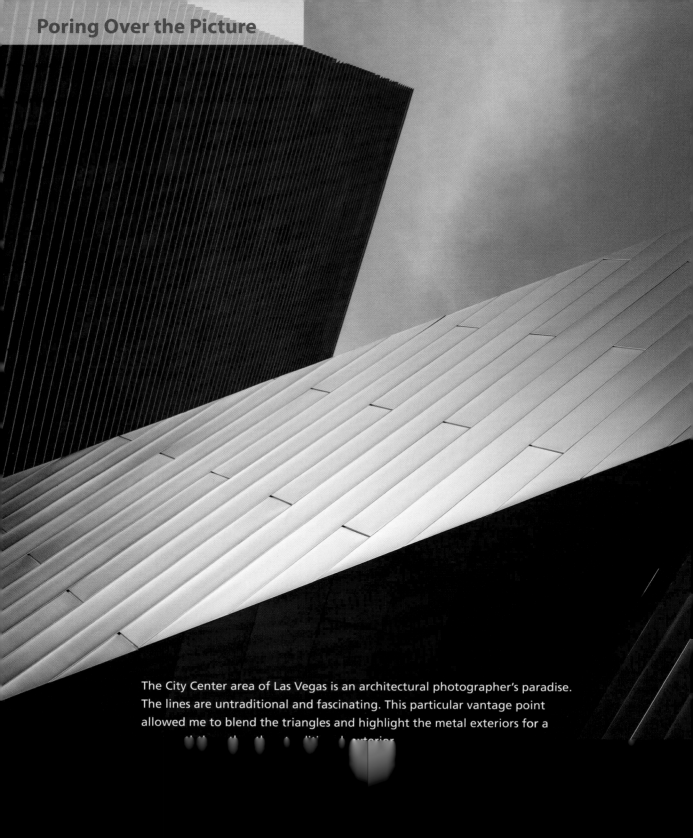

The City Center area of Las Vegas is an architectural photographer's paradise. The lines are untraditional and fascinating. This particular vantage point allowed me to blend the triangles and highlight the metal exteriors for a

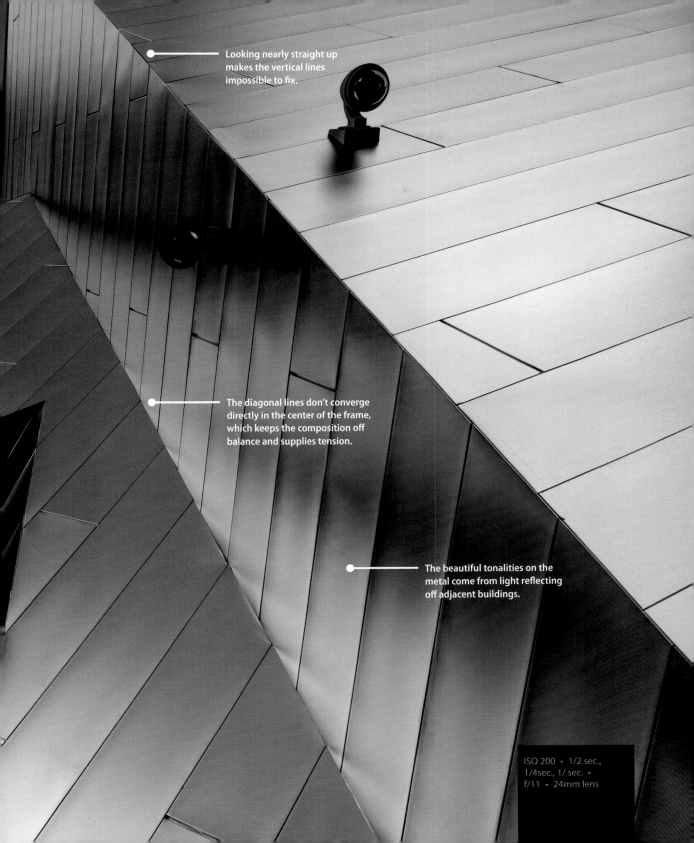

Looking nearly straight up makes the vertical lines impossible to fix.

The diagonal lines don't converge directly in the center of the frame, which keeps the composition off balance and supplies tension.

The beautiful tonalities on the metal come from light reflecting off adjacent buildings.

ISO 200 • 1/2 sec., 1/4sec., 1/ sec. • f/11 • 24mm lens

The low contrast at this time of day meant that only two exposures were needed to create this HDR.

ISO 100 • 1.5 sec., 3 sec. • f/11 • 85mm lens

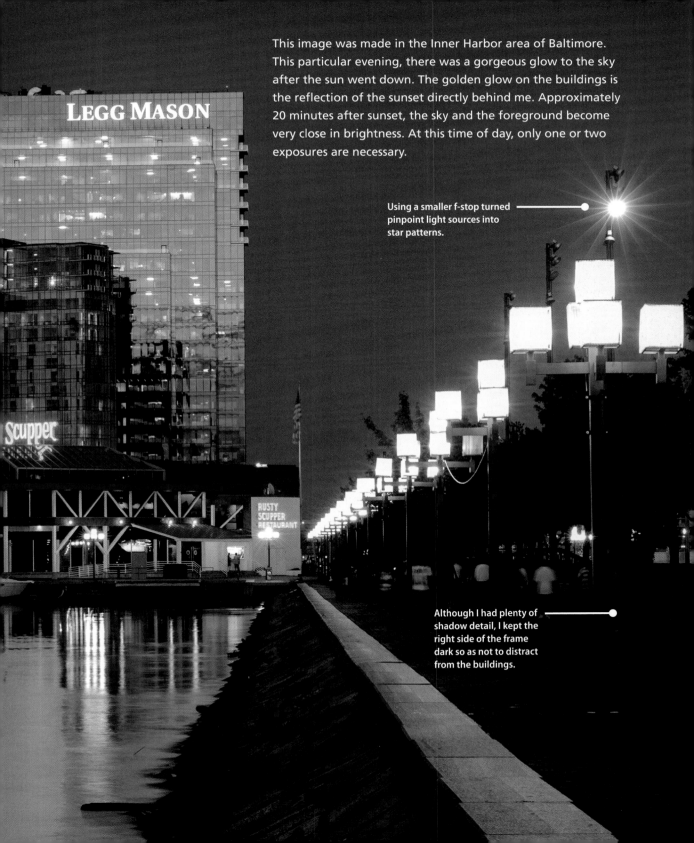

This image was made in the Inner Harbor area of Baltimore. This particular evening, there was a gorgeous glow to the sky after the sun went down. The golden glow on the buildings is the reflection of the sunset directly behind me. Approximately 20 minutes after sunset, the sky and the foreground become very close in brightness. At this time of day, only one or two exposures are necessary.

Using a smaller f-stop turned pinpoint light sources into star patterns.

Although I had plenty of shadow detail, I kept the right side of the frame dark so as not to distract from the buildings.

Equipment Considerations

Tripods

Most tripods are a standard height of about 65 inches. These tools function well for the vast majority of work you'll encounter. With architectural work, however, it is not uncommon to need a higher vantage point. Specialty tripods that extend much higher can be vital to getting the shot. I use a Gitzo Series 4 carbon fiber tripod that extends to a height of 9 feet. Using a stepladder, I can get the camera to a higher vantage point without depending on a lift. In **Figure 7.1**, I used this tripod to raise the camera height and separate the foreground lights from the background building. If I had been at ground level, the lights would have extended up into the building. The midground trees now create a nice separation between the two elements.

Figure 7.1 **An image made with the camera atop a 9-foot tripod.**

For photography that requires a high degree of precision, I prefer to use a geared head instead of a ball head. Ball heads are very convenient and quick to operate. They also are a bit smaller and lighter than the traditional geared head. These qualities make them a favorite among many photographers. Geared heads are slower to operate and typically come with more bulk and weight. Their precision, however, is well worth the tradeoff.

I use the Manfrotto 410 Junior geared head (**Figure 7.2**). Don't let the name fool you—it's a very solid and capable tripod head. Like pan-tilt tripod heads, geared heads allow you to move

Figure 7.2 **Manfrotto 410 Junior geared head**

one axis of the head at time. This means you can level your camera right to left without changing the up and down axis. Ball heads, by contrast, can move in all directions once the release is opened. I find this functionality makes it difficult to make small adjustments to camera orientation. The Junior geared head uses two knobs that allow for large adjustments as well as micro adjustments. Once you rough out your composition with the large knobs, you can fine-tune it with the smaller knobs.

Lenses

Many of the same lenses used for landscape photography are commonplace in architectural photography. Wide-angle lenses are a must for interior images, and normal to slightly long lenses are common for exteriors. The extreme telephoto lengths of 200mm or 300mm are rarely used in this discipline.

Wide-angle lenses will see the most use, so you'll want to ensure that you have lenses that cover the entire range. For crop-sensor cameras, that range is between 10mm and 24mm; for full-frame cameras, 14mm to 35mm will suffice.

A good rule of thumb in architectural photography is to use longer lenses when possible. The wider the lens, the more distortion appears at the edges of the frame. Normal focal lengths experience less distortion than wide-angle lenses and make the scene appear more natural. Wider lenses also make the background seem smaller while enlarging the foreground. This puts more emphasis on secondary subjects and may detract from the main point of your composition.

Tilt-shift lenses, also called perspective control lenses (**Figure 7.3**), belong in every architectural photographer's bag. They help control perspective distortion by allowing the back of the camera to stay parallel to the subject. When the back of the camera is not

level, the vertical lines in the image begin to converge. When the camera is tilted backward, vertical lines converge inward (**Figure 7.4**); notice that the lines that should be straight tilt toward the center. This image was made with a very wide lens, a 14mm.

When the camera is tilted forward, the lines converge outward, as in **Figure 7.5**, which shows the skyscrapers of New York City bending out of the frame.

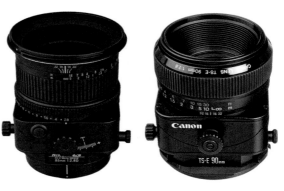

Figure 7.3 A Nikon perspective control lens and a Canon tilt-shift lens.

Figure 7.4 Tilting the camera up causes vertical lines to bend into the frame.

Figure 7.5 Tilting the camera down causes vertical lines to bend out of the frame.

Using a tilt-shift lens can help you correct for these distortions. If your camera back stays parallel to the subject, the vertical lines remain straight. The tilt-shift lens operates by allowing you to shift the optical axis of the lens in relation to the sensor plane. In **Figure 7.6**, the lens on the top has been shifted up and the lens on the bottom has been shifted down. This type of shift is used instead of pointing your camera up or pointing it down.

This is possible due to the large image circle that a tilt-shift lens throws back on the sensor. In **Figure 7.7**, the image on the left shows the entire image circle that a tilt-shift lens provides. The center image shows where your sensor would be in relation to the image circle. The image on the right demonstrates what happens when you shift your lens upward. The sensor area, in red, now captures a different part of the image circle. This type of shifting allows you to keep your camera back parallel rather than tilting your camera upward. **Figure 7.8** was captured by tilting the camera upward. **Figure 7.9** shows how the image would look using a tilt-shift lens shifted upward.

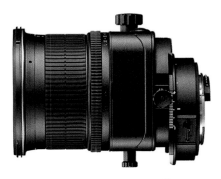

Figure 7.6 **Tilt-shift lens shifted up (top) and down (bottom).**

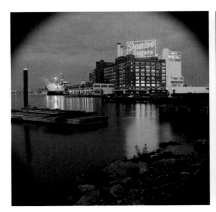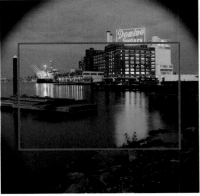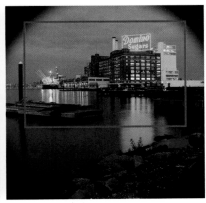

Figure 7.7 **The image circle of a tilt-shift lens; the sensor location is in red.**

Figure 7.8
Tilting the camera up causes vertical lines to bend into the frame.

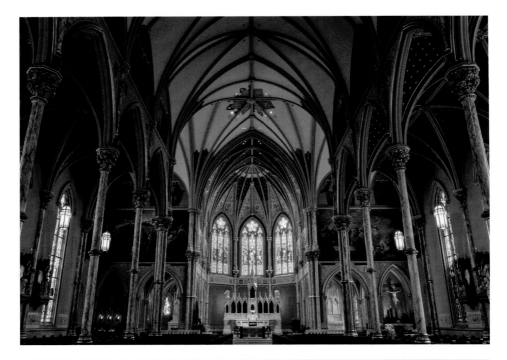

Figure 7.9
Using a tilt-shift lens with the lens shifted up and the camera back parallel produces straighter vertical lines.

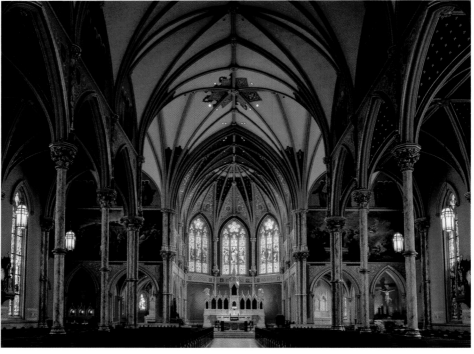

Accessories

Gone are the days when architectural photographers needed an array of lights, gels, and filters to correct for color balance and overcome the high contrast often associated with interior photography. Digital imaging and HDR programs have made our jobs much, much easier. Today, my camera bag includes a couple of Speedlights, gels to alter their color, and a photographic gray card.

Speedlights

I recommend purchasing the best Speedlight that is offered for your camera model. Top-end Speedlights are higher powered, allowing the use of the smaller apertures necessary for architectural photography. They are also durable, have quick recycle times, and provide the ability to alter the coverage area **(Figure 7.10)**. For those on a budget, off-camera manufacturer brands offer quality at lower prices. I use Bolt Flashes from B&H to round out my system.

Gels

In addition to the flash unit itself, you'll want gels to alter the color of the flash and modifiers to control the beam width. I control the color of my flash units with gels pulled from a Roscolux swatchbook **(Figure 7.11)**. For $2.50, these swatchbooks include every filter you could possibly need to alter the color of your flash. Simply tear out the correct color and tape it over the front of the flash unit. I typically carry a set of filters in a case with my flash. The filters alter the color of the Speedlight to match typical incandescent lighting.

Figure 7.10 **High-end flashes from Nikon and Canon.**

Figure 7.11 **A Roscolux swatchbook provides countless filters for your flash.**

A flash acts as a wonderful accent light, throwing a bit of light into heavily shadowed areas or adding highlights to flat areas. In **Figure 7.12**, I had placed a flash about 6 feet to the right of the camera. The flash was faced to the left to illuminate the foreground chair. I used a low manual setting of 1/16 power to throw a touch of light onto the sides and back of the chair. I used a 3/4 CTO (yellow/orange) filter over the flash to keep all the indoor illumination the same color temperature. This type of accent light creates small areas of interest that enliven a space and add depth to a photograph.

Figure 7.12
Low-powered flash adds a highlight to the side of the foreground chair.

Grip equipment

To create accent light, you'll need to mount your flash off-camera. This means you'll need a way to hold your flash as well as a way to trigger it. Grip equipment comes in a multitude of options for the photographer. To keep it simple, I carry a couple of lightweight light stands from Impact and couple of small flexible tripods from Joby. These small tripods are a great way to hold your flash in various locations. The better flexible tripods come with a moveable ball head, as seen in the lower-right corner of **Figure 7.13**. You'll also need to purchase a *cold shoe* to mount on the top of the ball head so that you can attach your flash (**Figure 7.14**).

For simple tabletop mounting, you can use the shoe stand that typically comes with your flash. For less than $8, you can purchase extra shoe stands. Some stands also provide a location for a wireless flash slave.

Figure 7.13 **Flexible tripod with ball head and additional cold shoe (top right).**

Figure 7.14 **Flashes mounted on flash shoe stands.**

Flash triggers

With your flash mounted off-camera, you'll need some way to trigger the flash. The least expensive and least convenient option is to use an off-camera shoe cord. The cord triggers only one flash unit and is limited by the length of the cord. It works great in a pinch.

The next option is to allow a camera-mounted flash to trigger another flash placed elsewhere in the room. This is typically an optical slave system that is built into higher-end flash units, and it works only in line of sight; this means that if the remote flash cannot see the flash of the camera-mounted unit, it won't fire. The best option is to use radio slaves, which will trigger the remote flash regardless of its position. A radio slave system

Figure 7.15 **Radio slave transmitter (right) and receiver.**

consists of a transmitter and a receiver (**Figure 7.15**). The transmitter attaches to the camera's hot shoe (the place your flash slides into on the top of the camera), and the flash slides into the receiver's hot shoe. You'll need one receiver for each flash, but only one transmitter. Radio slaves come in many makes and models, ranging from less than $100 for simple systems to over $400 for systems that retain the flash's TTL capability. Because I use my flash in Manual mode, the less expensive options are sufficient.

White balancing tools

The last accessory you'll need is a tool to help you get proper white balance. The variety of price and construction of these tools is nearly unlimited. They can be card stock, plastic chips, or even folding plastic wallets (**Figure 7.16**). While less expensive brands may suffice, products from noted color companies such as Datacolor and Xrite may be slightly more accurate.

Figure 7.16 **White balancing tools**

White Balance

Architectural photography is similar to landscape photography in that it demands the highest-quality imagery possible. This means shooting RAW files, using low ISOs, and having a rock-solid tripod. Using small apertures, such as f/11 and f/16, to achieve great depth of field is another similarity. When it comes to white balance, however, the two disciplines diverge.

White balance for landscape photography is typically straightforward. Simply use the white balance setting that matches your conditions: Daylight, Cloudy, or Shade. This approach also works well when shooting exterior architecture (**Figure 7.17**). Once you are indoors, things get a little trickier. Cameras come with white balance settings that match the more common interior lights, such as tungsten/incandescent and fluorescent. They are not always accurate, however. This is because those white balance settings are simply presets for exactly one color of tungsten or fluorescent bulb—but both of those light sources come in a variety colors. This is where Auto white balance comes in handy.

Auto white balance analyzes the colors of the brightest pixels in the frame (it assumes that these are the light source) and provides a solution to neutralize those colors. Many times, Auto works quite well, but at other times it's not accurate enough. For this reason, camera manufacturers created the Custom white balance setting, which is often used in interior photography, where getting the color correct is a must. Each camera handles the Custom white balance setting a little differently, so be sure to check your manual for instructions.

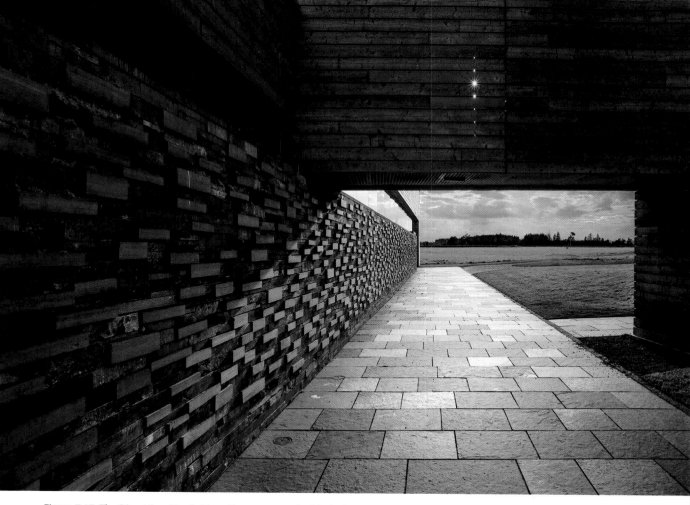

Figure 7.17 **The Direct Sun (Daylight on Canon cameras) white balance setting was used to provide natural colors on this exterior.**

Daylight white balance was used to capture the interior in **Figure 7.18**. The heavy orange color comes from tungsten lighting. I could have set my camera to Auto white balance, but with no light sources in the frame, it could have provided a false color, and a change of composition could have resulted in a different color solution for the same scene. Instead, I walked to the front and placed my gray card directly under the primary light source (**Figure 7.19**). Next, I filled my frame with the gray card (**Figure 7.20**) and took a picture. Cameras often will not fire the shutter when they can't focus on a smooth subject, so I usually switch to manual focus before taking the picture. The gray card does not have to be in focus as long as it fills the frame.

Figure 7.18
An interior shot
with Daylight white
balance.

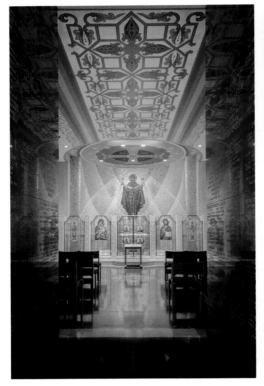

Figure 7.19 **Placing the gray card under the dominant light source.**

Figure 7.20 **The gray card before custom white balance.**

Once the picture was taken, I went into the camera's menu system and located the Custom white balance setting (PRE on a Nikon). This allowed me to choose the last picture taken. The camera then analyzed the photo and created a custom setting to neutralize the color cast (**Figures 7.21**). I set my camera to Custom and took the picture shown in **Figure 7.22**. Notice the clear separation of colors and the natural feel when a perfect white balance is used.

Figure 7.21 **The gray card after custom white balance.**

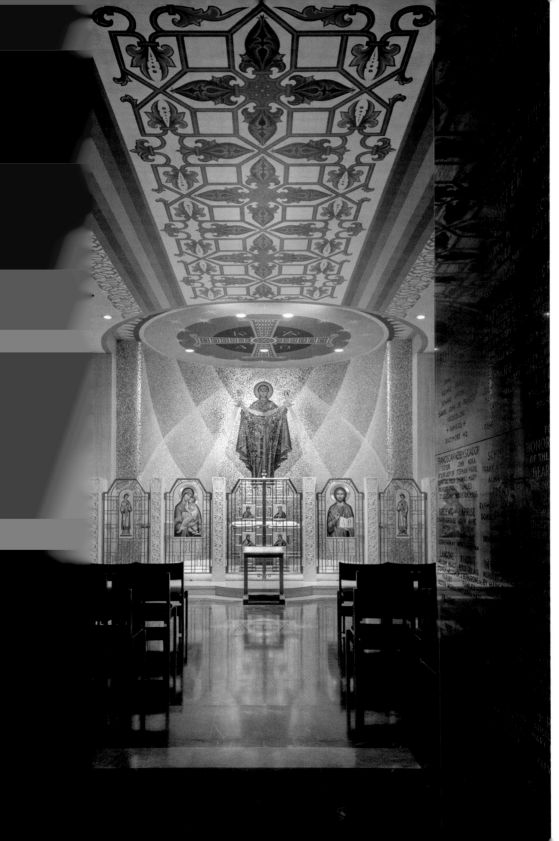

Figure 7.22
The final frame, shot with the Custom white balance setting.

Position and Focal Length

Good architectural photography starts with putting your camera in the right spot. Never settle for the first spot that catches your eye. Be sure to move around—right to left, and up and down—to examine all the possible locations. The position of the camera not only determines which lens you'll use but also the size of the foreground compared to the background. It also expands or flattens the perceived depth in the scene and controls which, if any, objects in the background will be obscured by foreground subjects. In short, camera position is vital.

For example, the images in **Figure 7.23** were taken with three different focal lengths. The image on the left uses a 24mm lens. To get the house to fit in the frame from side to side, I had to be fairly close to the building. Wide-angle lenses tend to make the foreground seem large and the background seem small. Here, the sidewalk becomes as tall as the building, and the lighthouse is tiny in the background. For the middle image, taken with a 50mm lens (normal on a full frame camera), I had to back up a bit to fill the frame with the building. The sidewalk seems smaller now and the lighthouse has grown. This has a very natural effect. For the last image, I backed up even farther and used an 85mm lens. Now the lighthouse dwarfs the building, giving the full effect of its height.

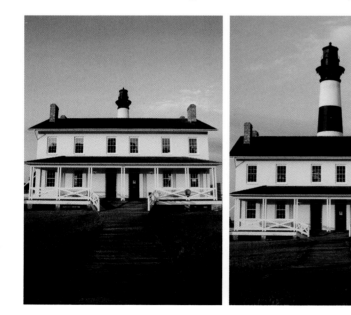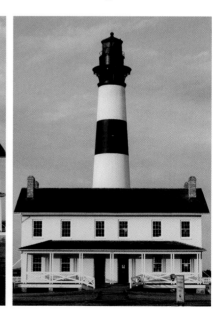

Figure 7.23 **The same scene shot with, from left to right, a wide, normal, and long lens.**

Earlier in this chapter I suggested using the longest lens possible when shooting. This doesn't mean trying to use a 400mm lens indoors. It just means that, given a choice, use a longer focal length. For exteriors, normal to slightly long lenses are the norm. For interiors, always opt for the longest lens the scene will allow. Wide-angle lenses tend to distort reality more than normal lenses, so the final image will have a more natural feel when made with longer focal lengths. That being said, when shooting interiors we are often limited to using wide-angle lenses to capture the scene.

Figure 7.24 shows another scene made with three different focal lengths. Note the location of the statues in relation to the walls behind them. The image on the top was made with a 17mm lens. Because I am so close, the statues are almost to my sides rather than being in front. The middle image, made with a 40mm lens, places the statues a little in from the sides of the frame. The bottom image, made with a 100mm lens, has the statues closer to center. Also notice the lack of the distortion to the vertical lines in the 40mm and 100mm images. Tilt-shift lenses can correct for the vertical distortion caused by tilting your camera upward, but they cannot alter the foreground/background relationship. In a perfect world, we would have tilt-shift lenses for every situation, but of course this is not always possible. For those situations, we turn to Lightroom to help square our images.

Figure 7.24 **Vertical lines are more distorted with wide-angle lenses.**

The Lens Corrections Panel

Back in Chapter 4 we used Lightroom's Lens Corrections panel (**Figure 7.25**) to remove chromatic aberrations, and to apply a lens profile to correct for the optical aberrations that are inherent in all lenses. This panel also provides tools to correct distortion that occurs from not aligning the camera back vertically and horizontally with the scene. The bottom of the panel contains the Upright modes: Auto, Level, Vertical, and Full.

Figure 7.25 **The Lens Corrections panel**

Click the Level button to level your image from left to right. Typically, it does a pretty good job. If you are in a hurry or the image has plenty of obvious lines, this button is a great option. Click the Vertical button to fix the convergence of vertical lines in your frame. The left image in **Figure 7.26** shows the original image, in which I tilted the camera upward to include the top of the church in the reflection. The center image shows the result of clicking the Vertical button and deselecting the Constrain Crop checkbox—a reasonable correction. For the image on the right, I selected the Constrain Crop checkbox.

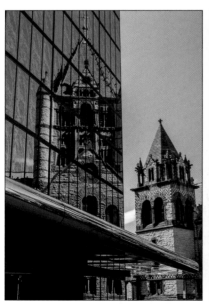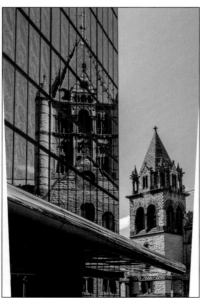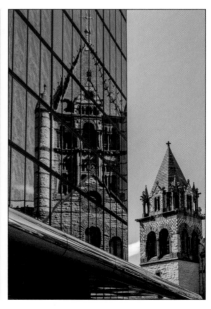

Figure 7.26 **The original image (left), the corrected image (center), and the corrected image after Constrain Crop was selected (right).**

The Auto and Full buttons are similar in that they both attempt to fix horizontal and vertical details, but Full is stronger than Auto and typically returns an image that needs to be severely cropped. You can simply click each option to quickly determine whether or not the result is satisfactory. Click the Off button to return the image to its original state. The top photo in **Figure 7.27** shows an HDR image blended in Lightroom with no adjustments. The bottom image shows the shot after clicking the Auto button. As you can see, the program did an excellent job of leveling and fixing the vertical distortion.

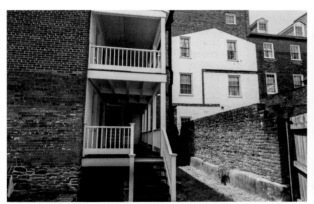

Figure 7.27 A before (left) and after using the Upright Auto option.

I recommend experimenting with the Upright options with the Constrain Crop checkbox unselected. If this checkbox is selected, clicking the Off button does not return the image to its original state, but keeps the crop. To get the image back to its original state, select the Crop tool and click the Reset button (**Figure 7.28**).

When precision is crucial, I use the Manual section of the Lens Corrections panel (**Figure 7.29**). Here you can fix all aspects of the image. While this section may take bit more time, it pays off in knowing that your image is perfectly corrected. Whether you use one of the Upright modes or fix your image manually, you will lose a good portion of the image.

Figure 7.28 Resetting the crop tool

Figure 7.29 The Manual area of the Lens Corrections panel.

Figure 7.30 shows the original image on the left and the corrected image on the right. The Lens Corrections panel will always make your image somewhat smaller due to the cropping that occurs when eliminating some of the elements on the top and sides of the photo. For this reason, it's a good idea during the initial capture to include more than you plan to use.

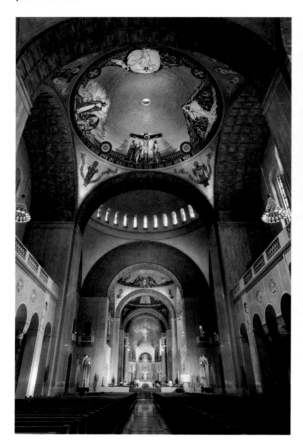

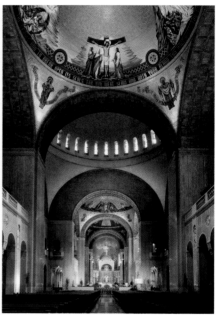

Figure 7.30 **The original image (left) and the corrected image.**

Adjustments Prior to Merging to HDR

When processing HDR images using Lightroom's Photo Merge > HDR command, it's easiest to keep your images unaltered before blending. The HDR process will copy *some* of the settings from the source files (your separate exposures) but not others. Primarily, Lightroom disregards tone adjustments, such as exposure, tone curve, and so on, and keeps color settings, black and white settings, and local adjustments. The set of adjustments that Lightroom keeps for Photo Merge > HDR images is different than those kept for the Photo Merge > Panorama command. Rather than try to remember what has been applied

to which images, I find it easier to keep the images that I plan to blend unadjusted. Because Lightroom returns a RAW (.dng) file, it makes no difference whether the settings are applied before or after the blend.

But this is not the case if you are planning to use Photomatix to blend your images. In this situation, files are best adjusted *before* sending them off. When making adjustments to images that will be merged, care needs to be taken in determining which settings should be synchronized between exposures. I typically synchronize all the settings except for the tonal adjustments.

Synchronizing settings in Photomatix

1. In the Develop module, make the desired changes to one photo in the series.

2. While pressing the Command (Mac) or Ctrl (Windows) key, select the remaining images in the series.

3. Notice that although all the images are selected, the one you made the changes to is a little brighter. This indicates that it is the active image and that the changes from this image will be applied across the others.

4. Press the Sync button, in the lower-right corner of the screen.

 The Synchronize Settings dialog appears (**Figure 7.31**).

5. Click the Check All button.

6. Deselect the Basic Tone checkbox.

Figure 7.31 **The Synchronize Settings dialog**

Processing Architectural Images in Lightroom

One of the more important (and often overlooked) adjustments in Lightroom is the camera profile. Back in Chapter 6, I talked about the picture styles that can be applied in-camera and how you emulate them using the camera profile in the Camera Calibration panel.

Architectural and interior photography differ from other disciplines in that the final image should be somewhat more lifelike and realistic. I find that the Adobe Standard and Camera Neutral profiles are usually the best match for my work. When you're experimenting with camera profiles, these two should be the place you start. They are both lower in contrast and saturation than Camera Standard and Camera Landscape.

Figure 7.32 displays four different camera profiles, as applied to one image that was blended using Lightroom's Photo Merge > HDR command. The Camera Neutral profile has the least saturation and contrast, which increase as you change to Adobe Standard, Camera Standard, and Camera Landscape. For this image I chose the Camera Neutral profile, but a slight decrease to the Blacks slider was needed to subtly boost contrast.

Figure 7.32
Four different camera profiles applied to the same image.

The Auto Tone option in the HDR Merge Preview dialog delivers reasonable and fairly predictable results, but the images come out a little bright for my taste. The goal of Auto Tone seems to be the creation of a full histogram with little or no clipping in the shadows and highlights. Not a bad goal, but not every image benefits from this type of histogram. **Figure 7.33** shows an image and its adjustments returned to Lightroom with the Auto Tone box selected. Not a bad blend, but the image feels overly bright in the shadows and somewhat low in contrast. A look at the settings in the Basic panel provides some clues as to why this is. The Exposure slider has been moved up to +1.25, which moves most of the image information in the histogram into the center. The Shadows have been brightened and the Highlights darkened. This further assists in keeping the image information centered. The slight decrease in the Blacks and slight increase in the Whites pulls the extreme edges of the histogram out and creates a deep black and a bright white. For an automatic function, this performs pretty well. For my architectural images, I typically like to see somewhat darker shadows and a bit more contrast in the midtones. I feel it gives a better sense of the room lighting and presents a more lifelike image.

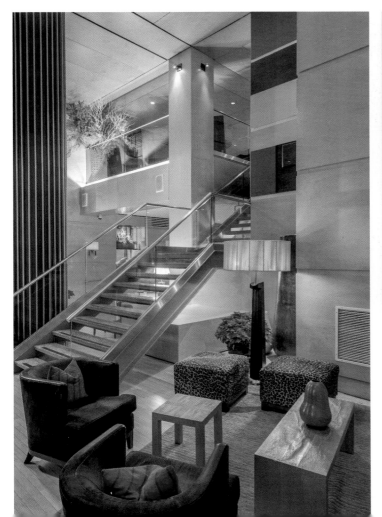

Figure 7.33 **Initial image with Auto Tone applied.**

Figure 7.34 shows the image after it's been adjusted. Lowering the Exposure to +0.65 has the overall effect of darkening the image. This means the Blacks can be raised a little, from –15 to –6. The Highlights and the Shadows sliders remain nearly the same. These changes deliver the desired effect of darkening the shadow area of the image.

Figure 7.34
Final image after adjustments.

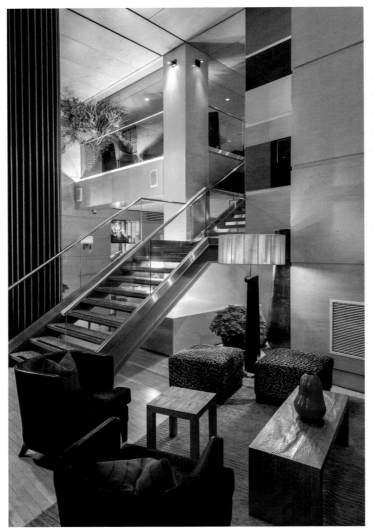

Next we turn to contrast. The Contrast slider delivers higher contrast but also increases saturation. Therefore, you can only increase it so much before the saturation becomes a problem. Raising the Contrast slider and lowering the Saturation slider rarely produces the desired effect. A slight increase of the Contrast slider to +8 was all the image could withstand without becoming overly saturated. The only move left at that point was to increase the Whites slider. Brightening the Whites and darkening the Blacks also increases the contrast in an image but does not come with the same increase in saturation that the Contrast slider delivers.

Raising the Whites Slider to +52 has the intended effect. The contrast has been increased, and the saturation remains reasonable. The increase in the Whites, however, has clipped important highlight detail. The only course of action was to locally decrease the highlights using Lightroom's Adjustment Brush. The Adjustment Brush allows the user to apply many of the Basic panel adjustments to specific areas of the image. In this case, I brushed in a decrease in highlights to the upper left of the image, where the light washes the wall and the plant.

Most of the images that I have processed with Lightroom's Photo Merge > HDR function have followed a very similar track—darkening the shadows by lowering Exposure, and increasing contrast by raising the Whites and Contrast sliders. Most of these images end with a darkening of specific highlight areas using the Adjustment Brush.

Processing Architectural Images in Photomatix

Photomatix offers some unique and very powerful ways to control the important highlights of your image. In Chapter 5, we discussed how using exposure fusion rather than tone mapping produced more realistic results. Within exposure fusion, you can alter the way you blend your images. The two methods I use are Fusion/Natural and Fusion/Real Estate (**Figure 7.35**). I find that Fusion/Natural gives better control over the shadow areas of an image, whereas Fusion/Real Estate provides better control over the highlight regions. For this photo, I increased the Shadows slider to 9.9 (**Figure 7.36**). This didn't quite provide the brightness in the shadows that I desired, so I will have to deal with that in Lightroom.

Figure 7.35
Choosing Fusion/
Real Estate from the
Method menu.

Figure 7.36
Increasing the
Shadows slider.

The next step is to set the highlight areas of the window. When standing inside, our eyes naturally perceive the outdoors as brighter and lower in contrast than the interior. The trick, then, is to keep the outside brighter than the interior while still preserving detail and maintaining a believable level of contrast.

Fusion/Real Estate has two sliders that provide powerful control over the bright areas: Highlights and Highlights Depth. The Highlights slider controls the brightness of the highlights. Moving this slider to the left darkens the highlights, and moving it to the right brightens them. The Highlights Depth slider controls contrast within the highlight area. Moving the slider to the left decreases contrast, and moving it to the right increases contrast.

Figure 7.37 shows the effect of too much contrast and darkening of the highlights. This is a common mistake in HDR photography, and it leads to a very unnatural look.

Figure 7.37
Highlights that are too dark and contrast that looks unnatural.

In **Figure 7.38**, I have slightly darkened the highlights by setting the Highlights slider to
−6.0, and I have decreased contrast by setting the Highlights Depth slider to −5.1. The image
is now very close but needs a bit of fine-tuning in Lightroom. **Figure 7.39** shows the final
image after increasing the Shadows slider in Lightroom.

Figure 7.38
A slight decrease
to brightness and
contrast in the
highlights.

Figure 7.39
The final image
after increasing
the Shadows slider
in Lightroom.

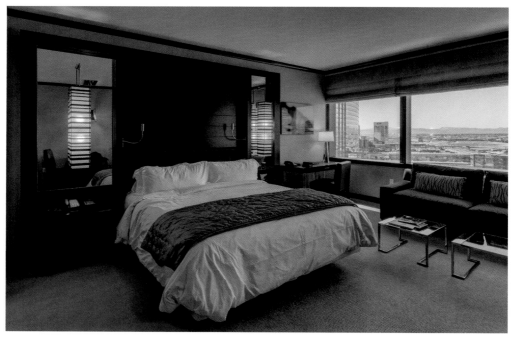

Chapter 7 Assignments

Explore camera standpoint

Positioning, of yourself and your camera, is one of the most important parts of architectural photography. Practice exploring different vantage points. Raise and lower your camera, and watch how the middle ground in your photo expands and contracts. Move your camera from side to side to see how foreground objects can be positioned to reveal or obscure the background.

One scene, three ways

Shooting a scene with three different focal lengths will teach you a lot about perspective and camera position. Find a subject that you can photograph from near and far. With a wide-angle lens, get close to the subject and take a picture. Then, move back and take the same composition with a normal-length lens. Move back even farther, and compose the same shot with a telephoto lens. Compare the results. Pay attention to how the lenses stretch or compress space. Notice how the foreground/background size relationship changes with each image. Also analyze how much (or how little) of the background is captured.

Custom white balance

Check out your camera manual for instructions on how to create and apply a custom white balance. Get a white balance gray card, and practice anywhere you find manmade illumination.

Inside, outside

No need to go anyplace fancy to practice interior photography. A room with windows in your own home will do just fine. Set up a tripod, and compose a shot that includes the windows and the interior. Turn on the interior lights, and make images at morning, noon, and evening. Beginning at sunset, shoot images every 15 minutes until it's completely dark. Notice how the color and exposure changes throughout the day, especially around sunset and sunrise.

Share your results with the book's Flickr group!
Join the group here: www.flickr.com/groups/hdr_fromsnapshotstogreatshots/

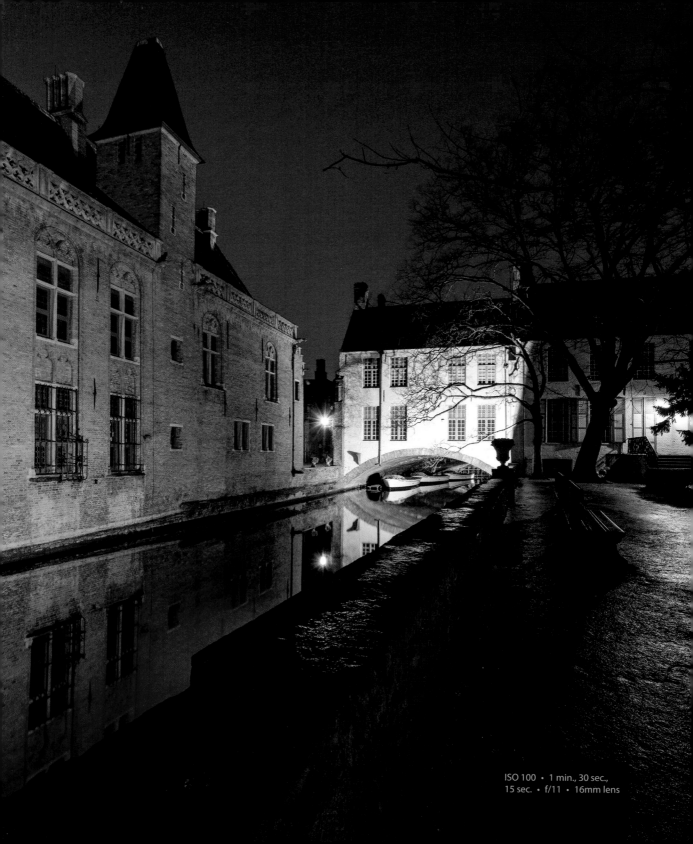

ISO 100 • 1 min., 30 sec., 15 sec. • f/11 • 16mm lens

8

Low-Light and Night Photography

Extending Your Photographic Day

Low-light and night photography is an exciting way to extend your day of shooting. Unusual color casts, atypical contrast, and vibrant color—shooting at night is mysterious and surprising. It's amazing the detail the camera reveals, and the light can be otherworldly. Digital cameras make getting good exposures easier than ever, and HDR programs extend our shooting times well into the night.

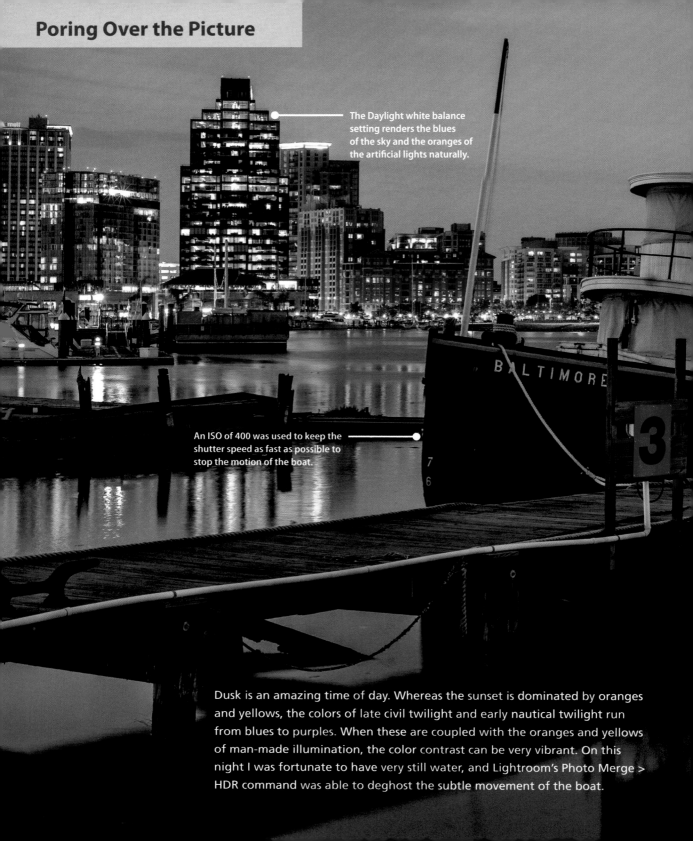

Poring Over the Picture

The Daylight white balance setting renders the blues of the sky and the oranges of the artificial lights naturally.

An ISO of 400 was used to keep the shutter speed as fast as possible to stop the motion of the boat.

Dusk is an amazing time of day. Whereas the sunset is dominated by oranges and yellows, the colors of late civil twilight and early nautical twilight run from blues to purples. When these are coupled with the oranges and yellows of man-made illumination, the color contrast can be very vibrant. On this night I was fortunate to have very still water, and Lightroom's Photo Merge > HDR command was able to deghost the subtle movement of the boat.

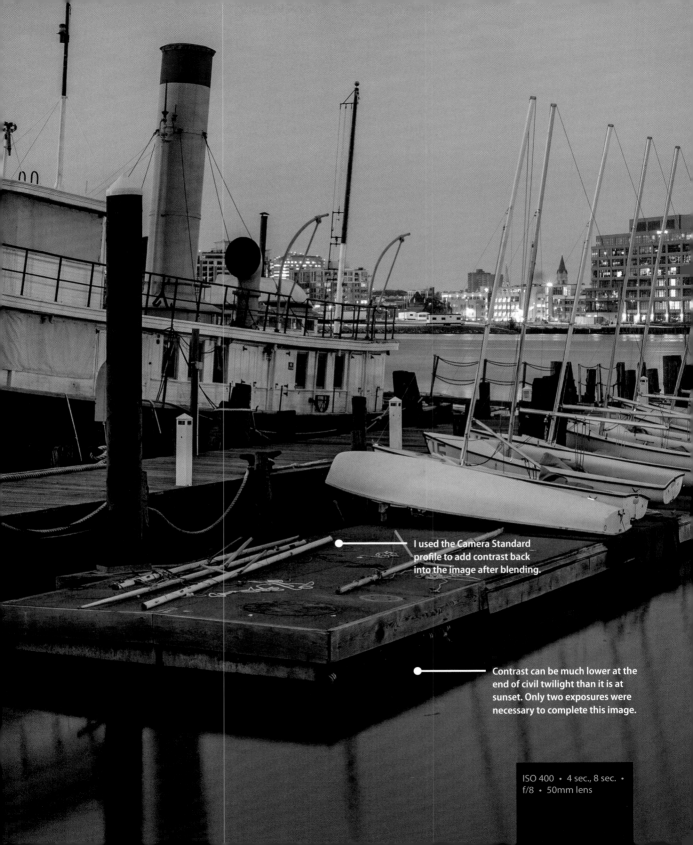

I used the Camera Standard profile to add contrast back into the image after blending.

Contrast can be much lower at the end of civil twilight than it is at sunset. Only two exposures were necessary to complete this image.

ISO 400 · 4 sec., 8 sec. · f/8 · 50mm lens

Capturing the detail in the moon and the foreground once the sun goes down is impossible without multiple exposures. This image was created using the selective deghosting offered in Photomatix. I selected the moon and adjacent clouds and directed Photomatix to use the darker exposure for the deghosting. After my first attempt at blending, I realized the standing stones were too blue, so I returned to Lightroom and added yellow color balance to the brighter exposure. The darker exposure was kept at a Daylight white balance. Changing the white balance on one image alters only the colors between the shadows (slightly more neutral) and the highlights (the sky remains blue).

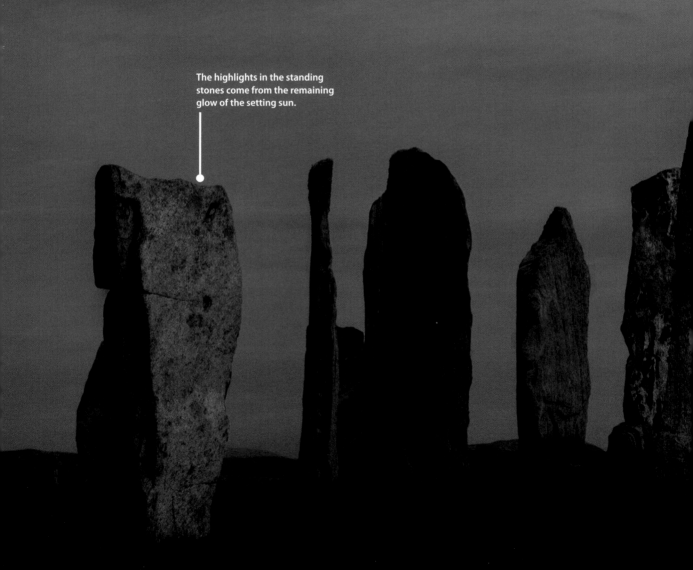

The highlights in the standing stones come from the remaining glow of the setting sun.

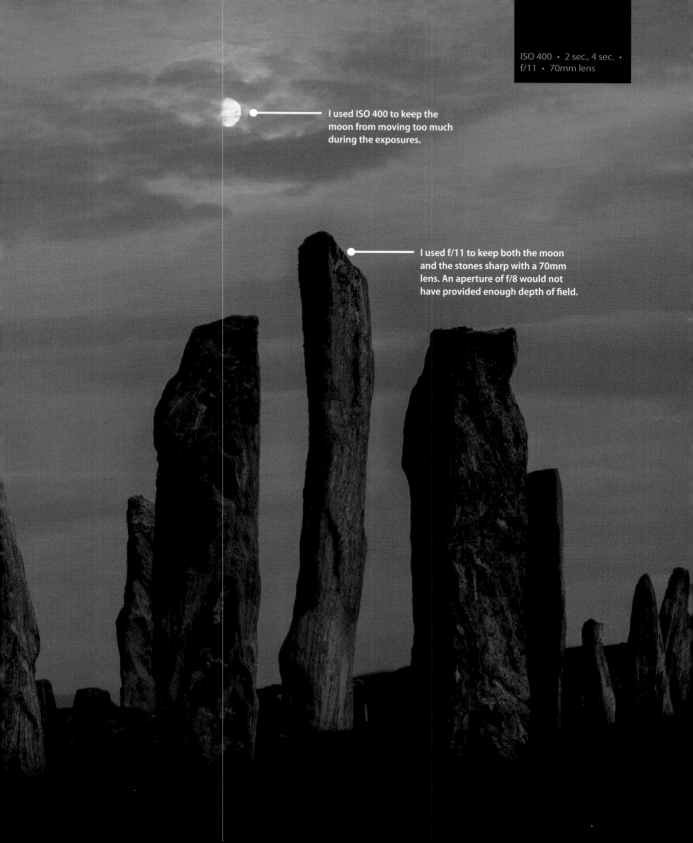

ISO 400 · 2 sec., 4 sec. · f/11 · 70mm lens

I used ISO 400 to keep the moon from moving too much during the exposures.

I used f/11 to keep both the moon and the stones sharp with a 70mm lens. An aperture of f/8 would not have provided enough depth of field.

Equipment Considerations

Creating great images at night or during low light requires much of the same equipment as landscape or architectural photography: a sturdy tripod, a good set of lenses, and a reliable cable release. More information on tripods can be found in Chapter 2, and on lenses in Chapter 6.

Remotes

For long exposures at night, I use a remote switch (cable release) with a timer. Timers such as the Vello Shutter Boss (**Figure 8.1**) allow you to set an exposure from 1 second to 99 hours, and also provide interval shooting and a self-timer—great for when you surpass the camera's timed exposures, which are usually no longer than 30 seconds. I prefer the wired remote switches to the wireless ones. The wireless switches use more batteries, and some use the hot shoe on the top of the camera, which you may find inconvenient if you plan to add flash to your images.

Filters

Although no special filters are needed for shooting under low light, it's important to have a high-quality haze or skylight filter if you use one for lens protection. Higher-quality filters have better coatings and glass to help alleviate the flare that is so common when shooting around artificial lights in low light. I prefer not to use a protective filter, but I'm vigilant about keeping the lens cap on when I'm not shooting.

Figure 8.1
Timer remotes provide a self-timer, interval shooting, and exposure settings of 1 second to 99 hours.

Flashlights

Flashlights are an important accessory for the low-light photographer. They can be used to find safe footing, locate gear in your bag, or even illuminate the scene itself. Inexpensive flashlights are fine for general use, but I prefer a higher-quality flashlight when adding light into a scene.

Flashlights are rated in lumens. The higher the lumen number, the brighter the light. I use a Surefire G2

Figure 8.2 Surefire G2 Nitrolon flashlight

Nitrolon 65-lumen incandescent flashlight (**Figure 8.2**) for most of my light-painting work. This small flashlight produces a very even beam of warm light. Less expensive flashlights may have odd patterns within the beam and can range in color. LED flashlights typically have a slight blue cast, whereas incandescent beams are bit more yellow. The incandescent beams produce a color that suits my style (**Figure 8.3**).

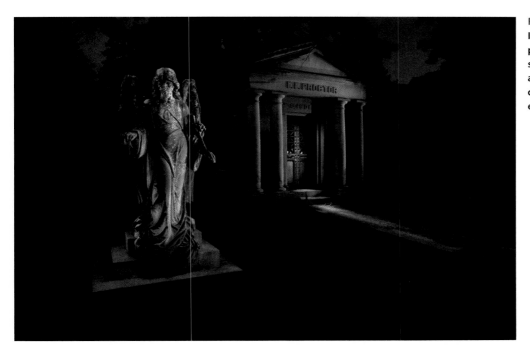

Working for long periods of time in dim conditions creates *night-adjusted vision*, in which your pupils are dilated to let in the maximum amount of available light. During these conditions, a bright light can be shocking or painful to your eyes, so I also use a low-powered LED flash with a red beam for searching around in my camera bag or looking at settings on my camera.

Apps

If you are planning a shoot where you want the moon to be in your photograph, you can use apps such as PhotoPills or Moon Seeker to show you exactly where the moon will appear over the horizon, and at what time (**Figure 8.4**). I used PhotoPills to calculate exactly where the blood moon of April 2014 would be during its ascent (**Figure 8.5**).

Figure 8.4 **PhotoPills displays the course of the rising moon.**

Figure 8.5
**Blood moon of
April 2014**

Camera Settings

When you're working in low light, lower your LCD brightness. Our pupils adjust to the darkness by opening up, so when you look at your exposure on the back of the camera, it seems unrealistically bright. Lowering the LCD brightness solves this problem by displaying an image suited for night-adjusted vision (**Figures 8.6** and **8.7**).

Figure 8.6 **Nikon's menu**

Figure 8.7 **Canon's menu**

Noise

Another setting worth exploring is Long Exposure Noise Reduction (**Figures 8.8** and **8.9**), which eliminates the noise that occurs when the sensor heats up over long exposures. Long exposure noise shows up in your photograph as tiny red, green, and blue shapes and dots. They are difficult to realistically remove in post-processing, so it's best to tame this beast in-camera. **Figure 8.10** is an enlargement of an image that suffers from long exposure noise.

Figure 8.8 **Nikon's menu**

Figure 8.9 **Canon's menu**

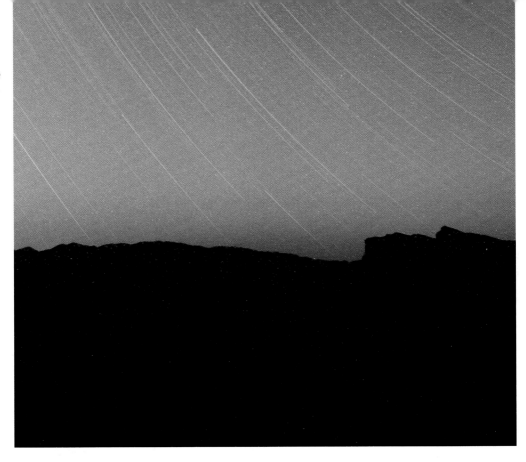

Figure 8.10
Long exposure noise creates small shapes and dots of color.

Every camera begins to produce this noise at different exposures, and this is compounded by the ambient temperature. Hot summer evenings produce more noise than cold winter nights. Testing your camera is the only way to be sure of safe exposure times. Testing procedures are explained in the assignments section at the end of this chapter.

When Long Exposure Noise Reduction is engaged, the camera will be unresponsive for twice the initial exposure time. For example, let's say that you need a 4-minute exposure to correctly expose the shadows of a scene. Once the shutter is triggered, it will expose the scene for 4 minutes, and then for the next 4 minutes it will locate and fix the offending pixels. Your camera is tied up for a total of 8 minutes. This really increases the time it takes to make test exposures and lengthens the overall shooting time, so it's best to engage Long Exposure Noise Reduction only when absolutely necessary.

Long exposure noise should not be confused with high ISO noise. Whereas long exposure noise comes from heat, high ISO noise comes from setting the ISO too high and makes an image look as if it's made of sandpaper (**Figure 8.11**). During some forms of low-light photography, you may want to raise your ISO somewhat, but raising it to point where

you see extreme noise is rarely necessary. Assignments at the end of this chapter explain how to test for acceptable levels of high ISO noise.

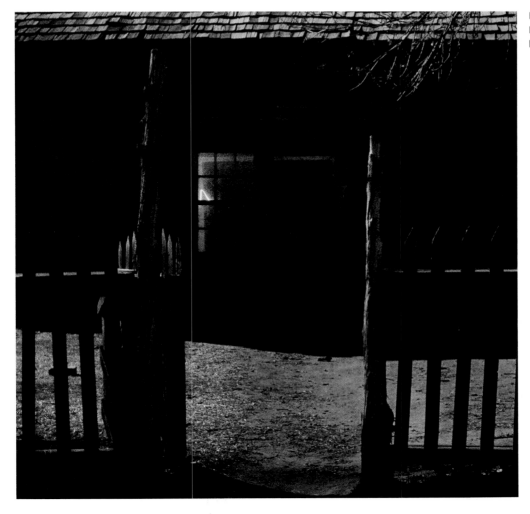

Figure 8.11
High ISO noise looks like sandpaper.

White balance

Setting the white balance in low-light or night photography is not as cut-and-dried as it is in other disciplines. It varies depending on lighting conditions, weather, and personal taste. The overarching decision is whether or not to correct; this ultimately depends on the desired effect.

Our eyes adjust on the fly to many types of visual phenomenon. They are excellent at ignoring color casts and allowing us to perceive natural or white light. We encounter this

on a daily basis as we move from daylight to indoor lighting—it seems to us that all the light we see is neutral (without a color cast) or at least not overly colorful.

The Daylight (Canon) or Direct Sun (Nikon) white balance setting renders colors naturally. This means that if the light has a color cast, Daylight renders it as is. The image on the left in **Figure 8.12** was shot under tungsten lights using Daylight white balance. The yellow hue is the real color of the lights. The image to the right is shot using the Tungsten white balance. To correct for the color cast, the white balance setting adds blue across the frame to cancel out the yellow. It then appears similar to what we see when we are in those conditions.

Figure 8.12
Tungsten lighting shot with Daylight white balance (left) and Tungsten white balance (right)

With every action there is a reaction. The camera corrects for one color of light by adding the opposite color on the color wheel. If the entire scene is illuminated by a single type of light, then this works perfectly. We saw in the last chapter how we could use a custom white balance to accurately correct for a color cast from a single light source. When photographing scenes illuminated by more than one source, you'll need to leave it uncorrected or choose a light source for which to correct.

Figure 8.13 was shot at the Hoover Dam, in Nevada. Three exposure of 60 seconds, 15 seconds, and 8 seconds where made at an ISO of 200. I then blended the images using Lightroom's Photo Merge > HDR command, with no ghosting.

The top image uses the Daylight white balance setting. The HDR image returned from Lightroom is a DNG file, so adjusting the white balance is as easy as selecting from the White Balance drop-down menu. The image has a heavy orange color cast from the sodium vapor lighting. This is a very common artificial light source used to illuminate large spaces and city streets. It's also very difficult to correct. The sky in this image is the natural blue of late nautical twilight. Although the sky looks natural, the foreground's color cast is just too much. When the color cast is this heavy, the subtle shades of color become overwhelmed and begin to look the same.

For the middle image, I used the White Balance Selector in Lightroom's Develop module and clicked a white sign illuminated by the sodium vapor lights. In an attempt to correct the orange cast, the WB Selector set the Temperature slider to the maximum amount of blue (2000). This setting ruins the color separation in the blue sky and gives the concrete of the dam a decidedly cyan cast.

The bottom image has the white balance set to Tungsten (2850). This intermediate setting doesn't completely fix the heavy orange cast, but it doesn't destroy the blue sky either. It's a setting that makes the scene feel like a night scene without the crush of the orange cast.

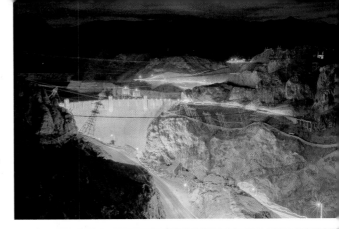

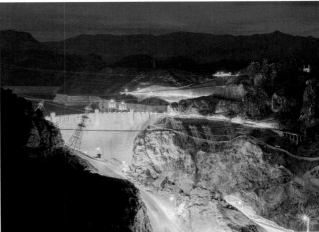

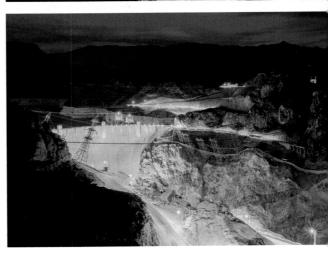

Figure 8.13 Daylight (top), Tungsten (middle), and Custom (bottom) white balance settings

When photographing in or near cities, you'll often experience a slight color cast from the city lights. The image on the left in **Figure 8.14** was made by painting the gravestones with my Surefire 65-lumen flashlight during a 3-minute exposure at ISO 100 and f/11. The graveyard was very near Washington, DC, so the illumination from the city creates a pink/orange cast. The image feels less like a night image with the warm color cast, so in the image to the right I set the white balance to Tungsten to return the sky to a more natural blue color.

Figure 8.14
Daylight (left) and
Tungsten (right)
white balance
settings under city
illumination

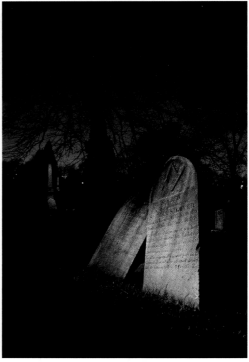

This type of white balance adjustment is not unusual even if you are nowhere near city lights. **Figure 8.15** shows a pair of images made under the light of a full moon. Using a timer remote set to 4 minutes, I set my camera to an ISO of 200 at f/5.6 to capture the ambient light of the rising moon. During the exposure, I jumped in my car and drove up the road with the headlights off but the parking lights on. Using the headlights would have overexposed the road and made the color of the taillights disappear. I then set a timer so that I'd know when I could return with the headlights on without casting my headlights onto an exposed sensor. The image on the left was left at a Daylight white balance, whereas the image on the right was changed to Tungsten in Lightroom. Because the moon reflects the sun's rays, images made under a full moon often have a very similar color cast to that found on a sunny day. Setting the white balance to Tungsten makes it feel more like moonlight.

Figure 8.15
Daylight (top) and Tungsten (bottom) white balance settings under full moon illumination

Occasionally you'll even want to keep your white balance set to Daylight, as I have done in **Figure 8.16**. This image of the Las Vegas skyline was made at the end of civil twilight. Daylight white balance allows the sky to retain the natural color for this time of day and each building to display its own unique color. The camera profile for the RAW exposures was set to Adobe Standard so that the intense color of the city lights wouldn't become overly saturated.

Figure 8.16 **Using Daylight white balance to portray the natural colors of the scene**

Techniques

Some of the best night shots in or near cities are made before it's fully dark. In Chapter 6, we discussed the different types of twilight. Civil twilight occurs 25 to 40 minutes after the sun goes down and 25 to 40 minutes before the sun comes up. During clear or mostly clear situations, the last 15 minutes of civil twilight at night or the first 15 minutes in the morning provide us with a unique lighting situation. At these times of day, the sky is just slightly darker than the city lights. This means that during this narrow 10-to-15-minute gap, twice a day, you can create realistic images with only one or two exposures!

Figure 8.17 shows a typical example, created during the end of civil twilight. The top image was made with one exposure using Daylight white balance. In this case, the fountains and background buildings have a slight yellow/orange cast from the city lights. The bottom image was created by lowering the Temperature slider in Lightroom to 4500. A very slight increase of the Shadows slider, to +10, was the only other adjustment. One exposure was able to capture the entire tonal range at this unique time of day!

Figure 8.17
Only one exposure was necessary to create this image of the fountains.

Figure 8.18 is another example of the same phenomenon. Here, the annual Christmas tree on the front lawn of the US Capitol is captured with only one exposure. Using an aperture of f/16 to ensure that both the Capitol and the statue in front were sharp, I exposed for 6 seconds at ISO 100. In Lightroom, I raised the Shadows slider to +10 and the Highlights slider to +40—very minor adjustments. Once again, Daylight white balance was used. This provided a natural sky, but a close look reveals a pink/orange cast on the exterior lights (sodium vapor) and a yellow/orange cast on the interior lights (tungsten).

Figure 8.18
One exposure was used to create this image of the US Capitol. Daylight white balance and small adjustments in Lightroom finish the image.

At this time of day, the skylight blends with the artificial lights, so the color cast is not as overwhelming. Daylight white balance typically looks good, and the dynamic range is low enough to capture with one shot. For these reasons, this narrow window of time is simply magic for the night photographer. We get the look of night without the extra effort that comes with it.

As you slip from civil twilight into nautical and astronomical twilight, the sky becomes darker and less influential, and the color cast from artificial lights becomes more powerful. **Figure 8.19** was taken near the beginning of astronomical twilight, when the sky was almost completely black. The image on the left used Daylight white balance. The heavy orange cast from the sodium vapor lights really affects the color. To eliminate the color cast, I lowered the Temperature slider to 3000, producing the image on the right. I used a small aperture, f/16, to obtain exposures of 30 seconds, 15 seconds, 8 seconds, and 4 seconds. The elongated shutter speed of 30 seconds allowed plenty of time for the taillights of the cars to record as they drove through the scene.

Figure 8.19
The sky is almost dark during the beginning of astronomical twilight.

I blended the four images using Photomatix's Fusion/Natural function. I used the Selective Deghosting option and circled the entire bottom of the frame to include the car trails (**Figure 8.20**). Instead of letting Photomatix choose the image for the deghosting, I right-clicked inside the selection and picked the +1 image (**Figure 8.21**). Photomatix used the brightest image (the one with the most car trails) inside the selected area.

Figure 8.20
Selective Deghosting in Photomatix

Figure 8.21
Right-clicking inside the selected area allows you to choose the desired image for deghosting.

When astronomical twilight finishes, the sky is completely black, and it can be very difficult to capture any detail in the sky. At this time of night, I simply exclude as much of the sky as possible. A large area of deep black acts as a hole for the viewer to get stuck in. It's better to fill your frame with as much light and detail as possible. **Figure 8.22** was shot well after sundown, when the sky was completely black. By standing under a bridge, I was able to completely fill the frame with detail, lights, and color. I needed to raise my ISO to 800 and set my aperture to f/4 so that my shutter speeds were fast enough to stop most of the motion of the horse-drawn buggy. I circled the horse and buggy in the Selective Deghosting area of Photomatix and chose the image with the least amount of motion.

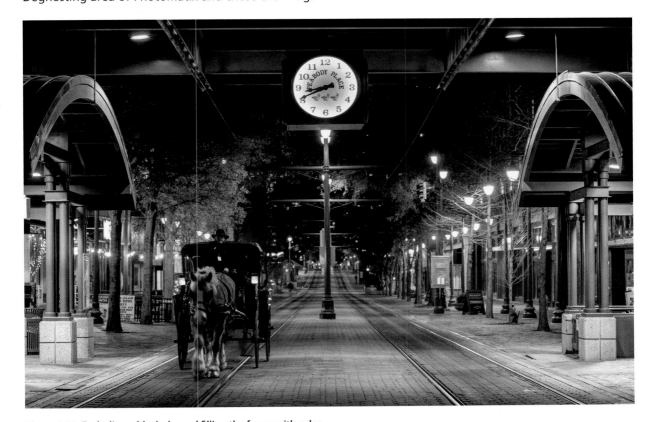

Figure 8.22 **Excluding a black sky and filling the frame with color**

One exception to dark skies occurs when there is low cloud cover, because the low clouds reflect the city lights such that the sky isn't overly dark (**Figure 8.23**). Situations like this open up many possibilities to the urban explorer. Conditions are usually a little lighter, and because of the lower contrast, fewer exposures are needed.

Another fun technique when shooting at night is to use smaller f-stops to create stars from light sources. This technique works best with smaller, pinpoint-type light sources, although

with a small enough aperture, many types of lights may work. If you're using a wide-angle lens, this effect can be achieved with apertures as large as f/8, but f/11 and f/16 work better. The HDR image in **Figure 8.24** was created using an aperture of f/14 with exposures of 1 second, 1/2 of a second, and 1/4 of a second.

It's important to realize that it's unnecessary to get detail in the actual light sources. The lights themselves are so much brighter than anything else that it would take many more exposures to darken them to the point of detail. This would influence your HDR blend and make the resulting image much darker. It's also important to have a bright white somewhere in your image to allow the image its full dynamic range.

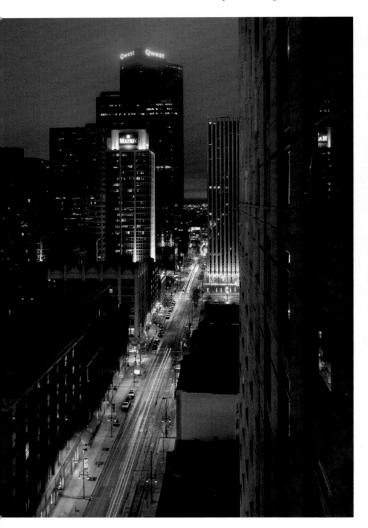

Figure 8.23 **Low cloud cover provides a lighter sky.**

Figure 8.24 **Lights turn into stars when using small apertures such as f/14.**

In addition to keeping a bright white somewhere in the image, pay attention to the saturation of the lights and that which they illuminate. In addition to streetlights, many other types of illumination brighten our cities and towns. Neon signs, accent lights, floods, and wall washes all bear consideration. Lights are most saturated when they are underexposed. The brighter they are rendered on our sensor, they less saturated they become. **Figure 8.25** is a case in point. The bright star points in the upper left of the scene show a good deal of saturation at the edges but get less saturated toward the center, where we see only a slight yellow hue. Compare this to the saturation of the yellow and red on the bridge. The yellow is more saturated than the lights above and is even more saturated as it darkens near the edges of the bridge. This is because the bridge has lights shining on it, whereas the lights above are the actual source. The best way to control the saturation of colors is by choosing an appropriate camera profile from the Camera Calibration tab in Lightroom. If you are blending images in Lightroom, this can be done after the blend. If you are using Photomatix, it should be done before exporting the images. Typically, you'll have the best luck controlling overly saturated lights by using Adobe Standard or Camera Neutral.

Figure 8.25
Using the Adobe Standard camera profile to control saturation in accent lights

Playing with motion over time is an exciting and somewhat unpredictable aspect of low-light photography. The long exposures necessary for these conditions allow the subject's movement to be recorded as it sweeps or flows across the frame. In order for this motion to show up, however, the subject must be brighter than the backdrop it's moving over. The waves in **Figure 8.26** created a misty or foglike feeling as they rose over and then receded from the rocks. The ocean was quite dark compared to the sky when I took this image, about 45 minutes after sunset, so I made two exposures of 30 seconds and 15 seconds at f/16 and an ISO of 100. Scenes like this can often be blended together without any deghosting, as the different motion patterns in the water combine to create a new and interesting look. If the motion looks unnatural, use selective deghosting in Photomatix to select the ocean and choose the brighter of the exposures.

Figure 8.26
Ocean waves create beautiful motion over a 30-second exposure.

A similar situation arises when capturing car trails. In **Figure 8.27**, you see that both the headlights and taillights are brighter than the road they move over. This allows them to stand out. A car without lights would be far less visible as it drove down the street. To capture the cars traveling up and down Pennsylvania Avenue, I used two exposures of 30 seconds and 60 seconds at f/11. If blended together without deghosting, the blended car trails cancel each other out, giving the lights an odd look. I exported these two exposures into Photmatix and chose the Selective Deghosting option. Once I circled the car trails, I right-clicked inside the selection and chose the +1 exposure to take advantage of the longer and brighter car trails. Using the Fusion/Natural setting, I completed the HDR process. I have found that using the Fusion/Real Estate option can sometimes lead to the disappearance of the fainter car trails. Use this option with caution!

Figure 8.27
Car trails selectively deghosted in Photomatix

The moon has fascinated humanity since we could look up. It's been the inspiration for an untold number of songs, poems, stories, and myths. Capturing it with our cameras has always been a bit difficult, however. The easiest way to capture the moon is to photograph it two to three days before the official full moon. On the day of the full moon, the moon rises well after the sun has gone down, which means the moon is much brighter than the sky and landscape in the foreground. This results in a black sky with a well-exposed moon, or in a well-exposed sky and foreground with a pure white, featureless moon.

Two to three days before the full moon, it rises as the sun sets over the horizon. This situation provides us with a couple of advantages. First, when the moon is closer to the horizon, it looks bigger given its proximity to the earth. Second, with the sun above the horizon, it's illuminating both the moon and the foreground equally, meaning the dynamic range of the scene is such that you can typically capture it with one exposure! This, of course, takes a little planning (smartphone apps help!) and a little luck.

Thanks to digital imaging, it's easier than ever to capture the moon, even if you missed the magical moment. **Figure 8.28** was taken on the day of the full moon, after the sun had already set. Its warm rays illuminate the moon, but the foreground barn sits in the shadow of the earth, making it much, much darker. Situations like these require multiple exposures. I made two exposures of 1 second and 1/2 of a second at ISO 100. In hindsight I would have been better off making two exposures of a 1/4 of a second and 1/8 of a second at ISO 400, because the moon moves much faster than we expect. The amount of movement across the frame depends on the focal length of the lens. The longer the lens, the shorter the exposure should be to capture the moon without blurring its edges or rendering it oblong rather than circular. I used a 150mm lens, so the exposures were too long and the moon appears in slightly different locations on each frame; exposures of 1/4 and 1/8 of a second would have captured the moon in one spot.

When a subject is in two different locations on your exposures, it's time for deghosting. Once again I turned to Photomatix for its interactive deghosting scheme. The Selective Deghosting option allowed me to circle the moon and choose the darker exposure for the source image. **Figure 8.29** shows a 100% view of the Photomatix moon on the left; Lightroom's HDR moon is on the right. The Photomatix moon leaves a darker orange halo around the lower left edge, while the Lightroom moon reveals a bright halo, a vestige of the moon's edge in the second exposure. Both will need to be fixed using the advanced retouching tools of Photoshop. The lesson here is that it's easiest to capture the moon a couple of days before the full moon. If this is not possible, meter the scene, and set your camera to auto-bracket to capture the correct exposures. Use a high-speed release mode, and choose a shutter speed that's fast enough to keep the moon in the same location on each frame.

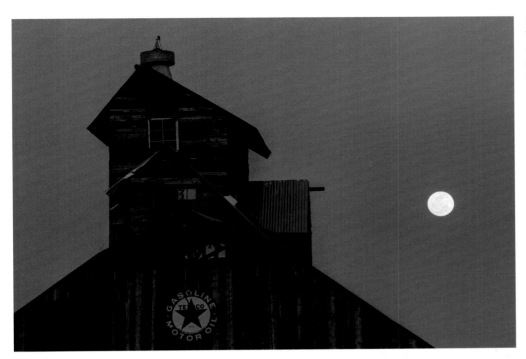

Figure 8.28
Two exposures combined to make this full moon photograph possible.

Figure 8.29
Photomatix blend on the left, Lightroom blend on the right

Chapter 8 Assignments

Test for long exposure noise

Long exposure noise is ugly and just plain hard to fix. It's best to know your camera's capabilities and limits. Set up your camera and tripod in a dimly lit room at night. Start a series of exposures beginning at 30 seconds. Try 1 minute, 2 minutes, 3 minutes, 4 minutes, 6 minutes, 8 minutes, and 10 minutes. Vary your apertures, and use a neutral density filter if necessary to keep the exposures the same. Download the images, and examine them at 1:1 to discover when your camera starts to show long exposure noise.

Test for high ISO noise

Using the methods outlined above, make a series of images at different ISOs. Begin with 100 or 200, and continue raising the ISO until you reach the fastest ISO offered by your camera. Closely examine the images on your computer at 1:1 to determine which ISO is the highest you feel comfortable shooting with.

Test your white balance settings

Experiment with different white balance settings while out in the field. Sure, you can always change the white balance in Lightroom, but large changes in white balance can be detrimental to your images. Viewing the correct white balance on your rear LCD may also lead to different exposure or composition decisions. It's always best to be as close as possible at the time of shooting. Small changes in Lightroom make no difference.

Share your results with the book's Flickr group!
Join the group here: www.flickr.com/groups/hdr_fromsnapshotstogreatshots/

Index

16-bit files, 87, 109, 115
32-bit files, 87, 109, 115

A

accessories
 architectural photography, 175–178
 landscape photography, 139–140
 See also equipment
action. *See* motion
Adams, Ansel, viii
Adjustment Brush, 160, 191
Adjustments panel, 113, 114–115
Adobe Standard profile, 187, 188, 212, 219
aligning images, 97, 112
Antelope Canyon, 30–31
Aperture Priority mode, 39–40
 bracketing exposures in, 44
 Manual mode vs., 41
aperture settings
 adjusting by stops, 10
 depth of field related to, 37, 150–151
 mode for prioritizing, 39–40
 star effect and, 131, 169, 217–218
apps
 DOFMaster, 140, 150, 163
 Moon Seeker, 203
 PhotoPills, 140, 162, 163, 203
 Sun Seeker, 162
architectural photography, 165–195
 accessories for, 175–178
 annotated examples of, 166–169
 assignments on shooting, 195
 correcting distortion in, 184–186
 equipment considerations, 170–178
 Lens Corrections panel and, 184–186
 lenses used for, 171–174, 182–183
 position and focal length for, 182–183, 195
 processing in Lightroom, 187–191
 processing in Photomatix, 191–194
 tripods used for, 170–171
 white balance for, 178–181
astronomical twilight, 153–154, 215, 217
attractions, visual, 62–66
Auto Align checkbox, 97
Auto Tone checkbox, 97, 100, 189
Auto white balance, 36, 142, 143, 178
auto-bracketing function, 44–45
autofocus option, 37

B

ball heads, 171
Baltimore, Maryland, 168–169
Basic panel, 81–83
bit depth, 32
black and white images, 126
Black Clip slider, 115, 116, 117
Blacks slider, 83, 103, 106, 190
blinkies, 42
blocked up shadows, 12, 13
blown out highlights, 12, 13
blue hour, 154–155
blur, motion, 64
bracketing exposures, 44–46
 auto-bracketing feature for, 44–45
 Spot metering and, 45
 tips for, 46
bright areas in photos, 62, 63, 64
Brightness slider, 114, 119

C

cable releases, 34, 202
calibrating monitors, 35, 47
Camera Calibration panel, 61, 85–86
Camera Landscape profile, 145, 146, 188
Camera Neutral profile, 187, 188
camera profiles, 61, 86, 187–188
Camera Raw adjustments, 81
Camera Standard profile, 145, 146, 188
cameras
 auto-bracketing function on, 44–45
 histogram display in, 10, 25
 overview of settings on, 36–37
 perception of eyes vs., 1, 10, 54–61
 profiles for specific, 61, 86, 187–188
 recommended for HDR photography, 32, 35
 sensor capabilities in, 10–11
 testing dynamic range of, 47
 See also Canon cameras; Nikon cameras
Canon cameras
 Continuous Shooting mode, 46
 Indicated Exposure meter, 40
 LCD brightness setting, 205
 Long Exposure Noise Reduction, 205
 picture styles, 60, 145
 tilt-shift lens, 172
car trails, 221

Cartier-Bresson, Henri, 64
chromatic aberration
 Lightroom reduction of, 75, 76
 Photomatix reduction of, 112
circular polarizers, 137
civil twilight, 156–162, 213–215
Clarity slider, 75, 76, 83, 107
clipping, 14, 16, 17
closed shadows, 59
clouds
 civil twilight photos with, 156, 157, 158–159
 landscape photography and, 151–153, 159
 urban night photography and, 217, 218
Cloudy white balance, 143
cold shoe, 176, 177
color in shadows, 59, 67
color labels, 78–79
color saturation, 115, 219
color vision, 59
Columbia River photo, 92–93
composite histogram, 11
composition
 distractions and attractions in, 62–66
 pure black areas in, 19–20
computer monitors, 35
Constrain Crop checkbox, 184, 185
Continuous High Speed Release mode, 46
Continuous Shooting mode, 46
contrast
 controlling high, 8–9
 experimenting with, 127
 limits of exposing for, 7
Contrast slider, 82, 107, 191
crop sensors, 32
Custom white balance, 178, 180–181, 195

D

Daylight setting, 141–142, 143, 179, 208, 209, 212
deep blacks, 83, 102, 107, 116, 117, 127
deghosting feature
 Lightroom, 98, 108
 Photomatix Pro, 122–126
degradation of images, 22, 23, 24
depth, creating, 146–149
depth of field
 app for calculating, 140, 150
 factors controlling, 37
 landscape photography and, 150–151
details
 highlight and shadow, 20–24
 retaining in photos, 43
developing HDR files, 100–109
digital cameras. See cameras

dimension, creating, 146–149, 163
Direct Sun setting, 141–142, 143, 179, 208
distance to the subject, 37
distortion correction options, 184–186
distractions, visual, 62–66
DNG file format, 99, 100
DOFMaster app, 140, 150, 163
DSLR cameras. See cameras
dynamic range, 6, 47, 58

E

equipment, 32–35
 architectural photography, 170–178
 cable releases, 34, 202
 cameras, 32
 computer monitors, 35
 filters, 134–139, 202
 flashes and gels, 175–176
 grip equipment, 176–177
 landscape photography, 134–140
 lenses, 32–33, 134
 low-light photography, 202–203
 remote switches, 34, 202
 tripods, 33–34, 170–171
 viewing loupe, 139
Evaluative metering, 41–42
exposure
 auto vs. manual, 41
 bracketing of, 44–46
 histograms displaying, 10–15, 38
 metering scenes for, 38, 40–41
 visual perception and, 57
Exposure Compensation button, 39, 41
exposure fusion, 87
 adjustment options, 114–115
 blending methods, 191–194
 default settings, 109–111
Exposure slider, 82, 101–102
eye vs. camera perception. See visual perception
eyepiece cover, 139

F

file types, 36
film types, 60
filters, 134–139
 haze or skylight, 202
 neutral density, 137–139
 polarizing, 135–137
flash equipment, 175–177
 gels, 175–176
 grip equipment, 176–177
 Speedlights, 175

triggers, 177
flashlights, 202–203
flexible tripods, 176, 177
Flickr group for book, 25
focal length, 37, 182–183, 195
focal ranges, 32–33, 134
foreground in landscapes, 146, 149
f-stops, 37, 40, 54, 55, 131
 See also aperture settings
full-frame sensors, 32
Fusion/Natural method, 191, 221
Fusion/Real Estate method, 191, 192, 193, 221

G

gear. *See* equipment
geared tripod heads, 171
gels, 175–176
ghosting in images, 98, 122
Glacier National Park, 4–5, 132–133
gray card, 179, 180
Grid view options, 100
grip equipment, 176–177
grungy look, 8–9

H

Hawaiian vog photo, 130–131
haze filters, 202
HDR files
 creating in Lightroom, 96–99
 creating in Photomatix Pro, 109, 116–119
 developing in Lightroom, 100–109
HDR Merge Preview dialog, 96, 97
HDR photography
 architecture as, 165–195
 black and white, 126
 camera settings for, 36–37
 equipment for, 32–35
 landscapes as, 129–163
 low-light shots as, 197–224
 programs for, 8, 74, 91–127
 reasons for using, 8–9
 situations for, 16–24
 technique of, 8
HDR programs, 91–127
 assignments on exploring, 127
 Lightroom features, 96–109
 loading files into, 87
 overview of HDR process, 87
 Photomatix Pro, 109–126
 plug-in modules, 74
high dynamic range scenes, 6
high ISO noise, 36, 206–207, 224

highlights
 blending images to restore, 22–23
 example of lost details in, 20–21
 overexposed, 12, 13, 14, 21
 retaining details in, 43
Highlights Depth slider, 193, 194
Highlights slider
 Lightroom, 82, 104, 105
 Photomatix Pro, 193, 194
histograms, 11–15
 bracketing using, 46
 displaying in cameras, 10, 25
 Indicated Exposure meter and, 42
 Lightroom example of, 11
 metering scenes using, 38
 pixel information in, 24
HSL panel, 84

I

image processors, 32
import settings, 75–77
Indicated Exposure meter, 40–41, 42
input sharpening, 75, 76
interiors. *See* architectural photography
ISO settings, 36, 206–207, 224

J

JPEG file format, 36, 61

L

labeling images, 78–79
landscape photography, 129–163
 accessories for, 139–140
 annotated examples of, 130–133
 assignments on shooting, 163
 camera settings for, 141–146
 clouds in, 151–153, 156, 157, 158–159
 creating dimension in, 146–149, 163
 depth of field in, 150–151
 equipment considerations, 134–140
 filters for, 134–139
 lenses for, 134, 163
 moonrise shots in, 161
 picture styles for, 145–146
 sunrise/sunset in, 153, 156, 162
 twilight hours for, 153–162
 white balance for, 141–144
LCD brightness setting, 205
Lens Corrections panel, 84–85
 chromatic aberration removal, 75, 76
 distortion correction options, 184–186

lenses, 32–33, 35
architectural photography, 171–174, 182–183
depth of field related to, 37, 150
landscape photography, 134, 163
normal, 33, 182
telephoto, 33, 37
tilt-shift, 172–174, 183
wide-angle, 33, 37, 149, 163, 171
Library View Options dialog, 79, 80, 100
light, studying, 67
Lightroom, 69–89
adjusting images in, 81–86
architectural image processing in, 187–191
Basic panel, 81, 82–83
Camera Calibration panel, 61, 85–86
creating HDR files in, 74, 96–99
deghosting function in, 98, 108
developing HDR files in, 100–109
downloading latest version of, 89
exporting to Photomatix from, 111
histogram displayed in, 11
HSL panel, 84
import settings used in, 75–77
labeling images in, 78–79
Lens Corrections panel, 75, 76, 84–85, 184–186
picture styles interpreted in, 61, 145
practice editing your images in, 89
preadjusting RAW images in, 120–122
preparing images in, 74–81
preset creation in, 76–77
Previous Import view, 116
stacking images in, 79–80
synchronizing settings in, 80–81, 187
Tone Curve panel, 83
workflow using, 74, 96
Local Contrast slider, 114
Long Exposure Noise Reduction, 205–207
low dynamic range scenes, 6
low-key images, 17–18
low-light and night photography, 197–224
annotated examples of, 198–201
assignments on shooting, 224
astronomical twilight and, 215, 217
camera settings for, 205–212
civil twilight and, 213–215
controlling color saturation in, 219
equipment considerations for, 202–203
Long Exposure Noise Reduction for, 205–207
low cloud cover and, 217, 218
moon captured in, 222–223
motion conveyed in, 220–221
star effect and, 217–218
techniques for shooting, 213–223
white balance for, 207–212, 224
luminosity histogram, 10, 11

M

Manfrotto 410 Junior geared head, 171
manual focus, 37
Manual mode, 40–41
Aperture Priority mode vs., 41
assignment on shooting in, 47
bracketing exposures in, 44, 45
Matrix metering, 41–42
megapixels, 32
metering modes, 39–43
Aperture Priority, 39–40, 41, 44
Manual, 40–41, 44, 45, 47
Matrix or Evaluative, 41–42
Spot, 42–43, 47
middle ground in landscapes, 146, 147
Midtone slider, 115, 116, 117, 119
monitors, 35, 47
mood of photographs, 17–20
moon
landscapes with rising, 161
shooting at night, 203–204, 222–223
Moon Seeker app, 203
Moraine Lake photo, 70–71
motion
blurring in images, 64
low-light photography and, 220–221
visual perception of, 55–56
multi-coated filters, 134
multi-segment metering, 41–42
multi-tool, 140

N

nautical twilight, 154–156
neutral density (ND) filters, 137–139
Neutral picture style, 145
New Develop Preset dialog, 77
night photography. See low-light and night
photography
night-adjusted vision, 203
Nikon cameras
Continuous High Speed Release mode, 46
Indicated Exposure meter, 40
LCD brightness setting, 205
Long Exposure Noise Reduction, 205
perspective control lens, 172
picture controls, 60, 145
noise
high ISO, 36, 206–207, 224
long exposure, 205–207, 224
reducing in Photomatix, 112
shadow area, 23
normal lenses, 33, 182

O

Oben CT-3461 tripod, 34
ocean wave motion patterns, 220
off-camera flash, 176–177
Ohio State Reformatory photo, 72–73
Open Shade setting, 143, 144
open shadows, 59
optical slave system, 177
output sharpening, 75
overexposed highlights, 12, 13, 14, 21, 42
overexposure warning, 42

P

perception. *See* visual perception
Perfect Exposure for Digital Photography video, 47
perspective control lenses, 172
Photo Merge features, 97, 186
photography terms, 12
Photomatix Pro, 8, 89, 109–126
 Adjustments panel, 113, 114–115
 architectural image processing in, 191–194
 creating HDR files in, 109, 116–119
 deghosting feature in, 122–126
 exporting images to, 111
 exposure fusion in, 109–111, 114–115, 119
 overview of settings in, 112–113
 Preview panel, 113, 114
 recognition of Lightroom edits, 78, 81
 syncing adjustments for, 81, 187
 tone mapping in, 114
PhotoPills app, 140, 162, 163, 203
Photoshop, 8, 74, 81, 86, 108, 115
picture styles/controls, 60–61
 assignment on exploring, 67
 landscape photography and, 145–146
pixel information, 24
plug-in modules, 74
polarizing filters, 135–137
Portrait picture style, 145
preset creation, 76–77
Preview panel, 113, 114
Previous Import view, 116
printers, calibrating, 35
profiles, camera, 61, 86, 187–188

R

radio slave system, 177
RAW files, 36
 bit depth of, 87
 captured by DSLR cameras, 60
 picture styles/controls and, 61, 145
 preadjusting in Lightroom, 120–122

reciprocal settings, 55
reflections
 blending images with, 157
 removing with polarizing filters, 136
remote switches, 34, 202
RGB histogram, 10
Roscolux swatchbook, 175

S

San Francisco, California, 94–95
Saturation slider, 83, 103
Sedona, Arizona, 50–51
seeing vs. perception, 54
selecting images, 97
Selective Deghosting option, 124, 216
self-timer, 46, 202
sensors
 capabilities of, 10–11
 sizes available for, 32
Shade setting, 143, 144
Shadow clipping warning, 106
shadows
 blending images to restore, 22–23
 color contained in, 59, 67
 image degradation in, 23, 24
 revealing lost details in, 20, 21, 106
 underexposed, 12, 13, 14, 16, 17, 25
Shadows slider, 82, 102, 104, 105
Sharpen Scenic preset, 72
sharpening
 input, 75, 76
 output, 75
shoe stands, 177
shooting bracketed images, 78
Shutter Boss timer remote, 34
Shutter Priority mode, 44
shutter speed
 adjusting by stops, 10
 aperture related to, 55
 f-stop combined with, 37
 visual perception and, 55–58
sidecar (.xmp) files, 61
silhouettes, 17, 95, 158
skies
 brightness adjustments for, 65
 cloud formations in, 151–153
skylight filters, 202
Speedlights, 175
spiral staircase photo, 2–3
Spot metering, 42–43
 assignment on exploring, 47
 bracketing with, 45
stacking images, 79–80
star effect, 131, 169, 217–218

stops, camera, 10, 41
Strength slider, 114, 116, 117
Sun Seeker app, 162
sunrise/sunset photos, 153, 156, 162
Surefire G2 Nitrolon flashlight, 202
Swiftcurrent River photo, 4–5
synchronizing settings, 80–81, 187

T

telephoto lenses, 33, 37
Temp slider, 82, 121
TIFF file format, 109, 113
tilt-shift lenses, 172–174, 183
timcooperphotography.com website, 47
timer remotes, 202
Tint slider, 82
tonal values
 adjusting in HDR images, 103
 histograms displaying, 11–12
 photos with full range of, 16
Tone Curve panel, 83
tone mapping process, 87, 114
triggers, flash, 177
tripods, 33–34
 architectural photography and, 170–171
 flexible, for flash, 176, 177
 geared vs. ball heads for, 171
 reasons for using, 33
 recommended for HDR photography, 35
 tips on buying, 33–34
Tungsten white balance, 208, 209, 210, 211
tunnel photo, 28–29, 104–107
twilight, 153–162
 astronomical, 153–154, 215, 217
 civil, 156–162, 213–215
 nautical, 154–156

U

underexposed shadows, 12, 13, 14, 16, 17, 25
Upright options, 184–185

V

variable ND filters, 137, 139
Vello cable release, 34
Vello Shutter Boss, 202
Vibrance slider, 83
viewing loupe, 139
Vignetting slider, 85
visual perception, 1, 10, 49–67
 assignments about, 67
 color vision in, 59
 contrast and pattern in, 58
 distractions and attractions in, 62–66
 dynamic range of, 58
 exposure related to, 57
 eye vs. camera, 1, 10, 54–61
 motion rendered in, 55–56
 physical processes in, 54
 picture styles/controls and, 60–61

W

West Fork Trail photo, 50–51
white balance (WB), 36
 adjusting in Lightroom, 82
 architectural photography and, 178–181
 Auto setting for, 36, 142, 143, 178
 Custom setting for, 178, 180–181, 195
 landscape photography and, 141–144
 low-light photography and, 207–212, 224
 tools for accurate, 178
White Clip slider, 115
Whites slider, 82, 102, 103, 106, 191
wide-angle lenses, 33
 architectural photography and, 171, 182, 183
 depth of field related to, 37, 150
 landscape photography and, 149, 163
wireless remote switches, 202

Z

zeroed out meter, 40, 41